Potlatch People
Indian Lives & Legends of British Columbia

MILDRED VALLEY THORNTON

hancock

house

ISBN 0-88839-491-8
Copyright © 2003 John M. Thornton

Cataloging in Publication Data
Thornton, Mildred Valley, 1890–1967

ISBN 0-88839-491-8

1. Indians of North America—British Columbia—Biography.
2. Indians of North America—British Columbia—Folklore. 3.
Legends —British Columbia. I. Thornton, Mildred Valley,
1890–1967 - Indian lives and legends. II. Title.
E78.B9T44 2003 971.1'00497 C2001-911048-0

We acknowledge the financial support of the Government of Canada through the Book Publishing Industry Development Program (BPIDP) for our publishing activities.

Editing: John M. Thornton, Nancy Miller
Production: Theodora Kobald, Ingrid Luters
Cover design: Ingrid Luters
Cover images, paintings by Mildred Valley Thornton: Front cover *The Hao Hao Dance of the Bella Coolas,* back cover *Tsimshian Totem Poles* and *Chief Billy Assu,* (Kwakiutl).

Published simultaneously in Canada and the United States by

HANCOCK HOUSE PUBLISHERS LTD.
19313 Zero Avenue, Surrey, B.C. V3S 9R9

HANCOCK HOUSE PUBLISHERS
1431 Harrison Avenue, Blaine, WA 98230-5005

(604) 538-1114 Fax (604) 538-2262
(800) 938-1114 Fax (800) 983-2262
Web Site: www.hancockhouse.com *email:* sales@hancockhouse.com

Contents

Introduction

For more than fifty years my mother, Mildred Valley Thornton, pursued her passionate self-appointed mission to capture for posterity the lives and legends of a rapidly vanishing culture along with images of the most prominent characters of that society—the Native peoples of Canada. Armed with her paint box, note pad and little else, she would foray for months at a time onto the Great Plains and later the British Columbia Coast and Interior in her quest to track down her subjects, paint their portraits and record their legends.

This was many years ago. Along with most of her subjects, she has since departed to what was once known by them as "the happy hunting grounds" but her works remain as graphic testimony to her tenacity, industry and talents—as well as being a major and singular contribution to the history of an almost forgotten era.

More than thirty years ago, recognizing the value of my mother's work, Mitchell Press of Vancouver, B.C., undertook to publish the manuscripts she had compiled and suggested that they be divided into two volumes, one of which would feature the Plains Indians and the other the Indians of British Columbia. Though the script of the Plains Indians had been written earlier, Mitchell Press decided to publish the British Columbia volume first and, in 1966, *Indian Lives and Legends* went to press. The result was a handsome, hardcover volume with a dozen full-colour reproductions of her paintings, each "tipped in" on its own full page. The book was an immediate success and soon sold out. Today it is considered to be a collector's item and individual copies fetch hundreds of dollars. Alas, my mother died less than a year after it was published. Her publisher, too, shortly thereafter died, and the second proposed volume lay gathering dust for more than three decades.

For the past fifteen years Mr. Anthony R. Westbridge, of Westbridge Fine Arts of Vancouver, has exhibited and promoted Thornton's paintings and has become a strong advocate of her work. He was determined to oversee the belated production of the second (unpublished) manuscript and finally, with the enthusiastic collaboration of David Hancock of Hancock House Publishers, the long-awaited second book appeared late in 2000. Entitled *Buffalo People,*

it was a soft-covered tome replete with dozens of illustrations including many in full colour. Though not a "companion piece" of the first book in terms of format, the second book is every bit as prestigious as the first. It was at the launching of this book that David Hancock announced his intention to republish the earlier volume. Now we have two truly companion volumes.

In a similar manner to *Buffalo People*, I have edited and, in a few areas, rewritten the text of *Indian Lives and Legends,* now retitled *Potlatch People,* to make it palatable for today's reader. Inevitably my mother used words and phrases that were patently accepted sixty years ago but today have quite different connotations. With this in mind, I have attempted to edit my mother's copy to a minimum, keeping as much as possible to her own words and only making alterations where necessary in order to clarify or modify the text in keeping with contemporary usage. In no case has the meaning of the text been altered. Information that I deemed to be of significance or historical note has been inserted in square brackets. The text is written in the first person, present tense, so the reader should keep that perspective in mind.

This book incorporates the original text plus several additional sections comprising recently discovered unpublished excerpts that I found among my mother's records. She had obviously intended to incorporate them in the original narrative, but for some reason they were mislaid.

—JOHN M. THORNTON

Preface

Years ago I began to paint Indians of western Canada. They provided romantic and colourful material for my brush and, at the same time, I had a favourable opportunity to study them as fellow human beings. Their legends, their art, their history, their way of life and spiritual concepts first commanded my attention and then my enduring respect. The adventurous past of these people is rapidly receding from our view. Much of the value concerning it already has been irrevocably lost. It has been my constant aim to garner as much information as I could, by whatever means lay in my power, to add to existing records.

My first memories of Indians were of those who came in the summertime, whole wagonloads of them, to sell their fine baskets to farm folk in Ontario. I know now that they were Delawares, of the same tribe as the illustrious Tecumseh.

They had good baskets, better than those sold in stores—skilfully contrived, much more colourful and in many beautiful shapes. Like the country stores, if you didn't have ready cash, the Indians would take in exchange butter, eggs or anything they needed.

I do not know why I was afraid of the Indians in those days, unless it was because I had heard people say they might steal our chickens. This of a race who traditionally looked upon thievery as a most heinous offence that would not be tolerated in any tribe! But their happy, carefree manner fascinated me. And when they went over the hill in their creaking wagons, a bit of my heart always went with them.

When I was a young married woman and the mother of twin boys, living in Regina, I read in the evening paper that an Indian baby had been born in a tepee on the Fair Grounds. How I should love to see it—a brand new little papoose! So a couple of days later I took my little boys, then not quite three, and we went to the Fair.

We made our way immediately to the Indian encampment. Nobody paid attention to us as we rambled about among the many other visitors. Few of the older Indians could speak English though some of the younger ones, educated at the residential schools, could. At last, with their help, we found the tepee for which we were looking. I hesitated outside, not wishing to intrude but someone spoke to

7

me and I said how much I would like to see the new baby. Instantly the flap of the tepee was thrown open with a gesture of welcome.

Inside it was clean, sweet and cool. Skin rugs lay on the ground where men and women sat in quiet conversation. Stretched across the tepee from pole to pole was a tiny hammock in which the baby lay, snug and warm. I was so interested in the sleeping child that I forgot all else for a moment.

Suddenly I became aware of a buzz of conversation around me—in the Native tongue. While I was lost in admiration of the little Indian baby, its mother and the others were wildly excited over my children—two of a kind, dressed exactly the same and looking as much alike as could be. They pointed first to one, then the other with much more animation than Indians usually display. Twins are rare among these people, and, unwittingly, I had provided a treat for them while they furnished one for me. It was fair exchange.

I was infatuated with the colour and character of everything around me and I resolved to come back next day with my paint box. A friend came to mind the boys and I returned to the encampment early and wasted no time looking for a subject. Any one of them would do.

Peter Weasel-Skin was sitting outside his teepee in full regalia, peacefully smoking his pipe in the warm sunshine. He didn't mind me being around any more than the little gnats that buzzed over his head. We were equally harmless.

As I worked, old women in colourful shawls crowded around me in eager curiosity, thrusting their heads so close to my paint box that I could hardly get my brush in for a refill. "Tsh, tsh, tsh," they kept saying over and over again. This was something they had never seen before and they called others to witness the wonder. Difficult as it made my task, I would not spoil their fun and worked furiously to capture, as best I could, the placid features of my subject.

The old women were completely bewildered when they saw the face emerging on my canvas. The little clucks and expressions became more excited and finally ended in hearty laughter. Peter Weasel-Skin was astonished when I showed him the portrait and even more astonished when I paid him for what had been, for him, just a pleasant interlude.

After that I painted Strong Eagle, a fine intelligent chap who spoke good English and was delighted to give me a bit of his time.

These first two Indian portraits established the pattern for all the work that followed later on. I painted Indians wherever I found them, in whatever they were wearing, with an absolute disregard for formality or prearrangement.

As I carried my still-wet paintings home, in the broiling sun, tired but happy, little did I know that I was committing myself to a task that, through many long years to come, would never let me go. How could I guess that these people, the first inhabitants of our beloved land, could so creep into my heart as to possess it utterly and to become the one compelling urge of my life—to record as much as I could have their fleeting history? In time no effort would be too labourious, no sacrifice too great to achieve this desired end.

Next day I took the boys with me and we went to the Fair again. This time I had no need to look for a subject. The Indians were seeking me—and whatever coin was offered. Strong Eagle came up smiling broadly and said he would like me to paint his wife, Rosemary. Fortunately, I did not commit myself, not knowing what sort of subject she might be.

You could not imagine anyone who looked less like the connotation of her name than Rosemary. She was a huge, fleshy woman who had been bitten all over her face by either mosquitos or blackflies. Bulging red lumps covered her features and over these she had smeared lavish quantities of soft lard. It was impossible to conceive a less desirable subject to paint, yet here was good old Strong Eagle loyally asserting her right to be immortalized.

The boys took one look at her, tugged at my hands and shouted "Come away, mother. Don't paint her. She scares us!" I mumbled something about "another time" to cover my embarrassment and hustled them off before they provoked a fight. Years later I saw Rosemary again in her own home on the reserve. Though her *avoir dupois* remained unchanged, she looked very attractive wearing a bright red bandanna. Her home was spotlessly clean. She had the reputation of being the best cook and one of the best housekeeper on the reserve, so it was understandable that Strong Eagle might find her unfailingly becoming.

When we moved to British Columbia in 1934, I discovered Indians of a totally different order from those I had known and painted in Saskatchewan and Alberta. Many times I went back on pilgrimages to the prairies, but in the main the past thirty years have

9

been devoted to painting the Indians of Canada's westernmost province. [Note: The time period referred to was circa 1934–64.]

Many friends have asked me if I ever learned any of the Indian languages. Since I have been continually going about among different tribes who spoke totally different languages (and often many dialects within the same language) it would have availed me little to learn any of them. I discovered early in my travels that there was one tongue all could understand—the language of the heart—and that would take you anywhere.

I found most Indians, even the older ones, have a little knowledge of English though they are sometimes cautious about disclosing that knowledge. Perhaps they rather enjoy seeing a non-Indian become somewhat frustrated and at a disadvantage for a change— and who could blame them? In any case, language has never been a barrier to me.

It is surprising how much one can convey without the spoken word. Indians must be the most intuitive people in the world. Even the children sense instantly the inner attitude of visitors. If you go to them with superficial or merely curious motives, they will perceive your intentions at a glance and an invisible wall of restraint rises instantly between you. Go to them with sincerity, genuine affection and respect as fellow Canadians and no people could be more affable, courteous or friendly. Nowhere in British Columbia did I find Indians using the sign language so common among Natives of the Plains.

I have painted Indians from the Yukon and some from close to the U.S. border, from the West Coast of Vancouver Island to the Kootenays. Mostly I have gone alone and independently on my travels. The few times I did not succeed in getting the subjects I wanted to paint was when someone else was with me. Nearly all the portraits have been done in a single sitting. This was more from necessity than from choice. I found that in this field of art you have to seize the opportunity where and when it is offered and pour every ounce of energy into one supreme effort. Your own comfort and convenience simply doesn't matter. Wanting the prize, you pay any incidental price in its obtainment.

When I was painting an Indian who was wearing an elaborate costume I concentrated on the face, making hasty indications of colour and design of the clothing which I would finish later. Rarely

did I ever touch a face again and then only at my peril. There is absolutely no substitute for working directly from the subject in portraiture.

I never posed my subjects—just watched what they did naturally and that is what I painted. If I got two hours for a sitting I was lucky. Much more frequently I had to be content with one hour and sometimes with less than that. The hard discipline of circumstances compelled me to register only essentials. There was no time for pondering over technical details or retouchings. You had to know exactly what you wanted to do, then do it with all the power and decision at your command, once and for all, without fear or equivocation.

What was needed mainly was physical endurance. The qualities of a good pack horse often seemed more important than intellectual acumen. Starting out on a trip with perhaps twenty or more boards to carry, as well as my heavy paint box, my suit case and, in later years, also a projector, slides and screen to show the Indians what I had done, demanded the limits of my strength.

I usually returned home with every canvas used plus as much additional improvised material as I could acquire. I would have crowded six months' work into a month or so of effort but it sometimes took me nearly six months to recover from the orgy of expended energy. Thereafter, I was ready and eager to set out again.

I made a point of searching out old people who had been a part of the early history of the province and who could remember many of their ancient customs and traditions. Always I talked to them as I worked to put them at ease and, in this way, obtained much valuable information first-hand. At the earliest opportunity I wrote it all down, so I would not forget it in the hurried events that might follow.

During these hectic and happy years I received impassioned letters from my dear mother who just could not understand why I was wearing myself out "chasing those wild Indians all over the country when there were plenty of white people to paint." I did not tell her that, in the main, my own race seemed to me a dull, expressionless lot compared to the Indians and did not interest me sufficiently.

I could not have accomplished the work had it not been for the unfailing support and cooperation of my understanding husband. [John Henry Thornton (1885–1958), born Sheffield, England; master baker and businessman.] When the boys were small, I took them

11

with me whenever I could. Under these circumstances I had to paint with one eye on my canvas and the other on the youngsters—good exercise for the eyes but rough on the nerves.

As the children grew older, my husband managed somehow to do double duty to fill in the gaps at home while I was away. Despite all this I was forever torn between two loyalties—the inevitable fate of a married woman with both a family and a career to serve. Often now I look back and wonder how I did it, but I am convinced of one thing: given a modicum of health, you can find time for anything you want to do, no matter how many difficulties may confront you. If you really want to do it, somehow you will find a way—nothing can stop you. Discouragement, lack of funds, ill health, indifference from others—I knew them all in full measure but persisted because I was determined to finish the job I had set out to do.

These writings have covered a long space of time. Most of the characters referred to in the present tense have passed away. I prefer to leave the accounts of my contacts with them as originally written. They live strongly in my memory.

Painting the Indians has been a rich experience for me. Often I have lived with them, journeyed with them, joyed and grieved with them. I am filled with gratitude that I was privileged to do this work at the last possible time that anyone could do it, recording a colourful and important phase and era of Canadian history which is all but over now.

My gratitude, however, is tempered with a deep sense of sadness. Many, very many of those whom I painted and therewith numbered among my friends, have trudged stolidly, uncomplainingly down their last long trail into the sunset. Too soon, others who remain must follow and something very rare and noble will have departed with them into the land of tomorrow—the abode of the great Sagalie Tyee, "The Chief Above All."

—Mildred Valley Thornton
1966

12

Indians of British Columbia

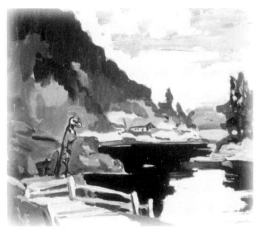

British Columbia Coast

The story of British Columbia Indians is such a vast subject that many volumes would be required to do it justice, and only a fully trained research worker should attempt the task. In recounting my own experiences it is neither possible nor necessary to give more than a few details and only those which will interest the average reader. Our libraries and museums offer much opportunity for those who wish to pursue the study further.

Living in the midst of the greatest fish spawning grounds in the world, the Coast Indians had access to an inexhaustible food supply, obtainable with little effort. Nature was prodigal in her gifts, providing bountifully materials for handiwork. The all-important cedar tree, spruce, mountain goat wool, shells, stone, jade, horn and argillite were used with marvellous ingenuity for many purposes. Elaborate and involved rituals and secret ceremonies, with emphasis on wealth, prestige and prerogative calling for lavish display, were the very core of existence and provided fertile soil in which their bold, exciting and dramatic art grew and flourished.

The Indian was never a purposeless person—there was thought

▸ *colour plate page 165*

and reason in everything he did. His art was part of the pattern of the whole design of life. It was the thing that gave meaning and direction to all Indian customs and ceremonies. Art was the outer symbol of a highly complex social and tribal existence.

The artist worked in constant collaboration with the songmaker, the dancer and the storyteller. He was absolutely indispensable to the rich culture of his race which indubitably accounts for the vigour and magnitude of his achievements.

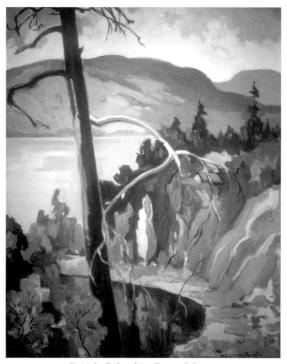

British Columbia Coastal Scene
[probably an early view of Marine Drive between
Horseshoe Bay and West Vancouver]

Kwakiutl

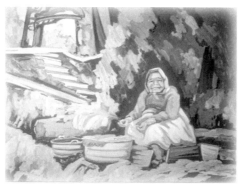

Kwakiutl Woman Cleaning Salmon

The Kwakiutl Indians, living on the northern tip of Vancouver Island and part of the opposite mainland and their neighbours, the Haidas of the Queen Charlotte Islands and the Tsimshian of the Nass and Skeena Rivers, produced the finest totem poles that have ever been carved. Nootka Indians on the western coast of Vancouver Island and Bella Coolas on the mainland also made totem poles, but they were less numerous and not as spectacular as those of the above-mentioned tribes.

The Kwakiutl are said to have originated the secret society. Prestige, wealth and privilege were of paramount importance and it was with them that the celebrated potlatch reached extravagant proportions.

Ceremonial dances of the Kwakiutl Indians had their roots in much preoccupation with the supernatural and the mysteries of life. Everything had meaning to them. Dance masks, beautifully carved and painted with natural dyes, represented various creatures in this fascinating world of the supernatural that held such an important place in their interpretation of life. Cedar bark, dyed with the juice of the alder, had secret significance and was always worn with the masks. Blankets worn during the dances were ornamented with gleaming pearl buttons that outlined the owner's principal crests. Singing, the beating of sticks on wood, rattles and whistles of vari-

▸ *colour plate page 131* 15

ous kinds accompanied the dances, each in its own place and to its own dance.

All the dancers "came out" from behind a large ceremonial curtain or screen. There was special meaning to this curtain. It was supposed to contain magic. No one was permitted behind it without permission of the chiefs or nobles. Every dancer had to make a right-hand turn before going back behind the curtain. If one turned left it would invite disaster and something would have to be done about it immediately to ward off evil.

Each person danced by himself or herself, never together. "We do not hug each other when we dance, as white people do," said an old chief. "Always dance alone."

Many creatures and subjects of the wild are represented in the dances. There are the salmon dance, the raven dance, the crab dance, the grouse dance, the spirit of the woods dance, the canoe dance, the hamatsa (or wild man) dance, the warrior dance and many others. There is the dance of the little bird that "ripens the berries." The raven mask comes from above. It is a spirit from the skies with a very long beak. The spirit of the underworld is always in a crawling position.

Indians say that there is a cave on Gilford Island about eighty feet up from the ground where the animals dance. There is a hole just big enough for them to crawl through and when you get inside you see a large room in the rocks. On one wall is the figure of a man with his arms outstretched, palms up, to welcome everyone. This is the secret place where all the wild creatures meet for their ceremonies. When you get inside the cave you must have a branch of salal with you to brush away the evil spirits. If you didn't do that you would be sick—"maybe die." At the back of the big cave is a huge, flat stone like the ancient ceremonial screen of the Kwakiutls. You could not leave the cave through the same hole by which you entered but had to go out another way.

In this secret place each animal had its own dance and its own dance mask. They came in one by one and each had its appointed part to play. There was the wolf who came in first, howling, and the raccoon who had to look after the fire. Then came the little mouse who was a sort of watchman. Occasionally he would be sent out to look around to see if any humans were in sight. Animals, fearing humans, could not dance if humans were around. The marten had

his dance as did the kingfisher, the sparrow, the owl, the deer and the fawn. When the wolf howls, the deer and the fawn drop down in terror until all is quiet again. The mouse is sent out a second time and, after being absent a long time, he reports that no humans are about so it is quite safe to proceed with the dancing. The bumblebee comes out with its own inimitable movements, then the mighty eagle and many others. Each had its own dance and the movement of each is uncannily like the creatures they represent when the Indians do the dances.

Chiefs Charley Nowell & Herbert Johnson

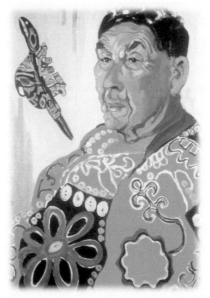

Chief Charley Nowell

It is thought that West Coast Indians first came into possession of pearl buttons when early Russian traders, seeking valuable otter skins, came to their shores. With the Indians' instinctive desire for beauty and decoration, they obtained the buttons through barter and used them to outline the crests on their blankets.

A chief's standing in the tribe was governed by the crests he was entitled to use. Additional crests were obtained through marriage. There were many other privileges that the Kwakiutl secured through marriage, such as the right to perform certain dances, to sing certain songs and to receive certain names.

Chiefs Charley Nowell of Fort Rupert and Alert Bay and Chief Herbert Johnson of the Hahwamis tribe were born when the old Native customs were in full swing. They grew to manhood with cen-

▸ *colour plate page 173* 18

turies of traditional behaviour behind them to influence their thinking and their actions. Over a quiet meal in my home they discussed with me the old days and the old ways. Chief Charley spoke fluent English, but Chief Herbert was not entirely at ease except in his own language.

We talked at some length about the potlatch. Speaking for Herbert, Charley said: "He likes to do it, and has done it lots of times. As a chief he wants to be good to all the people—doesn't want to be selfish—doesn't want to keep all the money he earns. He wants everybody to have it. That is what every chief thinks. We don't think it is wrong. We think it is good. When a chief gives everything he has, he never thinks he is poor. He will always have enough. The first thing our parents told their children was, 'Don't spend your earnings foolishly, keep them 'til you get enough, then give them away to other people, and they will look upon you as a good man.' So we know it's good, for we have that advice from our parents."

Potlatch is a Chinook word and it means "to give a present." The Hudson's Bay Company used the word in the early days in connection with barter, but the Indians say they had the ceremony of giving long before the white man came. "Ever since the first man was living after the flood, the Indians have given potlatches," Chief Nowell said.

A potlatch might be given for various reasons: a marriage, a funeral, a coming of age, to raise a totem pole. When Chief Nowell's son died all the people came from different places to bury him. The chief gave a potlatch and gave much money away on that occasion. Later, when his brother died, the people came again and he did the same.

By that time the potlatch had been forbidden by the government as it was felt that it impoverished the Indians, so the chief was arrested and put in jail for breaking the law. But sympathetic friends in Victoria secured a speedy release for him. When his son Alfred was seventeen, he married the daughter of Chief Mamalilikula who gave him 1,000 blankets. Then Chief Charley Nowell gave a big potlatch for the lad and gave away the blankets to the assembled guests.

The last time he gave a potlatch was when his daughter became a woman. This is always a great occasion among the Kwakiutls and

many blankets as well as much money were given away to celebrate the event.

As a very special favour Herbert has given me his own totem pole, which is standing in front of his house at Simoon Sound. It is one of the really old and rare pieces of such art that is left and is in an excellent state of preservation. Money cannot purchase these things but the generosity of the Indians knows no bounds to those they trust and respect. The totem pole stands twelve feet tall and is nearly three feet across, Herbert says.

Such things are not meant for the noise and bustle of city streets, but rather for the solitude and dignity of the woods and quiet waters. Just as soon as fortune favours me with a suitable place to put it, I shall send for the great totem—and who knows that I, too, may give a potlatch when it has been firmly set up in its permanent abiding place? [The pole remained at Simoon Sound.]

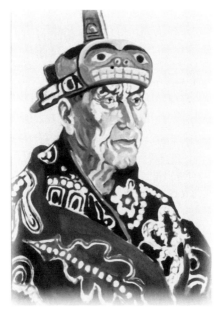

Chief Herbert Johnson

Chief of the Bella Bellas

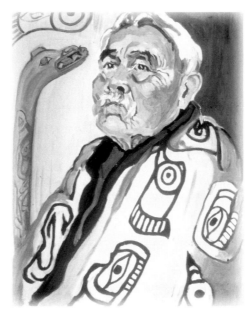

Chief Moody Humchitt

Beautiful, beautiful is the meaning of Bella Bella, and Moody Humchitt, chief of the tribe, was reported to be the "hyas tyee" man of the British Columbia coast.

Hyas, in the Chinook jargon, means "big" and tyee means "chief"; therefore, Moody Humchitt was a "big chief"—not just a common ordinary brand of chief but something special. That was the reason why I wanted to paint him. Everywhere I went, it was the same. Everybody acknowledged that the chief was a very important man. He was a member of the Grizzly Bear clan of the Kwakiutl.

He well deserved his Indian name Wo-ya-la, which means "big potlatch house," for he had given many a potlatch in the early days. They were grand affairs, too, by all accounts, famous for their size and displays of wealth. Tribes from villages all up and down the coast came at the chief's call to attend those fabulous functions.

According to the Indian way of thinking Chief Moody Humchitt

came of royal blood. His mother was a lady, a princess, a chieftainess in her own right. His grandfather had been a mighty chief. His father had been a chief too, and, as a chief himself, he was compelled to marry a member of the nobility. It would have been an unforgivable breach of traditional etiquette for one of his standing to marry a commoner.

Chief Humchitt is one of the last links with the historic past of his people. As a boy he had worn clothing made of wool from the mountain goat or cedar cloth and eaten the food nature had provided so bounteously for the Indians. He had been initiated into secret societies and instructed in the honoured traditions of his tribe.

Long ago the Indians of Bella Bella lived on another site some distance away from the present village, in a sheltered bay with a wide, sandy beach. One can see where the great cedar houses once stood and where the mighty canoes had been hauled up over the sands to safety. The present village is built on muskeg; all the houses and streets are on stilts along a rock-strewn shoreline.

As became a chief, Moody Humchitt had a big house in the "old town" and it was there that he called the neighbouring tribes to his potlatches. There were other big houses in the village and huge totem poles proclaiming the wealth and prestige of the Bella Bellas.

A chief never carved his own totem pole but always employed someone else to do it. This was an acknowledged custom among the tribes, probably a safeguard against the illegal use of crests.

It is many years since the chief had the masks, blankets, coppers and totem poles so important in his youth. His speaker's stick and a small rattle or two are the only relics he has retained from the old regime. The beautifully carved speaker's stick, which is prized very highly, had been given to him by the Haida of the Queen Charlotte Islands.

The speaker's stick of the coastal Indians is a symbol of authority. It is similar in concept to the mace used by Europeans in their councils and parliaments. Oratory was an essential qualification of a successful chief. When the chief spoke everyone listened with the deepest respect until he was through. Then, if someone else wished to speak, the chief handed him the stick and, so long as it was in his possession, he had the floor.

No Indian would ever be so rude as to interrupt a speaker. When

a speaker had concluded what he wished to say, he passed the stick onto someone else and he, in turn, had command of the audience.

Moody Humchitt's first wife died many years ago and he later married a "high woman" from Alaska. Her name, Sadahaim, means "treasure box" in the Tlingit tongue. Her mother was the daughter of a chief and she had to marry into nobility, so there was no loss of prestige either way when she married the chief of the Bella Bellas. She did not like to see him without any ceremonial regalia so she wove him a beautiful blanket which perpetuates a story from her mother's people.

Moody Humchitt died not so very long ago, possessed of many honours at the close of a rich and useful life. In accordance with tradition he was buried on Chief Island, a long, rocky, narrow island not far from Bella Bella, where repose the revered bones of the highest of the tribe. Big steamships pass by, unheeding, and passengers wonder at the tiny, weather-beaten frame houses that peer gauntly from beneath the sheltering trees. They do not know that this is a village of the dead—the last resting place of the highborn of the Bella Bellas.

Grand Old Man
of the Kwakiutl

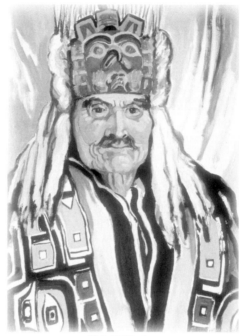

Chief Billy Assu

Cape Mudge is on Quadra Island directly opposite Campbell River in Discovery Passage. In the old days Indians at Cape Mudge were called Wi-all-cum. Campbell River people were known as Wi-will-cum. There used to be twelve great potlatch houses at Cape Mudge, but no traces of them remain today. All the old customs changed suddenly with the coming of Christianity.

When the United Church came to the village, Chief Billy Assu listened, observed and did some deep thinking. He was not the sort of man to take half measures. His shrewd mind foresaw the coming changes and when he made a break with the past it was swift and clean. The old Indian houses were torn down. The chief tells how he

put chains around his own great house, hitched it to a donkey engine and pulled it out to sea. A scow-load of the Indians' possessions, totem poles, regalia, rattles, masks, etc., was towed away and sent to the National Museum at Ottawa. To be sure, they were paid for these goods but no amount of money could buy them now. Cape Mudge Indians who visit Ottawa today view their tribe's former possessions with mixed emotions.

Cape Mudge has long been noted as one of the most progressive and prosperous Indian villages on the entire coast. This is due, in large measure, to the energetic forward-looking leadership of Chief Billy Assu. In his family circle, the chief is spoken of as "the old man," but from the lips of the Indians this is not a derogatory term. They speak of the old man or the old woman with affection and deep respect. To most Indians age has always meant experience and wisdom. All tribes listened with profound attention when the old ones spoke.

Chief William Assu of Cape Mudge is one of the grand old men of the Kwakiutls. He is more than eighty years of age but you would never think it to look at his tall (6 ft. 2 in.) erect figure, heavy dark hair and snapping black eyes. During his lifetime he has witnessed a dramatic transition from the old to an entirely different way of life and has marched resolutely in step with the times. Eighty years ago West Coast Indians lived according to the old traditions. They led a carefree, colourful existence, honouring old customs that had been observed for countless generations.

When Billy Assu was a baby, his father gave a potlatch to bestow upon him his first name Ya-kin-ak-was, which means "gives a guest a blanket." When he became a youth of fourteen his father gave a still bigger potlatch and he was given another name, Ma-ma-sa-ka-mi, meaning "giving away things." In due course, when he grew to manhood, he gave a potlatch himself and took a new name, Tla-gog-las, translated as "giving away plenty of things." And later at still another potlatch he took yet another name, Pa-sa-la, which meant simply "giving away."

The chief estimates that during his lifetime he gave several hundred small potlatches and two very large ones. For the big affairs he called people from Victoria, Duncan, Nanaimo, Comox and Campbell River.

At eighteen Billy Assu was a fine, strapping man weighing 212

pounds. Every morning, upon rising, he bathed by plunging into the cold waters of a spring behind his house. In winter he broke the ice to bathe. The cold water made him strong, he said. Then he would start out before sunrise to hunt.

One day, after a long hike, he shot a 220-pound deer at 9:30 in the morning and tramped until 3:30 in the afternoon carrying it home on his back. After a good meal he could have done it all over again and would have thought nothing of it.

At the end of the fishing season each year the chief declares he is going to retire and rest from his labours but when spring comes and the Indians begin to ready their boats, he is right in there pitching with the rest of them, eager and ready to start. The chief has always been a hard worker. He gave each of his sons a good start in life. He built them homes and gave them gas boats.

Billy Assu belongs to the Eagle Clan. His mother was an eagle and his father a wolf. Among his people the matriarchal system prevailed—always a son took his mother's crest. As the chief puts it, "Don't care much for a father's side, more care for mother's."

The chief told me that in the beginning Father Wa-kai was the first man at Cape Mudge. He was there before the flood. Wa-kai was known all over British Columbia. He predicted there was going to be a flood and made a great cedar rope that stretched from the top of a high mountain to the sea. He invited other tribes as well as his own to tie their canoes behind his to the rope as the whole world would be flooded and there would be terrific currents. Many of them did so and were saved. Some drifted hundreds of miles away in their canoes and it is claimed today that their descendants still speak the same language as the people of Salmon River, Green Point Rapids, Cape Mudge and Philips Arm.

Wa-kai boasted that he was the head of the most powerful tribe in the world as he had acquired all the important crests. He had many wives to prove his supremacy, having married many times to gain their crests. Additional crests could only be obtained through marriage. He would be married for a certain length of time, then give a great potlatch to get his freedom, or divorce as Europeans would call it, then marry again into a recognised tribe, all in the Indian way, of course. With each wife he would receive her slaves along with her crests. It was all part of the dowry.

It is said that Wa-kai never attacked other tribes and always

defeated those who attacked him. In the old days even the fierce Haidas never assaulted him but always travelled through the Johnson Straits at night to safeguard both tribes. Wa-kai made his own laws for the people of his area and kept patrols day and night in the Straits to watch for their safety from marauders. No fires were ever allowed at night.

When every Indian boy came of age, he had to take strenuous physical training to keep fit. That was one of the laws of Wa-kai. There were six families in his tribe, each with its own crest. Wa-kai chose only outstanding people and declared that even if ten tribes were to come against him they could never compete with him.

Chief Assu used to have two big totem poles in front of his own house. These had been carved by Johnny Kla-wa-chi and were painted in natural colours. The chief had told Johnny which crests to put on the poles and he made sure that they were carved correctly. In the old days it took several years to carve and paint an elaborate pole with tools that were stone axes and chisels. One skilled artist would be in charge of a job with two or three helpers. Poles were made much more quickly when the Indians acquired white men's tools. Paints used to be made from different coloured natural minerals and oxides mixed with fish oil. These paints were sometimes exchanged in barter with other tribes. There were also finer paints that were smeared on their faces for dancing and for war.

Totem poles were carved outside in summer but the carving of masks was different. These belonged to a higher class and had to be made secretly.

One of the crests on the chief's pole was that of a whale. This denotes that he was a person of high standing. No other tribe could harm him because the whale is a very powerful creature. At the top of his pole was the legendary bird Hoh-hok, who was supposed to have been the daughter of the great Raven, the Creator of the World.

All tribes had mythical ancestors who had supernatural powers. Indians claim that what their ancestors did thousands of years ago they have done today to perpetuate their legends and carry on their history.

There is much to be said for the old system. It was a great stimulus to individual enterprise. Every person had to earn his own standing. There was a constant struggle to maintain eminence of

position. If a man should flag or fail in his efforts and not give potlatches he would lose prestige immediately.

When Chief Assu gave a potlatch he would exhibit all his crests through dancing and singing. At one time he called sixteen tribes with more than 3,000 people and was host to them for three weeks. His great house, 300 feet long by 100 feet wide and 50 feet high, was bursting with food and items to be given away including many gold and silver bracelets and 6,000 blankets. That was about seventy years ago. [Now more than a century ago.] "Indians just like white man," says the chief, "like to give big party."

Names, songs and dances were treasured and carefully guarded perquisites of the Kwakiutl Indians. According to ancient unwritten but very binding laws, the only way to obtain extra rights of this nature was through marriage.

A great many years ago the chief had ardently desired to use a name belonging to a family at Fort Rupert. His eldest son at that time was about ten years of age. With great ceremony the chief and his people went to Fort Rupert and betrothed the boy to tiny Bessie Hunt, an infant of eleven months, for no other reason than to obtain the much coveted name.

As a symbol of the validity of such a transaction the chief was presented with a handsome Chilkat blanket and the carved headdress he wears so proudly today. Nothing ever came of the proposed marriage. In later years when the children grew up they both took mates of their own choosing but the bargain concerning the names still held good.

How the Loon Came to Be on Willie Siewid's Headdress

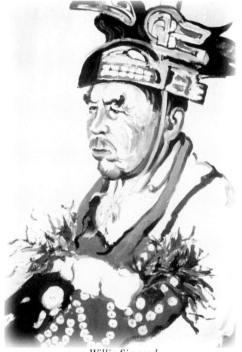

Willie Sieweed

(The following is related verbatim.)

Once there was a loon called Namoquees and the wife of the loon was named Lakeneezumka. They had a son and they lived in the village of Whamis. Later they moved to another place called Kedaguis. The boy grew up to be a man and after some years he went back to Whamis because there were lots of goats there and he needed food.

One day he went far up into the mountains, hunting, and he saw a goat a long way off. He came up pretty close to where he had seen it but when he got there the goat had disappeared. He didn't know

where it had gone but he saw a crane flopping along the ground as though it was wounded so he tried to catch it. The crane always kept ahead of him so he followed it for a long time.

Finally, to hide, it went under some long grass which was hanging over the rocks, but the boy followed and found himself in a place that looked like a cave. It was awfully dark inside and he couldn't see where he was going but he kept on walking. It was toward evening when he went in the cave and after many hours he thought he could see daylight and a house in the distance.

He went inside the house to see what it was there for and found it was where the goats lived. He jumped in so fast that they could not stop him.

One of the goats spoke up to his friends and told them not to be afraid of the man jumping in so suddenly because he knew where he was going. He was a friend of the goats and wanted to get something good from them. That was what was in his mind and he meant no harm.

The chief of the goats was sitting in his chair inside the building and he asked the man what he wanted, what he was doing there. Of course all the time the goats knew what was in his mind but they wanted to hear what he had to say.

The man saw something that was hanging above the chief's chair. It looked like a weapon and he said he wanted that. The chief of the goats told him to grab it by about the width of his hands, so he did and he was able to get just that much of the weapon. Then the chief said, "Is that all this young fellow wants? Maybe there are more things he would like to have." They knew all the time what it was that, in his heart, he wanted.

Now the chief had some spirit water that would bring a dead person back to life and that was what the young man really coveted but he didn't like to say so. They told him he could have some of the spirit water but that he would have to stay with them another four days.

Then they sent the rat, as he was the fastest thing they had, to go out and see what the weather was like. The rat went off and when he came back he told them that the weather was fine, so they all went out to feed on the mountain.

The man stayed the four days as he was told to do and then the chief of the goats told him he could go home but warned him to take

good care of the things they had given him, to cherish them and never do any harm with them. The chief told him never to take more than four goats at a time and to remember everything they had told him.

So the man went away and he used the weapon the goats had given him when he was hunting in the mountains. He killed one goat and took it to his own home and hung up the fat in the sun to cure it. Then he went out again to get the other three goats to dry the meat. After the man had finished his work, he thought of his father and mother. They were getting pretty old so he must go soon to visit them and see how they were getting along.

Strangely enough, his parents were thinking the same thing as their son. The mother said to the father: "It is a long time since we saw our son. I think we had better go to his house."

Now the man thought he had been with the goats in the mountains four days but it had really been four years. The parents knew it was four years and they were anxious to see their son after this long absence. Both left at the same time and they met at a certain place called Kaahma.

The man stopped at this place and decided to go in for a swim. He had a mask and he was swimming and riding on the mask in the water. Then the parents heard the call of a loon and they knew that their son was still living and soon they were all together again.

The parents asked the man where he had been all this time and he said not to talk much until they got home, then he would tell them everything. He showed them all the fat he had cured for food. He would see that they always had plenty to eat.

When they got home the man told his parents to take off their clothes and they did so and sprinkled the spirit water over their bodies. Immediately they turned into young folks. They were good and healthy and they always stayed that way. The man's name was Lasum and always after that his people never lacked for food and the loon became his crest.

Womby

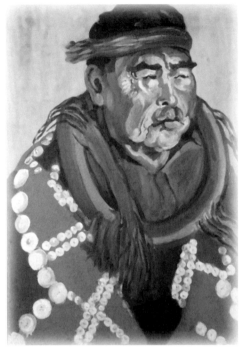

Chief Hemos Johnson

Hemos Johnson, or Moo-um-kim to give him his tribal name, was hereditary chief of Kingcome and a man who commanded the respect and admiration of all who knew him. He was affectionately called Womby by all the West Coast Indians because Womby means "father," and he lavished the impartial love of a wise father upon them.

He was a tall and stately man of erect carriage and noble bearing, gracious in speech and manner. The chief had never been known to raise his voice in argument or violence but always spoke in quiet, gentle tones befitting a person of high rank. If any of his people disagreed with him and addressed him in loud and angry speech, he would tell them that nothing was to be gained by losing one's temper, then quietly walk away. Few men along the coast have inspired such genuine affection among family and friends.

▸ *colour plate page 136* 32

The chief was the soul of hospitality. Fishing boats and other watercraft often came to the village and he considered it a shameful breech of good manners not to be on the beach to welcome them officially and cordially, always extending a courteous greeting to the "stranger within the gates."

When the chief's health failed some years ago, his son-in-law suspended all his extensive and lucrative operations at Comox and took the entire family to live for three months near the chief—that he might have the comfort and cheer of their presence around him.

Death had no terror for this kindly man. He met it as he had met every circumstance in life, with dignity and composure. He said he had no regrets—that he had lived a long life and had enjoyed every minute of it. Now it was his children's turn to enjoy life in like manner.

The chief had been an orphan and had never known the personal love of his parents, which was something he had always missed. Now he was glad that he was going home to them. He advised his family thus: "Be honest with yourself and everybody else and you cannot go far wrong. When troubles come, be patient and quiet, let it work out. Take your mind off whatever is disturbing you and fasten it instead on your blessings."

Moo-um-kim looked on all people with compassion and understanding. Like many others of his generation he saw God reflected in the natural world around him. He heard His voice in the rush of the waterfall, in bird songs and in the music of the wind through the trees.

When he was an old man visiting his daughter at Comox she took him to Elk Falls, a place he had heard much about but had never seen. He stood where he could behold the raging torrent in all its splendour, gazing in silent wonder at the majestic sight and when he came away he announced: "It gave me a new song." It had all come to him there, the words and the music of a song straight from the Master of all harmony—a song that would always be his alone.

Songs, names and dances were personal property, of great value to the Kwakiutl and the chief would never dream of using them for mere amusement. To suggest that he accept money for such a performance would have deeply offended him as something wholly beneath his dignity.

His eldest child, a daughter, was trained to succeed him in his

high position. As a little girl she was taken to the woods by the elders of the tribe and taught the ancient songs of her people. With only the birds and other wild creatures for an audience the child would pour out her soul in song. Her quick, intelligent mind enabled her to master the songs readily—to the great joy and satisfaction of the elders, but when she was sent away to the Indian residential school, these things grew dim in her memory.

It was all brought poignantly [back] to mind, however, as she approached womanhood and preparations were made to celebrate the important occasion with a potlatch, when she would be given a name in keeping with her rank.

After the chief's death she inherited all her father's rights and tribal honours and felt it was her duty and privilege to hold the customary funeral potlatch for the father she adored, despite the fact that the potlatch had long since been outlawed by the government. The chief's daughter chose Gilford Island for this historic event because of better anchorage and because there was a house large enough to accommodate the many guests.

From far and near they came at her call to pay their respects "in death to the man so beloved of them in life." As each boatload arrived the daughter met them on the beach with solemn dignity. It was an impressive sight when the people from the chief's own village of Kingcome entered the bay. Seven boats, which brought them, were lashed together as they came toward the shore, slowly and abreast, their occupants singing the time-honoured funeral songs of their people.

Tall cedars echoed the mournful sound, the wind dropped to a whisper and even the waves were still. Those watching on the shore stood hushed and silent as the sobbing girl went to meet them and to accept with humble gratitude this touching tribute to the dead chief.

In her own words his daughter, Mrs. Ethel Wilson, tells about her people—the Kwiksootainus.

The Kwiksootainus

My people are of the Kwiksootainu tribe who have dwelt for untold generations on the island of Wyastdums, known on the maps as Gilford Island. It is situated in the inland waters to the north of Vancouver Island. We are of the Kwakiutl Nation.

In years gone by great communal lodges of our tribe, each housing a single family unit, stood a little back from the waters of the bay, facing out to sea. A group of small islands at the mouth of the bay provided excellent shelter from the prevailing winds. Here my people would spend the winter months fishing, making canoes, carvings and doing things needful in the course of daily living.

In the spring the tribe would gather their family possessions together, load up their canoes and move to the summer village and fishing grounds up Kingcome Inlet on the mainland. There they would fish and make oolichan oil, our basic food, for the coming winter.

The oolichan run is short, coming between March and April. Our people would lose no time in gathering these valuable fish swimming up the river by the millions to spawn. It was a wonderful sight to behold, with the whole river a moving mass of silver as far as the eye could see. The sky was white with gulls flying over them. The oolichans were rendered down for their oil which was to us what butter, shortening, cod liver oil and medicine are to people today. It was also used for barter with other tribes.

Berry picking soon followed and the gathering of herbs. By the time this was over the salmon run was under way. The great harvest was gathered in huge quantities and dried for winter use. When white men came and built fish canneries our people would go off to work at these places after their own needs had been supplied.

Before the Kingcome River froze over in the late fall, the tribe returned to their island home for the winter months, leaving only a few behind to trap furs.

Our people thought nothing of travelling for days in their dugout canoes to and from their appointed fishing villages. The journey to Kingcome was not as far as that travelled by the Fort Rupert tribe whose mainland summer fishing villages were up

Knight Inlet, a distance of about a hundred miles from their winter homes.

The Kwiksootainus shared Kingcome Inlet fishing with three other tribes of the Kwakiutl Nation in a joint ownership. All converged for the fishing and got along well together, making this time of harvest both pleasant and profitable. My father's name came from the Quaguil tribe of Fort Rupert. On marrying my mother he took his place amongst her people and he also took her tribal honours.

Many years ago the people of our tribe were invited to a big potlatch given by the Bella Coolas, where [at Bella Coola] they were billeted in various lodges during the festivities.

The Bella Coolas had ceremonial dances different from ours and for certain of them they used bird whistles of great value, as well as other sacred possessions and charms belonging to their tribe. All these valuable things having to do with the ceremonies were kept in a special box which was always carefully guarded. When the festivities came to a close, this box was taken to some secret place and hidden for safe keeping.

Now it happened that an old lady of our tribe was billeted in the lodge where these secret articles were kept during that particular potlatch. She became very friendly with the family and was so disarming in her ways that those guarding the tribal treasures grew careless. The old lady coveted the whistles used in the bird dances. If she could get hold of them her people would make similar ones for their own ceremonies, she thought.

The opportunity came. She took two [whistles] from the box and hid them on her person. One was a whistle that when blown gave forth the sound of a crow and the other that of the hoot owl. She took these treasures home to the island, saying nothing to the rest of the tribe but to her son she revealed the secret.

When the Bella Coola people checked over their box of sacred objects before hiding them away, they discovered the theft. This was an unforgivable insult. The Bella Coolas would be revenged.

So it came about that when the Kwiksootainus journeyed to their summer fishing village on the southeast shore of Kingcome River, the Bella Coolas planned a surprise attack. A range of mountains separated the Bella Coola country from Kingcome Inlet, so a picked band of warriors was sent overland, taking several days to

reconnoitre the rugged terrain. They found a draw [pass] through the mountains and passing down, came out on the bank of the river some fifty miles inland. Below them lay a meadow. They would seek out their enemies and slay them while they slept. So they descended into the narrow valley of the unknown country, not realising that the open land was a treacherous quicksand. The warriors dashed out into the open and sank hopelessly into the mire. The last to come out of hiding were saved from death and returned to their people with their story.

This tragic event did not overcome the desire for revenge. The following spring, once again, they formed an attacking party of about fifty warriors and, going through the draw, kept to high ground until the village of the Kwiksootainus was sighted on the opposite bank. The Bella Coolas descended. The village with its sleeping inhabitants would fall easy prey to them. All they had to do was swim the river.

Now the Kingcome River runs very fast at this point and here the Kwiksootainus had placed their long tubular nets to catch the fish. These nets are wide at the mouth and are staked out to catch fish that are swept back in the fast water which they ascend to spawn. The Bella Coolas could not see the nets and traps and in swimming across many became fouled up in their mesh and drowned. Those lucky enough to escape retreated for the second time. In the morning our people came in for a shocking surprise. Instead of a catch of fish they found their nets clogged with dead Indians.

After this second failure the Bella Coolas decided upon a different method of attack. Very early in the spring of the next year, before our people departed for Kingcome Inlet, they found their opportunity to strike. The Kwiksootainu men had been invited to a ceremony by a neighbouring tribe. Only women and children and a few ailing old men remained in the village. On this fateful night all had retired but one woman who, for some reason, walked down to the shore. There she saw a strange man. She thought this odd but as he made no move towards her, she concluded he was just resting from a journey. As she returned to the lodge of her family, she thought she saw a solid line of canoes just out in the bay—just a trick of the moonlight.

Without warning the Bella Coolas struck. The night was made

37

hideous as they rushed into the lodges and, grabbing women by the hair, slashed off their heads. The avengers killed every living thing that came within striking distance, even the dogs. While the massacre was going on a little boy, who had been crippled by some strange illness, managed to save himself by rolling over and over until he was hidden in a great nettle patch that grew nearby. Here the poor child lay in hiding for four days until the enemy withdrew. Cautiously he crept out. It was then that he discovered that he could get up and walk. The stinging nettles had cured him.

The boy hunted among the dead and found four babies living. These he gathered together and, wrapping them up in blankets, placed them in a canoe and set out for Village Island where he left them in the care of kindly women. From there word was sent to the men of our tribe telling them of the massacre. It was then that the story of the stolen whistles was told by the son of the old lady who lost her life at the hands of the Bella Coolas on that awful night.

My grandfather and his family were saved from being wiped out in this raid because they had gone on a visit to Fort Rupert to see his people.

Our tribe was deeply shamed on finding the cause of all this trouble. To be called a thief is one of the worst things that could happen to an Indian and we were called just that. We would never live it down. The son of the old lady was made to suffer for his mother's sin, and his children after him. Indians do not forget.

Once when we were at Kingcome during the fishing season, my uncle Billy took my sister and me far upstream in a canoe where the quicksand is. He told us about the Bella Coolas losing their lives in it because they didn't know where the pathway was but he did not tell us what brought them over the mountains. There was a safe way to cross the quicksand area. Our women used it when out berry picking but one false step and the quicksand would swallow you up, our uncle told us.

When I was about fourteen years of age boys at our old village decided to make a football field. The ground was clear but hummocky so they set to work levelling it off. This was where the massacre had taken place, possibly seventy-five years ago and as they dug and scraped they came across many bones of the dead. Fish crates were brought out and filled with these grizzly relics of the

past. Each day, ten, twelve or fifteen crates were filled. The estimate was that between five and six hundred people were buried there.

My people never talked about this shameful part of our history. I found out quite by accident when I was a young woman. At that time I was working at the Charles Creek cannery which was about two hours canoe ride from Kingcome. All the girls working there were more or less related, my cousin among them.

Now it happened that my cousin and another girl had a quarrel and, in the course of their bickering, the other girl accused my cousin of tribal disgrace. Said she: "At least I come from a tribe that are not called thieves."

This was an insult and I resolved to get at the bottom of it. On returning home I found my uncle had come to visit with us. I brought the subject up at the supper table and the result was surprising. Uncle Billy, like my father, was of the old ways and set in the lore and customs of our people. Both he and my father clung to the ways of the past as much as possible in the face of modern times. My father looked very stern and disapproving when I spoke, and my uncle looked stricken. He rose and entered another room, closing the door after him and there he stayed for several hours.

My father told me it was a forbidden subject and I should never have brought it up. But how was I to know? I would not be put off, so my father decided to tell the three eldest of us the story of our tribe of the massacre and why, when anyone wished to insult us, they called us thieves—a name we deserved.

Pride is a great thing among our people. We must always try to be proud—but it can be carried to extremes as in this case. Even today the granddaughter of the old lady is still ostracized. Members of the tribe will not forget the shame and so an unhealing sore spot remains.

My father, Hemos Johnson, was a chieftain of the Eagle Clan, proud of his place in the tribe and set on keeping up the old traditions. I, being the eldest (of his children), had to sit quietly and listen to the stories of our people while the sound of other children at play caused me to fidget and be inattentive. I couldn't be bothered then, but now I am sorry that I didn't listen carefully for much is lost of the folk lore of my people that I would now value. My mother is also of the Kwakiutl nation. Her tribe, the Gwa-wa, lived on McKenzie Sound.

There is a story I would like to tell about my great-grandfather on my mother's side. He was a whaler which was a very dangerous occupation in those days. Only the bravest men went out to sea in canoes to bring home these prize catches. Great-grandfather was a rover. He earned silver dollars working for white men but money didn't mean much to my people in those days. They got brown sugar molasses and hard tack with it but otherwise they were content to live off the land and sea in their own way.

Great-grandfather went away to sea, sailing for days and days toward the setting sun. The weather became warmer and by and by they came to some islands where people wore grass skirts. Lots and lots of fruit grew on these islands. Here they went to work for farmers and were paid in silver dollars by white men.

After a long time he returned to his tribe and family. His wife had no need of the silver dollars he had brought so he melted them down and made a silver cross upon the family copper—an article of great importance to the Native people. By doing so he made it much more impressive and valuable.

The old gentleman accumulated much wealth in his roving. When he died, he left $1,400. His daughter, my grandmother, having no need for the money, let it go to her cousin who, in honour of the old man, held a funeral potlatch and gave it all away.

Moving Day is Always

As a young man Andrew Wallace had lived on the spot where the town of Ocean Falls, British Columbia, now stands. [Ocean Falls is now (2000) all but derelict, the forestry industry thereabouts abandoned.]

The Indian village had been built on a selected place with a convenient supply of fresh water at hand. Here, with the majestic mountains rising grandly behind them and the fruitful sea eternally casting its harvest at their doors, they lived a life of such comfort and ease as could hardly be imagined by less fortunate folk who had to struggle constantly for the means of subsistence.

Into this peace and quiet came white men who looked with cold and calculating eyes upon the abundance about them. "A great site for a lumber mill," they said, scanning the mighty trees that covered the mountains as far as the eye could see. "And lots of water power from that stream!"

Over their camp fire they discussed their dreams: the conquest of the forest, harnessing the water, the accumulation of wealth. "Yes. This is the place, this is where we shall begin," they decided without so much as a thought for the little Indian village whose people had been there for centuries before them.

"We'll have to get rid of those Indians first," someone suggested as an afterthought.

"Oh, that will be easy," laughed another.

So it was that the white men went to talk to Andrew Wallace. One place was as good as another to the Indians they figured, so they asked them to move on.

"I live here long time," Andrew said, "my family live here always, used to build canoe on beach, lots of fish in sea, lots of berries, lots of everything. Why do you want us move?"

White man say, "Going to make power, you go away."

Strange are the ways of the white folk, thought Andrew. Yet, because the land was so vast and there were many other places to live, the Indians, with their usual courtesy, were willing to oblige the outsiders. Another season found them settled quiet and content some distance from their old village. A little lake poured its water over a nearby precipice into the sea. Here they hunted and fished.

41

Here they held a potlatch with its feasting and singing and dancing and secret ceremonies. Life had changed very little after all, and things were as they had always been. But not for long. The white man's town was rising rapidly on the site of their old home. The great saws could fell a tree in the wink of an eye. Steamships came into the quiet bay bringing more people and the food to feed them.

Sometimes Andrew would listen to the sounds of all the activity and unhappy feelings came into his heart, feelings he could neither understand nor express but somehow food had lost its flavour and dull fears stabbed at his consciousness. Then, one day, the white men came again.

"They say to me, 'you move another time, you go farther away.'" He never thought of refusing. He was helpless as a child before these strange predatory creatures who took everything for granted. So, because they did not know what else to do, the Indians moved again, still farther away, and settled into what they hoped was a permanent abode.

But, when a couple of years later, the same inexorable fate pursued them even to this secluded haven, Andrew uttered a string of livid English oaths (there are no words of profanity in any Indian language) such as would not look well in print and prepared to leave that part of the country forever. He went to Bella Bella where he could dwell in peace.

He has lived there so many years now that he has almost forgotten the sting and heartache of his early years. Recalling the old days he said he had been a boat builder. "Sometimes white man want cabin boat—I make him. 'Nother man wants gas boat—I make him too."

Andrew is not a chief, not a "high" man, but always wanted to be one. So he watched his chance and when an old chief died years ago, he took possession of his speaker's stick and refused to give it up. Because he has the stick, the symbol of authority, he thinks he is a high man and tries to make other people think so too. The stick is his most prized possession. He never lets it out of his sight and says there is a "big story" about it.

Actually, according to Bella Bella standards, he can never be a high man because he was not born into a high family.

Andrew was much interested in having his portrait painted and

displayed quite human vanity—wanted me to take out some of the wrinkles to make him "pretty." He spends his spare time carving wooden spoons in the ancient designs.

Telling me about his first wife, he said, "I get twelve children by my first wife; then she get stomachache and die." His present wife is many years his junior.

Outside his house a clothesline was piled high with clothing of assorted varieties. It looked as though large and frequent washings were done there but the house, inside, bore no evidence of such activity.

Andrew sat on a shaky box. So did I. Since he wasn't very comfortable, he made a poor sitter, but I didn't allow that to dismay me. I never really posed my subjects; I just watched what they did and that is what I painted.

Andrew brought out a lovely old Indian mask and wanted me to buy it—said he didn't want anybody to have it who was not interested in the Indians. It was cumbersome to bring home but is now one of my treasured possessions, having been carved with primitive tools and painted with natural dyes.

Some time after I painted the portrait I was in Bella Bella again and went to pay my respects to Andrew. I found him a pathetic figure, sitting on the edge of his cot, totally blind. He was so pleased to have a visitor and grateful for a break in the dull monotony of his life. I was very sorry that I could not drop in every day to bring a little cheer into this lonely life now drawing to a close.

Hum-zee-dee

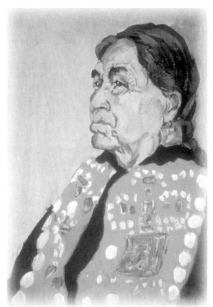

Mary Moon

Puntledge River Reserve at Comox on Vancouver Island was a very important Indian village long years ago. Mrs. Mary Moon, aged matriarch of the tribe and the only one left of her generation, says the Indians gave beautiful Comox Valley its original name, Komox, which means "land of plenty."

Nature had provided everything in abundance for her children—salmon, cockles, oysters, clams from the sea, deer, game, roots and berries from the land—all there for the taking. Other tribes viewed the rich valley with envious eyes and tried, many times, to invade the village. Remains of a great semicircular fort near the beach had seen many a grim scene of siege and slaughter but time has covered them tenderly over with moss and shrubbery and the soft winds carry no echoes of long gone strife, surrender or victory.

Two vast community houses once stood on the beach with Native symbols, dear to the hearts of the people, painted on their fronts. Enormous totem poles proclaimed the wealth and prestige of

▸ *colour plate page 137* 44

the Comox tribe but these have long since disappeared into museums of far away places. Nevermore shall Native women use their big clam shells and pointed sticks to dig for roots and herbs or the men come home with deer over their backs for a big ceremonial feast.

Dark-eyed little Indian children gaze in wonder today at the towering heights of the Forbidden Plateau but there are few left to tell of the Hairy White Giants who used to inhabit those lofty aeries. Many are the legends of luckless Indians who were caught and hurled into the terrible "valley of death," of women and children snatched away never to be heard of again. In the Chinook dialect Indians called the place Hiyu Cultus Illahie—the Forbidden Plateau. It was the abode of the evil one, of strange devils in human form who laid in wait to seize and destroy the unwary.

Pretty, neat, well-painted homes on either side of the road today give no clue of the old way of life—except along the beach. There, at low tide, you may see hundreds of small stakes protruding from the sands. They were not visible until a few years ago when the earthquake of 1946 heaved them up from their ancient footings. White people would never guess what the stakes were, but Mrs. Moon can remember when they meant three square meals a day to her people. They were fish traps that the Indians had built in front of their homes. Strands of cedar had been interwoven between tall stakes so when the tide came in it deposited rich, red salmon there and left them high and dry when it went out again. Each family had its own fish trap and never used each other's.

Mrs. Moon grew up on the Puntledge River Reserve and spent most of her life there. She had five children by her first husband Billy Frank, and her son, Andy Frank, is present chief of the reserve. He was born on nearby Tree Island in a tent during a fearful storm when wind and rain lashed the frail shelter mercilessly. His mother and father had been gathering clams when the storm overtook them.

When Mrs. Moon was a young girl, her uncle Nep-kap-um-kum of Fort Rupert, sang at a great potlatch that had been given to make her a dancer and he had honoured her by giving her his name. It was her name after that and no one could use it without her permission.

It sometimes happened that younger Indians have taken famous names to bestow on white celebrities in the act of making them honourary chiefs without the consent of the owners. Though such

infringements are rare, they are hotly resented by the owners of the names and [the perpetrators are] never forgiven. Names, songs and dances were real and personal property that Indians guarded jealously.

A child's first name was chosen long before it was born. When it was still small the people were called together and it was given another name. You could not give a child just any name you happened to fancy. Great discretion was necessary and due regard for the rights of others.

It was a really important occasion when a boy or girl reached maturity. The people were called to a great potlatch to bestow a permanent name. There was much ceremony and feasting. This would be the greatest name of all and the one by which the youth would always be known. Other names might be received afterwards but they were just honourary.

Indian names had no particular gender. Sometimes a man might be given a name that belonged to a woman and vice versa. People sometimes gave others permission to use their names and songs but did so with some misgivings. Long ago an Indian from Fort Rupert had asked Mrs. Moon's permission to use some of her songs and dances and she had consented. Her father was very angry about this and never ceased to lament her lapse from traditional custom. Years later her son gave a big potlatch at Cape Mudge and got them all back again. "I'm very glad for that," said the old woman with much satisfaction.

Because Mrs. Moon had so many relatives in different tribes, she had acquired a great many names and always a potlatch had been given to bestow them upon her. Having many names was, to an Indian, what honourary degrees from a university are to others.

Mrs. Moon's most important name is Hum-ze-dee. It is a very high name indeed and very few people have ever had it. Having no written language the Indians developed prodigious memories. They knew all the names of important people in neighbouring tribes and every tribe knew all the names of its own people. Because Indians attach so much value to names they do not like to see them used carelessly. Mrs. Moon says Comox is an Indian name. It belongs to the Indian people, and it is not right for others to use it for business purposes.

White people have taken to calling the road which runs through

the reserve Dyck Road. Mrs. Moon thinks this is gross presumption. "It is not the Dyck Road," she says emphatically. "It is the Comox Road. White people have no right to call it the Dyck Road."

Ne-gaed-zee & Oo-ma-gi-lees

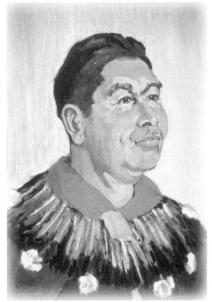

Andy Frank

Chief Andy Frank, whose Indian name is Ne-gaed-zee, owns a priceless ceremonial mask called Qwa-ye-qua, meaning "the greatest of all." Only Chief Andy is qualified to wear it. Certain of the possessions of the coastal Indians were considered so valuable that they were given names as though they were people. Some of the chief's coppers and masks had both names and legends pertaining to them.

Chief Andy Frank's mask had been passed down from generation to generation to the late Chief Joe Nim-nim and was used by him when performing the ancient ceremonial dances of the Puntledge tribe. When the chief's time came to go, he chose Andy and trained him to take his place, to inherit the chieftainship and all his regalia, and to be the wearer of the great ancient ceremonial mask of his tribe. He felt that, of all his family, Andy was best qualified to uphold the honoured traditions of his people.

Some years ago I painted both the chief and his wife, Oo-ma-gi-lees, at their attractive and comfortable home in Comox. The story of the mask had been passed down by word of mouth for hundreds of years. The legend says that a mythical figure called Qua-ye-qua was crossing a river, which is now known as the Quinsim River, when a man named Testleyee came upon him unexpectedly. Testleyee was the first person ever to lay eyes on Qua-ye-qua and looked upon the experience as a very great privilege, having a special significance. Ever since that eventful day Qua-ye-qua has been the name of the mask of the man who does the ceremonial dances of the family of Testleyee. The mask became the highest ranking mask at all dances of the Puntledge tribe.

Oo-ma-gi-lees

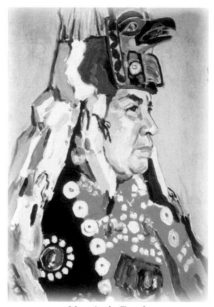

Mrs. Andy Frank

Chief Andy Frank's wife is one of the highest ranking Indian women in British Columbia. It was her father, George Hunt, who helped Professor Boaz in his exhaustive research among the Kwakiutl many years ago.

When Boaz first went to Fort Rupert, at the request of the Smithsonian Institution, 700 Indians were living at the ancient village and the old ceremonials, with all their colour and fantasy, were in full swing. He made several trips and spent many months among them, learned their language, respected their customs and loved the people. When he was an old man he went back to visit them once again. Meanwhile the great houses had been torn down, most of the mighty totem poles were gone and a mere remnant of the population was left. He stood before them, horrified, weeping openly and unashamed over the cataclysmic changes that the years had wrought.

▸ *colour plate page 140* 50

When Mrs. Frank came of age her father gave a great potlatch of oolichan grease in her honour. There are no oolichans on Vancouver Island so he bargained with the people of Rivers Inlet, who owned the fishing rights there, and paid them for permission to fish in those waters. All his people went with him to "make grease" during the short oolichan run in the spring. By the time they had finished they had 940 four-gallon tins of the oil and beautifully woven cedar mats were draped over the barrels when they were placed in the canoes. It required a whole fleet of dugout canoes to transport them from village to village all along the coast and the oil was given away in the time-honoured tradition.

When the fleet of canoes stopped at each village to dispense the largesse, Mrs. Frank, as the person being honoured, dipped out the oil to fill the big tins that the people brought down to the beach in which to receive it. She said she felt like an oolichan herself by the time the giving was all over and she had handled enough grease to do her for the rest of her life. Nevertheless, this was one of the most unique potlatches ever given on the coast and it is still remembered by a few of the old people who took part in it. We shall never see its like again.

At Fort Rupert, when the Indians gave a potlatch such as this for a girl, they pierced her ear and inserted a small pearl in it. Some women had it done many times, indicating many potlatches and high social standing. There would be a little row of pearls all around the rim of the ear. The pearls came from abalone shells.

When a chief died, no children were allowed to play outside for four days. Everything was quiet. No one went about except of necessity. On the fourth day all the high ladies shortened hair (to their necks) as a sign of mourning.

Among some tribes twins were considered a mark of special favour from above. When Mrs. Frank's mother had twin girls, she went away and stayed four days alone in a tent. Then a big potlatch was given and four men bore her, sitting in the middle of a huge cedar board, into the great house, one man at each corner. Her face was painted and she wore four big, white seagull feathers in her hair.

All the people had gathered inside the house to receive her. The men who bore her entered on the right side and walked slowly and ceremoniously around the house that all might see her. That is how she came back in triumph [to her village] to live with her family

again after the birth of twins. Because she had twins she was thought to have supernatural powers and could work magic. When the weather was cloudy people would come and ask her to make the clouds go away. She would go outside and watch and wave an arm in one direction, then the other arm in another direction as though sweeping the clouds away—and they would go.

It was believed that people fishing for oolichan or salmon would always have good luck if a twin was aboard the boat. Among the Tsimshian, mothers rubbed the bodies of twins with oolichan oil until they shone to make them healthy and strong. Then they wrapped them in rabbit skin blankets or furry robes.

Kwakiutl Indians had special songs for twins. When the children were small they were carried in their mother's arms when she was dancing, but when they were older they danced alone. Small or big, they always wore a band of cedar bark and feathers on their heads. In the room where twins were staying eagle feathers and cedar bark hung at the backs of their beds.

Some relatives of twins would call the people together for a big potlatch to give the twins their names. It might be an uncle, their father or grandfather. All the women who danced at the potlatch wore a cedar headband with four eagle feathers standing up at each side. If other people gave a potlatch of their own they would ask twins to dance as a special feature—and to ensure good luck.

Mothers of twins never nursed their babies separately but would nurse them both at once. It was thought if one were nursed first the other would feel jealous and die.

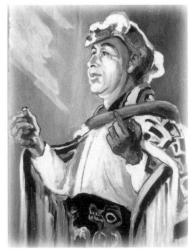

Mrs. Andy Frank

West Coast Vicissitudes

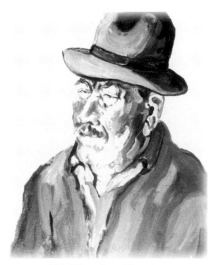

Chief Napoleon Maquinna

Never, so long as I live, will I forget the day I painted Chief Napoleon Maquinna.

I was a guest at the Indian residential school at Kakawis on the stormy and forbidding western coast of Vancouver Island. The Indian village was a mile away.

A mile did I say? I mean a mile by land or as the crow flies but three or four miles by water. "I'll just walk through the woods to the village," I told Father Mulvihill, principal of the school, "and see whom I can find to paint."

I was accustomed to going alone to Indian villages without restraint and always took the shortest, quickest and most direct route. The priest smiled tolerantly. "You would never make it," he explained, "there isn't even a decent path and you would be in mud to your knees. No one ever goes that way."

"Well, how do you get there?"

"By boat," he laughed. "The water is our highway here. Boats are street cars and automobiles for us." Then he imparted a thrilling bit of information.

▶ *colour plate page 141* 53

"Chief Maquinna is down from Nootka visiting his daughter at the school. He is staying with friends at Clayoquot. Would you like to paint him?'

Would I indeed? Memories of his famous ancestor raced through my mind. The first Chief Maquinna, of whom we have any knowledge, had been a great ruler of his people. Friendly at first to early traders, their frequent betrayals and humiliating treatment of him eventually roused his proud spirit to resentment.

Back in 1803 the good ship *Boston* had come to Nootka seeking wealth in furs. Thoughtless words from the captain set Maquinna's noble heart ablaze. He and his warriors managed to get aboard the vessel and went berserk, killing the entire crew except one John Jewett, the ship's armourer, who they thought would be useful to them as a slave to fashion weapons. They plundered the ship and set it afire.

Later, it was discovered that the sailmaker, John Thompson, was also alive and Jewett pleaded for his life, claiming that he was his father, so he, too, was retained as a slave. The two men remained the unwilling captives of the Indians for three long and harrowing years. It was a grim life they were forced to lead until they eventually made their escape and John Jewett returned to England to relate the thrilling story of his experiences to the world in a book which is greatly treasured by collectors of Canadiana today.

Small wonder, then, that I wanted to paint the present chief, Napoleon Maquinna, modern emperor of Nootka, descendant of his famous forbearer. He was expected to come to the school that morning, so I waited patiently for the sight of his boat bouncing over the frothy waters of the bay.

Noon came and he had not appeared. At three o'clock we decided that I had better go to Clayoquot and paint him there. Brother MacDonald would have to take me. He handed me a pair of high rubber boots, several sizes too large, and told me to get ready.

The school at Kakawis is on the crest of a rocky promontory. Below it is a flat, sandy beach. The water is too shallow for a pier to be built but a quarter of a mile away a huge cement block serves as a dock to which a big gas boat is always moored. All ships have to tie up there. Everything and everybody must be transferred to an Indian dugout canoe that serves as a sort of ferry to and from the shore.

I stowed myself and my paints aboard the dugout and Brother MacDonald settled himself at the oars after giving the canoe a little push off the beach. [Inasmuch as all canoes are propelled by paddles (not oars), this appears to be an anomaly.] The waves were sweeping over the sand, breaking in long, foaming curves, rolling and breaking, rolling and breaking in the eternal rhythm of the sea. The good brother kept the canoe poised and the oars ready. I wondered why he didn't start but kept discreetly silent under conditions of which I was totally ignorant.

There we balanced as wave after wave came in. Suddenly he gave a mighty heave on the oars and, in a jiffy, we were out in smooth, quiet water. "You have to wait for the ninth roller," he explained. "That takes you out into calm water."

Steadily he pulled until we reached the cement block where we transferred to the gas boat. When we left that haven we also left quiet water behind us.

As we rounded the end of the peninsula which hides Kakawis from Clayoquot, we emerged into choppy seas and a brisk wind sent us over the glistening water at a great rate. Presently a big fishing boat appeared. "It's the chief going to the school," yelled Brother MacDonald and he waved his arms to hail the fishing boat. After a bit of manoeuvring we pulled alongside and a number of faces peered over the side to see what we wanted.

"Let me go back with them," I asked, for I was very cold. "I'll wait for you at the block."

I scrambled aboard where I met the chief and his family and a number of other Indians. Most of them were barefooted, including the chief. They did not seem to be aware of the cold but I was glad to huddle in the shelter of the cabin.

Of course we beat Brother MacDonald to the cement block where more than half the crew got into the chief's dinghy to row ashore. The chief, Brother MacDonald and I settled for the dugout. It did not take us long to get to the shore and there, again, I was absorbed by the actions of the skipper as he waited for the right moment to beach his craft. His back was to the land and I sat in the stern of the canoe with my back to the sea. Evidently there was a psychological moment to go inshore just as there was to leave it. Brother MacDonald held the canoe poised like a great grey bird ready for flight as he waited to pull [on] the oars.

Perhaps our extra passenger distracted his attention for an instant; perhaps he miscalculated the action of the rollers or missed the count. Whatever the reason, he heaved on his oars just a second too late for, instead of going in on the crest of the wave—wham! Was I, or was I not, drowned? Something had hit me in the back with a tremendous wallop as a tumultuous white wall of water broke over me like a miniature Niagara, soaking me thoroughly from the waist down. It seemed as if the whole Pacific Ocean had rushed up to engulf me, but the wave took us ashore all right.

I struggled to my feet, gasping for breath and dripping like a fountain. The dismay on the skipper's face was laughable as I dragged my drenched extremities up the beach.

Climbing the long flight of steps to the school was a toilsome journey as I now weighed considerably more than when I left it. My feet went squish in the big rubber boots as I walked and my clothes went flippity flap around my shivering limbs.

When I left home, I had only expected to be away for a few days and never dreamed of going to Kakawis but when the opportunity had presented itself I had grasped it joyfully, forgetting that I had but the scantiest supply of clothing for emergencies.

My luggage consisted of a large screen and projector, a heavy paintbox, a number of canvas boards and a suitcase. Five parcels for one pair of hands—that is why I decided to dispense with everything but the essentials in dress.

Having just recovered from pneumonia I dared not wear those wet clothes the rest of the day but I had practically nothing with which to replace them. Waiting in bed until they were dry was out of the question when the chief was there to be painted. I resolved to take extreme measures. I punched a hole in my vest with my palette knife (at the high water mark) and tore it round. It was a sad looking garment now—minus a foot in length but the top was dry and the tail, I ruminated disconsolately, would make an extra paint rag when it dried.

The back of my girdle was soaked too and I couldn't endure that, yet wear it I must. Another brain wave. Making a pad of all the dry paint rags I possessed, I pushed it up between my girdle and my back, as best I could, thus isolating the danger zone, as it were. With dry shoes and stockings and my one and only print dress in place of my wet woollen one, I went down to paint the chief after hanging

56

my dripping coat and other garments around the big kitchen range to dry.

It was fun painting Chief Maquinna, even though I was chilly in my meagre apparel. He was big and fat and jovial and there was nothing he liked better than just to sit. I had quite an audience but finished the portrait without further mishaps. Then the priest came in and asked if I would go to another building and speak to the boys' class before the bell rang for dinner. I hastened to the room and commenced to give the children a lesson in art.

All was going well when suddenly I felt something slip. Horrors! My paint rags had come loose from their moorings. Terribly unhappy, I manoeuvred gingerly to the back of the room while I engaged the children in rapid fire conversation, giving them directions for intense application to work. Safely in the corner, I managed to hitch myself together well enough to finish the lesson.

It was a precarious business getting back to the main building again. I risked grave hazards crossing the yard and when I finally reached the haven of my room, with my dry clothes retrieved from the kitchen, I heaved a vast sigh of relief. I had painted Chief Maquinna, pleased the children and avoided a cold. Also I had learned one never-to-be-forgotten lesson—always, always, take a change of clothing along no matter how brief a visit you plan to take. You can never tell...

HOMELAND of the Haidas

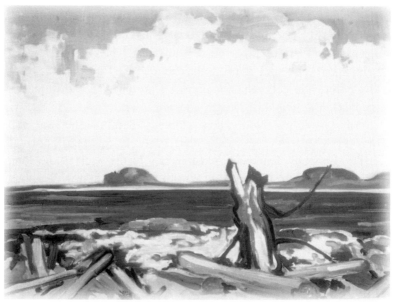

Queen Charlotte Islands Beach Scene

If you were a Canadian Robinson Crusoe and could make a choice as to where you would like to be shipwrecked, take my advice and pick the Queen Charlotte Islands. You would probably live to bless the stormy seas that put you there. The islands have just about everything that any reasonable human being could ask for, but most Canadians have only scant knowledge of them.

Speak about the Queen Charlottes anywhere outside British Columbia and people give you blank stares of noncomprehension. It is simply a name to most people and little is known by the general public of life on the islands. Despite fortunes being made there by big timber interests, the islands' fascinating history and rich resources are virtually unknown and untapped.

There are men scattered across Canada, however, who can tell you something about this little Eden of the Pacific if you ever have the chance to talk to them. They are the eagle-eyed skyroving lads

in (light) blue who put in months on end at the big RCAF aerodrome at Aliford Bay during the Second World War. They saw one of the finest parts of the Queen Charlottes—but they didn't see it all, by any means.

Those who happened to be there during the winter months will doubtless have vague memories of glowering purple mountains looming darkly all about them, losing their lofty peaks in a swirl of cloud and mist. Perhaps they remember the rain, which seemed ever ready to come down, either in a drizzle or a deluge, according to the whim of nature. They likely think of wild and turbulent seas crashing and thundering against the rocky shorelines or scurrying over the sandy beaches. Many of them will have nostalgic memories of happy evenings spent in the warmth and hospitality of gracious Indian homes, the doors of which were never closed to the service men, by day or night.

Mr. and Mrs. Ed Stevens of Skidegate showed me an album filled with every manner of calligraphy and revealing, better than I can tell, the gratitude and affection of the young men who had found a warm and sincere welcome deep in the hearts of a fine Native family.

They found music, fun and companionship, marvellous dinners of venison, plum pudding, cakes, pies and all the other things that spell home to lonely lads confined to service quarters in a strange and isolated part of the country.

Some of the men may recall having their routine activities curtailed somewhat by the Indians. It seems the air force had been in the habit of practising gunnery by shooting over Maud Island. It was uninhabited and no harm could come of the firing—so they thought. The Indians of Skidegate did not feel that way about it at all. True, there were no homes on the island but for generations it had been an Indian burial place. It was sacred to them—a sanctuary of the dead. So they sent a delegation to interview the air officer commanding. "How would you like it," they asked, "if people were shooting off big guns over your ancestors?"

The officer saw their point and from that time on there was no more gunnery practice over Maud Island.

The first white people to see the islands were probably Spanish traders, said to have visited the Charlottes as early as 1638. Other adventurers followed from time to time, and in 1786 Captain Dixon

on the *Queen Charlotte* (a vessel fitted out by the London Company of Adventurers), took his ship into these waters.

He was the first navigator to sail down the whole of the West Coast from north to south. He named the islands after his ship, bequeathed his own name to Dixon's Entrance and named North Island and Rennel Sound.

The first British sloop of war to visit the area was HMS *Discovery* under the command of Captain Vancouver, who spent three years surveying and exploring the coastline. In 1852 the Hudson's Bay Company, having heard that there was gold on the islands, sent a ship to investigate. A small vein was found at Coal Harbour—the first gold to be discovered in British Columbia.

The Queen Charlottes have what is probably the last stand of Sitka spruce in the British Empire. These trees grow up to immense proportions, frequently six to eight feet in diameter [at the base] and up to 200 feet in height. Single trees containing 150 board feet have been logged. The wood is generally fine grained, tough, strong and elastic. Some years ago the total stand of raw timber on the islands was more than 14 billion feet, consisting of spruce, hemlock, red

Skidegate Mission, Queen CharlotteIslands

▶ *colour plate page 160*

and yellow cedar and lodgepole pine, with another 1 1/2 billion feet of small timber. Forest fires were practically unknown.

The Queen Charlottes is a small green world of verdant growth and romance. On the rock-girt, mist-enshrouded, tree-blanketed islands there lived, in the old days, a haughty, venturesome, resourceful and artistic race who were, in many respects, unique among Native peoples. Haida Indians were the aristocrats of the coastal tribes.

In their enormous war canoes, made from a single cedar tree and capable of carrying sixty or more men, they roamed the length and breadth of the coastline, hunting the sea otter, making ceremonial visits, pillaging other tribes and carrying captives off to slavery.

Haida artists were not merely odd people to be tolerated and excused as white artists are, they were among the most important folk in the tribe, for only they were capable of translating, into material form, the cherished symbols of the race. The men who could carve elaborate totem poles, war canoes, handsome food dishes and exquisite metal jewellery, received the honour and compensation that was their due.

Less than a hundred years ago the villages of Masset and Skidegate consisted of many great community houses, with a row of stately totem poles before them, fronting the sea. Thick as masts in a harbour they stood and must have been far more intriguing. Barely a trace of the old glory remains today. New and modern homes have arisen where the huge houses used to stand. At Masset one forlorn and paintless old totem pole reels at a dizzy angle by the roadside, with brush and bracken winding around its knees. Indians today hurry past it, intent on their business and never giving it so much as a glance. Many of them do not know who made it or what it meant. [Since this was written, over fifty years ago, there has been a concerted effort by the Indians to resurrect their history and culture.]

In the heart of the village, in front of the home of his descendants, stands a granite tombstone that commemorates an exploit in the life of one of the greatest Haida warriors, the redoubtable Edenshaw. A copper plate tells how he held off his bloodthirsty tribesmen singlehanded and saved the lives of the crew of an American schooner, the *Susan Sturgiss*, which had been captured, pillaged and burned. The white men were held as slaves by the Haidas until they were ransomed by the Hudson's Bay Company

which paid many bales of blankets for their release. It is an exciting page of Canadian history but means little to the Indians of Masset today and nothing at all to most others.

At Skidegate only one old pole remains. This is a memorial pole. Long ago the grave box, which reposed on top of it, fell to the ground and disappeared. Migratory birds have rested in the cavity it left, dropping seeds of huckleberry and salal. Now new life has grown out of the old, and luxurious green fronds hang down over the solemn eyes of the carved figures with ridiculous impropriety.

Walk further down the street and you will see deep grass-grown depressions where the great houses of the Indians once stood. Well dressed, black-eyed, merry little children roll and tumble on the grounds where the mighty totems used to be. They speak another language and are ignorant of their past.

Aǥnes Russ & Susan Gray

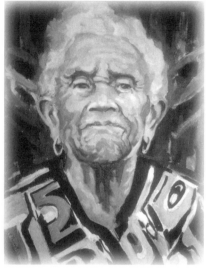

Mrs. Agnes Russ

Down in the village is an aged Haida woman who was part of the old order. She can tell you things that make your eyes bulge and your spine creep but she won't unless you are one of the elect, one of the very few who come with warm understanding—tried and trusted.

She belonged to the high people, royalty as it were. Class distinction was recognised on the Queen Charlotte Islands in the old days and, indeed, among all the coast tribes. There were high people and low people and no indiscriminate mingling among them. This old lady had been a member of the aristocracy with all the privileges and prerogatives accruing to her position.

White people make a lot of fuss about getting married nowadays [circa 1948]. It was the same with the Haidas long ago, the main difference being that the bride and groom had nothing to say about it. The old folk made all the arrangements and the young ones took it like lambs—mostly. They were never consulted at all, but they had a good idea of what was brewing when the chief of another tribe

came and talked to the girl's mother, bringing all his head men with him.

Mrs. Agnes Russ told me all about it.

"The family of the girl sits on one side of the house, the family of the boy sits on the other side. They had a long pipe made of deer horn, they cut tobacco and give it to everybody, and they sit there and smoke and talk all night long.

"After long time the mother of the girl says 'all right' and the father agrees."

At that critical moment the girl steps across the room and sits down beside the boy. That constitutes the marriage ceremony—no licence, no banns, no showers, no ring, yet perfectly legal according to Indian custom.

Next move was on the part of the bride's parents who brought many blankets and gifts to be distributed among the guests.

A chief's daughter, who set up housekeeping in those days, had a sinecure compared with modern times. Being a high person she never soiled her hands with manual labour. Agnes said she started out with eight slaves to do her bidding. Slaves cut wood, caught fish, dried berries, dug the wild turnips, did all the cooking and cleaning. A chief's daughter must maintain a dignified, aloof attitude toward the common people. She must keep her own counsel and never talk freely to others. She must even eat special food and could not partake of common things as eaten by slaves.

Each family had its own crest and as many other crests as they could procure in compliance with their unwritten but very binding laws. Wealthy people had their crests carved on the big totem poles for all the world to see, but they also had them tattooed on their bodies for their own secret gratification.

It cost real money to get yourself tattooed in those days, probably as much as to get your face lifted today—at the rate of so many Hudson's Bay blankets per hour. Ten blankets might pay for doing one crest. First the artist carefully drew the design on the flesh. It was all done freehand and no art school ever produced more meticulous draughtsmen than the Haidas. Once the drawing was perfected, four needles were tied together and these were pricked all along the pattern until the blood was flowing freely.

The Indians made a sort of wood dye from the alder. They burnt the wood, took the soot and rubbed it into the wound.

Agnes has vivid memories of when they did it to her. She was a small child. "I cried," she said, "I don't like it, wipe off the blood. People do that before they know there is a God in heaven—after they know they do it no more."

Ideas of superiority still persist among the Haidas. Even now, when Agnes visits Masset, the chiefs give her presents of dishes, money and clothing as they did long ago.

There are many people living who were slaves under the old regime. They got their freedom when the practice was forbidden by the government years ago but the high people know who they are, and some of them are quite arrogant about it. With a royal rebuke Agnes chides them for this attitude, saying "You must not do that to them. Slaves cost a lot of money but free people did not cost one cent." Which is perfectly true.

Her grandfather had three great houses in Masset with many slaves. He was very wealthy in furs, blankets, canoes, masks and other things. People are poor now by comparison, she thinks. Her father was a white man, an American sailor who wished to take his Haida wife to the United States but the Indians would not permit

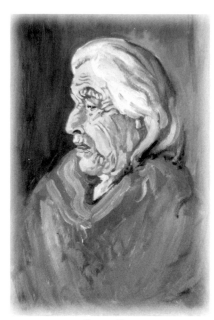

Susan Gray

him to do this unless he left their child behind. This they eventually did and the little Indian wife left her ancestral home to live and die in a strange land.

In the years that followed, Agnes' father gave Captain Lewis [presumably the captain of a trading vessel that called at Masset] money to offer to the old chief in an endeavour to get repossession of the child, that he might educate her and bring her up as a white child, but the grandparents refused to part with her. So Agnes stayed in Masset and, at an early age, became the wife of the youthful Chief Steilta.

▸ *colour plate page 135* 65

The young chief did not live long, and even when he lay dying his people were preparing to raise an enormous totem pole to honour his successor. Vast quantities of food and property had been accumulated for the big potlatch, which always accompanied such events. According to ancient custom, as soon as the young chief died Agnes would have to marry his brother who would then become chief.

Some unseen power seemed to have raised the veil and revealed a glimpse of the future to the dying man. He told Agnes, in secret, that all these practices were wrong and that they would soon have to go. He advised her to go to her relatives on the mainland, on some pretext, and never to return.

So the grief-stricken young widow went to Port Simpson to visit her people and there she met some missionaries. Mr. and Mrs. Thomas Crosby took a liking to the comely girl and welcomed her into their own home. Agnes said she learned there to perform the first work she had ever done, plain cooking, sewing, mending and keeping house. Later she entered the Crosby Girls' Home where she learnt to read and write.

In Port Simpson she met a young Native man from Skidegate who had become a Christian and they promptly fell in love—to the secret satisfaction of Mr. and Mrs. Crosby. How different was this second marriage from the first one! They were wed in church by a Christian minister. There was music and song and much rejoicing. Mrs. Crosby had made her a wedding gown from lace curtains with her own hands and had provided a sumptuous dinner to celebrate the event.

When her husband was sent to the islands later as a missionary teacher at Skidegate he chopped down the mighty totem poles and the thick planks of the old houses, with mistaken zeal, and split them up and burnt them for firewood. Then he built the big frame dwelling where Agnes still lives.

Not far away is the home of Susan Gray, another link with the past. How well I remember tramping in the woods and along the shore with this aged Indian woman whose portrait I had painted. She showed me veins of gold in the rocks and pointed out an old village site where a path had been cleared on the beach, long ago, for pulling the canoes up onto the shore. Not a single trace of the vil-

lage remains, just the wide stretch of smooth sand running into the sea.

Susan took me to the little cemetery down the road where her three husbands are sleeping. She told me of the virtues and faults of each of them. Laughter and tears mingled in the recital of the long-gone years. I followed the old woman through the tall, matted weeds that were higher than our heads, which she parted with her hands as we went to a little sandy mound, the grave of a beloved son who had died forty-five years ago. She stood there silent, with bowed head as time rolled back in her memory. Tears rolled down the rugged, old face as she said brokenly, "I not forget that little boy."

Old Masset

A few years ago, on almost any beach in the Queen Charlottes, you could pick up round glass balls that had drifted across the Pacific and swung in straight from Japan. They were floats of many sizes that had broken free from the nets of Japanese fishermen. Tourists picked them up avidly—no other souvenirs were like them anywhere.

The people of Masset put them on their lawns as ornaments and the fishpond in the village had them floating among the goldfish and water lilies. The balls haven't been coming across in such numbers in recent years but here and there one may find them still.

Across the inlet from Old Masset is the abandoned Indian village of Yan. Many are the tales the old ones tell of Yan. You hire a boat and cross the wide mouth of the inlet—on a quiet day if you have any choice in the matter. Rank grasses obliterate all traces of the old houses which used to front the white, shell-strewn beach of Yan. A few weather-beaten poles sway drunkenly from their bases.

The crests of raven, bear and eagle stare down with gaunt, stricken eyes across the wild waters. The place is heavy with history, burdened with time, aching with memories unexpressed. You leave it with a feeling of unutterable sadness. It is a cemetery of vanished hopes and ambitions. You catch yourself listening for the sound of lost voices but the whole area is irrevocably sealed into the imponderable silence of dead years.

Only one thing remains the same at Old Masset—the ravens. Anyone who has ever been there will never forget the ravens. They dominate the landscape and they certainly dominate the consciousness. Ravens give the place individuality and meaning. One can readily understand how it was that the raven became one of the most important Haida crests and why the Indians wove countless legends around the audacious bird.

I sometimes think the ravens are [the] renegade souls of people— they act so uncannily human. You can go along the beach and watch and listen to them for hours. After a while you imagine you know what they are saying. Their slow, deliberate flight with its sure sense of destiny, their trickery, their follies and failings, their humour, sagacity and sly, wise propensities set them apart from all other birds.

Ravens like to perch on the bare, jagged tree branches that pierce the skies of Masset, where they can gossip undisturbed and still keep a wary eye on intruders. Their genius for organisation is quite apparent. There is great freedom of speech but a firm policy of precedence among them. Breaches of protocol are not tolerated. You have never seen ravens at their best until you have seen them at Old Masset.

The weather at Masset is absolutely unpredictable. One moment the sun will be shining brightly and rain falling the next. Growth is exuberantly luxurious. Anything that can grow at all grows larger and better at Masset. Flowers and vegetables flourish in prize dimension. Even the moss on the trees grows thicker and longer than any other place in Canada.

There are no paved roads in the Queen Charlottes. A gravel trail, part of it planked, from Masset to Tow Hill, about eighteen miles, is all the road there is on Graham Island worth mentioning. It pays to go over it, though—not once but many times, for you will always see something of interest. You feel as if you have plunged into the forest primeval. [Since this was written successive provincial governments have overseen the construction of miles of paved roads.]

Thousands of deer abound on the islands and you are sure to see many of them any evening. They will stand stock still in the middle of the narrow plank road, placidly ignoring your honking [automobile], daring you to hit them. Just as you think you will be obliged to get out and push them off the road they give a quick flip of their white tails, kick up their heels, joyfully and impudently, and disappear into the deep, impenetrable rainforest.

Moss on the trees near Masset is fantastic. Long, pale festoons of it swing lazily from the tall evergreens in the more open places but in the heart of the woods there is another variety that seemingly turns the place into a story book retreat for goblins and gnomes. Every stump is caped and hooded, every stick and fallen log huddles under a blanket of thick green-gold plush. The rainforest looks like some incredible scene in fairy land. You catch yourself peering around nervously, expecting a pixie to step out and make fun of you or a mischievous little elf to trip your feet in the deep moss carpet spread beneath you.

There never was a menagerie like the woods around Masset—there will never be another. The whole forest comes alive. It is full of strange animals and strange people in another strange world—a

shaggy, vivid, bronze-green world of bursting life, startling surprises, emotions and mystery. Snow White and the Seven Dwarfs never saw anything like it, for this is real and tangible. The camera would need a new technique to record it.

From every branch and twig of the dark evergreens hang fat cinnamon bears of all ages and some of them lie along the boughs, woolly and well-fed. You are sure they will let go the branches and come waddling toward you but on closer examination you discover they are all made of moss—every last one of them.

Some of them seem to be huddled up sleeping, others are hunched up in a sitting posture but most of them are hanging by their well-furred paws, fat and heavy. The likeness to live bears is positively uncanny and perfectly ridiculous.

Real bears of flesh and blood prowl through the woods beneath the moss ones and do not look any more alive than do those on the branches. The live bears are big and fat too but browner and darker in colour than the moss ones and you don't feel any too comfortable when you hear the twigs cracking under their slow deliberate feet, to be confronted with their quizzical stare.

Bears are terribly curious and you just wish you could answer their questions quickly and satisfactorily and be on your way.

Strange things happen along the trail to Tow Hill and strange people have lived there. You go through the old Indian reserve of Yakan. Big houses and lofty totem poles are nothing but a memory now. Wild geese fly in a long V above you and utter a haunting, lonely dirge for the days that are gone. Wild duck flutter past at a lower level, grouse go into hiding at your approach.

On an isolated, serene little strip of beach nine bald eagles are holding a council of war. Their resemblance to a meeting of the legislature is ridiculous—wise bald heads, dark jackets and white waistcoats, all in solemn conclave.

The rainforest between Yakan and Tow Hill is like a jungle. It is a graveyard of fallen giants through which the piping growth of fresh young trees push up in thick, green defiance. Bracken, vines and smaller trees are woven into an impenetrable web of verdure. There is no place to put your foot. It is impassable for all but wild life. You feel that strange, furtive eyes are staring in the dense undergrowth, watching you with secret satisfaction from their invulnerable domain.

Tow Hill is a small peninsula running sharply out to sea toward the north. It is a cliff composed of columnar volcanic rock which rises abruptly to a height of 200 feet. The Indians can tell you many legends about it and how it got there.

On the extreme north eastern corner of Graham Island is Rose Spit, a long, treacherous sand bar extending several miles into the sea. This great sand spit has always been regarded by the Haidas as the abode of some powerful Nok-Nok or evil spirit. Actually it has been formed by storms and tides meeting from the west and south, constantly adding to sand deposits through countless millenniums. It resembles Sandspit near Skidegate, a similar formation, and vessels of all kinds are obliged to go miles out of the way to avoid both of them.

In the old days many a good ship went down off Rose Spit and even the hardy seafaring Haidas came to grief if the storms took their dugout canoes in that direction.

There are isolated small clearings along the road to Tow Hill where people had come in the depression years to wrest their food from nature but most of them left later. Grey, dejected buildings tell the story. Several bachelors stayed on, finding life with nature kinder than life with men. You are astounded to come suddenly upon a clearing with wide, green lawns, attractive buildings of good design and well-tended gardens, flowers and shrubs. Bishop's Court is a bit of old England with its garden and fruit trees. It had been someone's brave dream many years ago. An old man now lives in this imposing place, alone, isolated, but content with no desire to leave.

On the sea side of the road, fierce storms that tear down from the Arctic have piled the sand into gigantic pillows around the feet of spruce and hemlock, gradually engulfing them in long, deep dunes. Not far away is a wonderfully wide, level beach, possibly as good a Waikiki or Copacabana but not nearly as well known. It is like a smooth, hard pavement and you could drive over it for miles when the tide is out.

As you go along you notice a broken little trail stealing away into the woods. Curiosity tempts you to follow it to the end where it breaks out into an open space. A few tired looking unpainted buildings indicate human habitation. At the sound of voices an odd little being comes to the door of the nearest building. It is a small man, thin and wiry, in shabby clothing, wearing a battered cap over his

eyes. He is frankly pleased to see other humans and when he learns that one of them is an artist he disappears into the tiny frame dwelling and returns with half a dozen drawings of his own. Pride is written all over his sensitive, honest face—pride and pleasure to meet a kindred spirit.

The pictures are not half bad—better than many that have hung in art galleries. The little man has drawn the things he knows—horses, dogs, deer. He has used lots of rich colour and the draughtsmanship is good. He creates the drawings for the pure love of it and gives them all away to anyone who cares for them.

A tame fawn comes up to him and he tenderly fondles the velvet-soft nostril of the trusting creature. Wild geese come down to visit him and rest their great wings. The grouse and even bears know that he is their friend and protector. He is one with nature and its creatures. Fear plays no part in their lives with him.

He takes you into his house. It is the most amazing domicile you ever laid eyes upon. It consists of one large room. In one corner is a cot, in another is a table of sorts and the remnant of something that passes for a chair. It has a seat and three legs but no rungs. There is an old grey box which looks much safer to sit on. In the middle of the room is a stove, stout, red with rust but looking quite serviceable. Rough shelves are on the walls and fastened in corners.

By the stove is a block of wood and an axe. One looks at the floor and judges that the accumulation of forty years of chopping and splitting wood is lying there in perfect peace. All over the floor are the chips and dust, perhaps a foot deep. The legs of the old stove show just a little above the knees, the little cot barely misses the debris by an inch or two.

Mingled with the chips and dust and slabs of wood is all the cast off clothing the little man has discarded through the years. They are the same colour as the dust and you hardly know which is which. Nothing has ever been disturbed here—nothing ever moved. An old hat or coat drops down from its peg and stays there for ten, twenty, thirty years or more. No useless effort has been expended. The little man has not worn himself out washing, cooking and housekeeping but has given his soul up to the enjoyment that nature provides so abundantly.

The remains of an old wash basin are lying there and you surmise that it had its uses—long ago. Strangely enough, I have no rec-

72

ollection of disagreeable odours in the place, just the impression of freedom from unloved tasks and absolute relaxation of body, mind and spirit. I am sure, however, that if any wild creature came to the little man's door seeking shelter and warmth, it would be invited in and cared for with all the courteous hospitality of old England.

The little man had not always lived thus. In the beginning, which was ever so long ago, he and a brother had come to Canada from the Old Country. Like so many others, they took up land on the prairies. It was a hard, gruelling life. One disaster after another swooped down on them and finally they threw the whole project and left. Their souls had been starved for beauty as much as their bodies had lacked for food. They wanted trees and grass and flowers and animals and birds. They found them all in the woods near Masset, especially the trees—tall, dark and splendid. They hewed themselves out a little home. Instead of wheat, which was always threatened by drought, hail, frost or wind, they would raise goats and sell the meat to the folks of Masset.

They dug the soil, labouriously planted a garden and imported a few goats. Years went by. The goats begot more goats until there were grandfather and grandmother goats and uncles and aunties and cousins. The brothers would come into Masset and buy quantities of feed for them during the winter months. They brought goat's milk and sold it, but no goat meat went over the counter of the local butcher. After raising and feeding and caring for the creatures, how could they kill them? Eventually the investment became too burdensome and they had to give up keeping goats entirely.

They had a horse but could not bear to have it work and they dug up the garden themselves, slowly and laboriously, with a spade. Meanwhile the horse got fatter and fatter until finally it died because it was too fat to live.

These two dear souls did everything the hard way—and loved it. They were the personification of patience and gentleness. Years ago one brother died and the other stayed on, living closer and closer to the creatures of the wild, in perfect communion with nature and her works—one of the few completely happy persons I have ever known.

Haida Artist

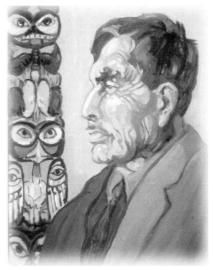

Mark Spence

Tall and awesome are the totem poles of the Haidas, with strange creatures cut deeply into the heart of stout cedar logs.

Early explorers tell that the poles were originally a necessary part of the great houses of the Indians in this area, that they were always found inside as substantial supports of the structure. On these supports crests of the clans were carved and painted with great care and skill. Later, as pride of ancestry expanded and the custom grew more popular, totem poles were erected outside the chief's house as the visible symbol of his standing in the community, for all the world to see.

Special characteristics distinguished the totems of different tribes but the purpose was always the same. It was a primitive form of heraldry, akin in essence to the family coats-of-arms of the British Isles—an indication of the wealth and rank of the holder.

Totem carvers were regarded as especially gifted men and they were accorded the same deference and respect as was bestowed on the masters of art in early Greece and Rome. Only they could record, in enduring form, the cherished traditions of the tribe.

▸ *colour plate page 141*

Infinite skill and patience went into the carving of a totem pole and when the work was completed the erection of the pole was an occasion for great rejoicing, accompanied by much feasting, dancing and secret ceremonies.

The bold and fierce Haidas were the terror of all other tribes as they sped up and down the coastal waters in their powerful canoes, plundering villages, killing many, carrying others off to slavery. Many are the tales that are told of their prowess and daring, many the legends as related by the old men and women who can remember the history of their people.

All is changed today. In place of the mighty war canoe, beamy diesel-powered fishing boats are owned by the Haidas. Prosperous modern towns occupy the sites of old-time villages. There are few who practice the ancient arts—fewer still who remember the ancient lore. [Fortunately, since this was written, Haida art has made a remarkable recovery.]

As a little boy, Mark Spence of Masset had listened to his father conversing with Edenshaw, the greatest carver of them all. He had gazed in wonderment and awe on the magic results of his genius and had resolved that, when he became a man, he too, would be a carver and make great totem poles that would invite admiration from all who saw them.

Many years later, at the request of the government of British Columbia, he carved two massive poles for Thunderbird Park in Victoria. There they stand, an enduring testimony of his skill.

Mark Spence was born in the village of Stlinglennos, which means "way up the inlet." His Indian name is Kwin Kwoyah or Wealthy Nose, derived from the fact that his ancestors were heavily tattooed across the bridge of their noses. To be elaborately tattooed was a sign of great wealth and prestige in the tribe.

Mark was a good musician as well as an artist. He had been bandmaster of his tribe and had played with Victoria orchestras as clarinet soloist. Once he carved a beautiful violin, which he delighted to play. Two chisels and a couple of old table knives, ground down and fitted into his own homemade handles—these were the only tools he used for his carving.

There are some people in whom gentility is inborn, regardless of education, travel or training. It comes into the world with the per-

son—a carryover, perhaps, from some distant previous existence. Mark Spence was such a man.

It was my privilege, for more than a year, to have close, personal contact with him, to solicit interest in his work, to help him sell his carvings, and I like to think that the last year of his life was the happiest he had ever known for he was constantly employed doing the work he loved. He took pride in invariably doing his level best. The recognition and remuneration he received gave him a new sense of self respect and added to the zest of his life. Never have I met with such sincere gratitude. In simple heartfelt words, expressive of his feelings, he would tell me how his work progressed.

He was no dawdler. No sooner would I ask him to execute an order than he would be busily engaged upon the project. I was always astonished at his unflagging industry, his trustworthiness and promptitude. Our frequent correspondence was a constant delight to me and now that he has gone, I am glad I saved the letters that he wrote—so warm, so honest and wholesome they were—the unrestrained outpourings of a noble and grateful heart.

One of my treasured memories will always be my association with this gentle and kindly old Haida Indian. I share with you some of these letters, that you may see for yourself what manner of man he was.

August 5, 1944

My dear Mrs. M.V. Thornton

I have just written you a few words in reply that I have duly received your most fine letter yesterday. I was glad to know that you landed back saved to Vancouver from your enjoy holiday trip.

I am very well these day, and do so much carving which I could not any longer keeped because everybody said my carving of totem poles was better than any totem poles was made in these part.

Well now my friend I should say that I going to appreciate your consideration not only for me, but many different part of the Indians which you might be paintings done. This is all for present, I am respectfully yours,

Mark Spence

November 10, 1944

Mrs. M.V. Thornton of Vancouver, B.C.

Dear Friend

I have writing you a few lines to lets you know that I was very well so far, and hoping you are doing well these day. I was also glad to learn that my daughter send you a piece of present. I am very sorry for delayed answering to your letter. Well now I would like you to do me a great favour, first that Mr. Morris told me some time ago that you wanted 30 inch totem pole, if you really wanted it you might buy me a hat for it. The hat that I've wanted is this, Turpin Bros. Ltd. letters 629 Granville St. Vancouver, B.C. selected quality, the Brock fur felt, the size of the hat 7 1/4, not more, not less, the colour of the hat are fawn, because I've wore that kind of hat from 1928 and still wore it, lots of holes in this old hat now. If it cost you too much let me know and I will lets you have another totem pole whatever size you want, and say so if you please. I hope this will not cost you a troubled so much.

There are not much things to mentioning about so I must close and say goodbye, and good luck to you, and happy in life.

Yours respectfully friend,
Mark Spence

November 14, 1944

Dear Mrs. Thornton of Vancouver B.C.

I have drop you a few lines to lets you know this small totem pole are finished right now. I do say you are a God blessing to me. I am deeply grateful to you for all your God blessing kindness to me. I know none any of my relations have done things like that to me as you have done. I shall be happy when I have starting to wear those expenses hat.

Yours faithfully friend,
Mark Spence.

Then later he wrote:

I have received the post money order which your kindness done send me a few days ago, and I am most enjoyed to know that you got the hat for me which I've so much appreciate. I am going to expecting to see you some times with a great pleased.

December 8, 1944

Dear Mrs. Thornton of Vancouver, B.C.

I received your fine letter this morning and was glad to answered it at once, yes, the hat was indeed satisfactory, and it right size and very handy, and good shape and fine colour.

At Christmas time he wrote to say:

I wish you a merry christmas and a happy new year to you and your family, and we anticipate of the christmas same as anyone do.

I do hope you are quite well these day and always doing a fine work, thank you very much for the money order which I have received of you last week. I shall be able to lets you know about my starting work on those two big totem poles which you do not wanted to miss it, so now I prayed to God for my health and doing good job for you all, there aren't much to mentioning about. I do hope you are in best of health and never say die. May God bless you for ever, and good luck to you all, and I shall be expecting to see you some time with my great wish for you.

I am yours respectfully friend,
Mark Spence.

Tsimshian

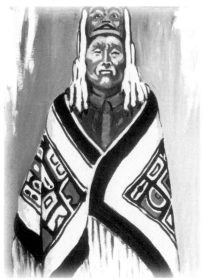

Tsimshian Chief Billy Williams

Tsimshian Indians may be divided into three groups—the Tsimshian proper found near the mouth of the Skeena River, the Gitekshan who live farther inland on the same river and the Niska who inhabit the basin of the Nass River. Coastal Tsimshian were traditionally fishermen of halibut, seals, sea lions, sea otters, salmon and oolichans. Those in the interior of the province were hunters, chiefly of mountain goat and bears. They recognised four divisions socially: royalty, nobles, commoners and slaves with a matrilinear descent of inheritance. Feasts and potlatches were held for every important occasion, their customs being strongly influenced by the Haidas of the Queen Charlotte Islands and the Tlingit to the north. The Tsmishian believed in a sky-god and other supernatural beings of less importance. Their medicine men had great power that was often used in a baleful capacity to further their own ends.

They had a complicated organisation that found expression in spectacular totem poles, carved masks, dishes, rattles and other objects. The Tsimshian were especially noted for their beautiful

Chilkat blankets. These were woven from mountain goat wool and cedar bark in striking colours and elaborate designs. They were prized possessions of the highest chiefs, worn only on ceremonial occasions and are much valued by collectors today.

The Chief of Kitwancool

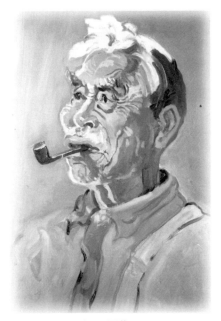

Amos Williams

Amos Williams, head chief of Kitwancool, was 103 and proud of it. He had been a hunter and trapper until he hit the century mark. Recently he had taken all his savings, of several hundred dollars, out of the bank and ordered himself a handsome tombstone from Vancouver. To the Tsimshian dying is almost as important a consideration as living and old Amos wasn't leaving anything to chance.

When the tombstone arrived on a flatcar at Kitwanga it still had to be transported by truck some twelve miles to Kitwancool. Amos called the people together, paid all his debts and gave a great ceremonial feast to mark the placing of the stone in its permanent position. Everyone who touched it, from the time it was loaded on the truck at Kitwanga until it stood gleaming in the sunlight in its appointed place at Kitwancool, received appropriate payment for their services according to the best Tsimshian traditions.

Everybody had a good time and it made old Amos exceedingly happy. Now all his affairs were in order. Everything possible had

been done to guarantee that, when the time came, his wishes would be carried out with honour and distinction befitting the head chief of a proud and mighty tribe.

Kitwancool is in the very heart of the Tsimshian totem pole country and its people have produced some of the finest poles in existence. Indians of Kitwancool are very superior people who like to keep aloof from the world and its turmoil. They, with the people of the nearby villages of Kitwanga and Gitsegukla, visit each other's reserves and attend each other's potlatches and ceremonies.

When an old man dies the tribe comes and takes everything in the home to give away at the potlatch and feast after the funeral. The widow gets nothing unless she can save something "on the side" and is often left penniless. It was due to circumstances such as these that the government outlawed the potlatch, though it is still held sometimes in remote places.

So now old Amos had no worries or responsibilities anymore. He could enjoy each day as it came and even felt a certain exaltation as the years piled up one by one, adding to his prestige in age as well as in acknowledgment of wisdom.

I knocked at his door several times before I heard footsteps shuffling along the bare floor. Amos peered at me through a crack in the door, with great curiosity, then invited me into his little two-room house.

I tried to tell him that I wished to paint his portrait but he had never heard of such things as portraits and [white] artists were a species quite beyond his ken. To avoid committing himself to something of which he had no knowledge, he said he "had to do the dishes."

I threw my equipment on the bed in the corner, took off my coat and followed him into the kitchen. "I'll help you do the dishes, Amos," I said cheerfully and commenced to pile them up, ready for washing. Amos got the dish pan and filled it with hot water from the kettle, adding lots of good strong soap.

I looked around for a dish towel. Amos pointed to a large general purpose bath towel hanging on the door which evidently served all needs. Who was I to quibble about towels in another person's house? I took it and began to wipe the dishes. Meanwhile Amos watched every move I made with a look of undisguised bewilderment on his honest old face. Not every day did a white woman come into his house like that—and never before in all his experience had one helped him with the dishes!

I kept talking to the old man to put him at his ease. Once, when he put a dish down that was not quite clean, I popped it back into the dish pan—"You'll have to do better than that," I chided. He washed it over again and told me he couldn't see very well, that's how he missed the dirt.

Finally the dishes were all clean and I carefully put them away in the little cupboard and hung up the towel. I took the old man by the arm and gently eased him into a chair, then handed him his pipe and tobacco. When he was comfortably smoking I got out my canvas and paints. Then the light began to dawn, "Ha," he croaked, "you make picture."

Amos was quite pleased to be painted and made sure that I wrote on the back of the canvas that he was 103.

Those rare moments, quiet and alone with the old people, are occasions I shall always treasure in my memory. I can recall the atmosphere of the occasion—the warm glow of the kitchen fire, the bare, neat, clean little room, sunlight streaming across the red oil-cloth on the table and the pungent smoke from the old man's pipe, curling like an aura above his sparse, white hair—no noise, no interruptions, no urgency, just complete understanding and deep peace.

No place else but among the older Indian folk will you find such blessed detachment from the toils of the world. Little wonder that I prolonged my pleasant task. Little wonder that I was loath to leave.

You ought to see old Amos saw wood. Just outside his house he had driven two sets of stakes crosswise into the ground, forming a horse on which to saw his logs. Younger Indians had cut the timber and left it there for Amos to saw into stove-lengths for his own use. He has his own method of getting a big log up on the horse. He goes about his task casually. There is never any hurry for anything and eventually he has the log in place. Next move is to go into the house for a kitchen chair. This he places in a convenient position, sits himself down comfortably with one foot on the ground and the other braced firmly on the log. He then proceeds, happily and leisurely, to saw it through.

Now and again he pauses to relight his pipe, to talk to a passer-by, or merely to sit and gaze at the towering mountains around him. He has learned to enjoy work and to exact the maximum contentment from all that nature offers. He is at peace with the world and his own soul. He is 103 and proud of it.

Builder of Peace

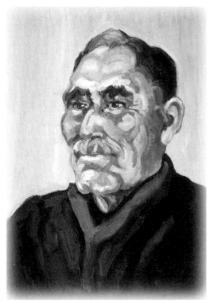

Chief Heber Clifton

Chief Heber Clifton of Hartley Bay made the news in 1948 because of a pair of gold bracelets, skilfully carved in ancient Indian designs, which he presented, on behalf of his people, to Princess Elizabeth as a wedding gift.

While the Tsimshians carved some mighty totem poles in the old days, they were never workers in metals. So in order to get the bracelets for the princess, the chief brought over from the Queen Charlotte Islands a gifted Haida craftsman who did the engraving in Prince Rupert under the watchful eye of the chief and some of his councillors. Where they obtained the gold is a mystery, which they did not see fit to reveal. A copy of the legend concerning the engravings was sent with the gift. The chief proudly showed me the acknowledgement of the bracelets by the princess in her own hand.

Heber Clifton has nine children, five boys and four girls, all living—a tribute to the wise care of their mother. He has forty-two grandchildren and twenty-eight great-grandchildren.

‣ *colour plate page 141* 84

Among the coastal tribes of Indians in British Columbia are kingly men and regal women who have been born to rule just as surely as any European monarchs. In every generation, among all races, there are those into whose hands destiny thrusts the sword of power and upon whose brows may be seen the signet of authority. It was even so among the Indians. They, too, have had their great men and their great moments. There have always been those among them who won renown for their prowess in war, but Heber Clifton will be remembered for his conspicuous gifts as a builder for peace.

Coast Indians have ever placed high value on pride of place. Those who attained power on their own merit did so by superior intelligence and ability but many inherited their positions from backgrounds of generations born to leadership. They were what the Haidas called high people.

Heber Clifton was trained for leadership just as people in other lands have been trained for their thrones. Highly intelligent, forward-looking with a deep sense of responsibility, he is a kingly man in every respect—kingly in his six-foot-two of splendid physical manhood and kingly in his strength, his moderation, his wisdom, his tactfulness and in his calm, majestic bearing. Beside him, through the years, has stood his loyal wife, quiet, sweet, motherly and strong—the perfect counsellor and helpmate to a man of action.

The day I visited the Clifton home they were not aware that visitors were coming so I found them exactly as they were at all times. I stepped into an atmosphere of comfort, taste and well-being. The chief, who was recovering from illness, was in bed. He was in his pyjamas, but that "wouldn't do" so he put on a dressing gown and sat in an armchair that I might paint his portrait.

It was clearly evident that he was receiving good care. No hospital ward could have been more spotless. The chief in these surroundings had the additional tonic of being in the midst of his own people, served with the devotion and tenderness of which they are capable.

Heber Clifton's Indian name is Gla-gum-la-ha, which means "the crashing of the heavens," signifying great power. He is the absolute ruler, the unquestioned authority of his group; a wise and noble-hearted man of unimpeachable integrity who has always cherished ideals of progress and worked with the laws of his country and of his church [United Church].

Earlier than most Indians he discerned the advantages of peace and prosperity and has been foremost in every good work among his people. It is said that there has never been a potlatch at Hartley Bay. The clean, orderly homes, good gardens, bright flower beds and the attractive little church in the centre of the community testify eloquently to his influence and his example.

I am told that there have been occasions when Indians from other reserves, bent on jollification, have come in their boats, well supplied with fire water, intent on uproarious celebrations at Hartley Bay. The chief, ordinarily the most hospitable of men, met them at his tiny wharf and politely but firmly told them to keep moving, making it clear that he would tolerate no drunken brawls in his domain.

The chief used to be a fisherman and a trapper. He also did mining and prospecting and sometimes acted as a guide to white prospectors. He recalls once, long ago, when he and a couple of other Indians were guiding a party of white men. He had found pure gold cropping out of a cliff. He broke off a piece and took it to the white men. One of them, named McMullen, grabbed it greedily out of his hands and would not return it to him, demanding to be shown where it came from. The other Indians resented his ugly manner and warned Heber that they would shoot him if he dared to tell. So the secret remained with the chief, but after the white men had gone away he never could find the place again. He is the only one living who knew where it was at the time.

The late Dr. G. H. Raley, well-known retired missionary and teacher for the United Church, told of Heber Clifton's good offices as a peacemaker. It was through the chief that Thomas Crosby, pioneer missionary, interceded with the warlike Chief Shakes of Kitkathla and induced him to extend the hand of friendship to an ancient hereditary foe. This was quite an achievement as old feuds die hard among Indians.

Heber Clifton is related to the Metlakathla group of Indians to whom the missionary William Duncan rendered much valiant service. He belongs to the Eagle Clan and although, under the matriarchal rule of the Tsimshians, his sons would ordinarily inherit their mother's and not their father's crest, breaking all ancient precedent, he took all his sons into his own clan and conferred his crest upon them.

There were only twenty people in the village of Hartley Bay when he came there from the Old Town, a few miles away. That was many years ago and the population is now 200 [circa 1948]. His people do not scatter about as do many of the coast tribes. They are sober, industrious and God fearing, with a deep allegiance to their church, their village and their chief.

Chief Ernest Duodoward

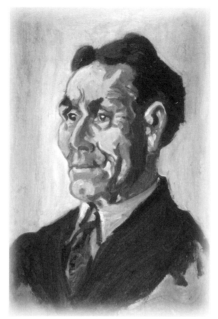

Chief Ernest Duodoward

Many years ago I met and painted Chief Duodoward in his home at Port Simpson, where history is in the very air you breathe. He was a quiet, kindly man, the gifted son of a most remarkable woman who had been born at Port Simpson in 1854. The chief had inherited her crests, the grizzly bear and the blackfish.

His mother was a very high-ranking person indeed, of royal lineage, a chieftainess in her own right. Her name was Mallask which means "one who can foretell the future." It was the biggest name in the tribe. She had inherited her title and her position from her ancestors on her mother's side since the beginning.

She was descended from the Temlahan nation. All people connected with Temlahan, from as far away as Kitsilas, have the same family name, the same dirge and the same lullaby. After "the flood" [an ancient cataclysm according to native lore] their canoes drifted around and scattered the people as far north as Kitsilas and to Port

Simpson. "And that's how you find the same names in these (various) groups," said the chief.

As a little girl Chief Duodoward's mother had been initiated into one of the secret societies of her tribe. After going through the ceremonies, which were accompanied by beautiful songs of praise, she was made to disappear for ten days, hidden in the woods, feasting and fasting and waited upon by members of the society. She was given a little food and drink at long intervals. Always an item of food was first sacrificed to the gods by being put into the fire. When she was given a cup of water she had to turn the cup around "four times as the sun goes," before she drank it.

During her ten days of seclusion "the Moon brought her back home twice for a few hours and then she was taken back again by the God in Heaven." At the end of her vigil "the Sea Grizzly brought her back to a point right outside the present Eagle House," and, though only eight years old, she was recognised as a princess and ready to take her place as leader of the tribe.

A short while after going through these ceremonies her mother and stepfather took her to Victoria where she met a devoted white woman who wanted to adopt her. Since smallpox had broken out along the coast her parents left her with this kind woman. She was taken to Sunday School and baptized. Afterward she went to a convent and was confirmed in the Anglican Church.

Later, when the smallpox epidemic was over, she returned home and found that a marriage had been arranged for her to someone of her own rank. When she was sixteen she was duly married to Alfred Skahwait Duodoward with much ceremony between the tribes of the eagle and grizzly bear. Her dowry was the coast waters from Skeena north to Sitka. Her husband's people could now hunt in these waters, chiefly for the sea otter.

When the princess was eighteen her first son was born. Later, she and her husband went to Victoria for six months where they stayed with a Mrs. Lawson who was a Methodist. At that time she met the missionary Thomas Crosby, who subsequently went to Port Simpson where he was to live a life of dedicated service to the Indians there.

Mrs. Duodoward resented certain stories that Indians went to Victoria merely to obtain whisky. She said probably her own family's trip was so [mis]interpreted and nothing could have been further

from the truth. She said there was a place called Whisky Bay where barrels of liquor were sold, but this nefarious trade ended abruptly when a man-of-war arrived. Its officers searched every house, rolled the whisky barrels out and drained the liquor into the streets. While they were still in Victoria a second child was born, the couple was remarried according to the Christian faith and the children were baptized. Many a challenge and many a hurdle had yet to be surmounted. A history of this dedicated Indian woman would put to shame the manoeuvring of many white politicians. She knew what she wanted to do and in what she believed.

She was descended from the raven. She was a grizzly bear but she took her husband's crest, the eagle, and had the Eagle House built—a mansion in those days, with seven bedrooms upstairs. It was a place where she could hold church and Sunday School services and teach her people. Although now a devout Methodist who shunned some of the old practices, she had preserved her Indian ceremonial costume all through the years that she might be buried in it as befitted a person of royal rank.

Mr. Duodoward died in 1912 at ninety years of age, but Mrs. Duodoward continued to live regally in the Eagle House until she died in 1943. She should be rated as one of the most memorable women in the history of British Columbia.

Her son, Chief Ernest, was living in only the lower part of the great house when I was there. For forty-seven years he had been organist in the church and a leader in all good works. He valued highly two wonderful coppers in his possession. One of them was said to be 200 years old. It was the largest copper I have ever seen and beautifully engraved with his crests. He had been offered $1,000 for it which he refused.

His tribe had bought it as a present for their chief. It took two years to pay for the copper. The first payment consisted of 10 slaves, 10 big canoes, 10 sea otter skins, 10 boxes of oolichan grease, 10 moose hides—tens of everything. The following year it was the same and then the payment was complete and the copper his.

The name of the copper is Na-roo-ukt, which means "to flee from." The native copper raw material came from Copper River and it has been pounded by hand, then carefully and wonderfully engraved with the chief's most important crests. The chief passed away some years ago.

Portrait of Sarah

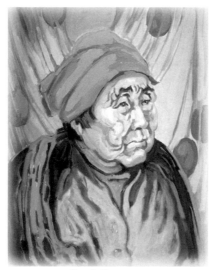

Sarah Gunanoot

Did you ever have a hunch about something? Did some unseen hammer ever strike a resounding blow on your consciousness with an impact that could not be ignored? That is how the thought of Sarah Gunanoot came into my mind.

Of course I had wanted to paint her for years and once almost did so, but fate slipped in and foiled me.

Hazelton is a long way from Vancouver but a few years ago I was travelling in that direction with a view to painting Sarah. Alas for the schemes of mice and men—and women too, for that matter. It so happened that the very train that took me into the little town beside the Skeena River was the same one that bore Old Sarah away in the other direction, off to a coast cannery and a season of profitable work.

Soon thereafter I was planning to go to the Queen Charlotte Islands to paint some of the Haida Indians. The precise day I was to leave the thought of Sarah returned. I sat down immediately and wrote the Indian agent at Hazelton to enquire if, by any chance, Old Sarah might be going to work in one of the canneries in the vicini-

▸ *colour plate page 174*

ty of Prince Rupert, for I would be coming home via that city in about a month's time and would like to meet with her if possible. I asked the agent to write me at Masset and I received the expected letter in due course. It came in the morning on the same steamer that took me to Prince Rupert in the evening.

Sarah was at a cannery all right, somewhere along the Skeena, but the writer had not the foggiest idea which one. Perhaps the Indian agent at Prince Rupert could help me find her.

It was barely daylight when we docked at Prince Rupert and I phoned Mr. Anfield, the agent there, as early as decency would permit. No, he did not know where Sarah was but her daughter lived on such and such street. If I would take a taxi and go to that address I would get news of Sarah.

The taxi driver and I cruised around the unfamiliar, steep, rocky little streets and we finally found the house. It was teeming with rain and I sloshed through the wet, weed-grown path and knocked at the decrepit door of the old, unpainted house. A rusty padlock indicated that my knocking was in vain so I knocked at the adjoining door. Presently it opened a crack and one shining dark eye peered out suspiciously.

Sarah was not there and they did not know where she was. That was all the information I could get before the door slowly closed to end the conversation. Fortunately I had asked my driver to wait and he took me back to my hotel from where I phoned the Indian agent again.

Mr. Anfield said he would see what he could do and an hour later he phoned to say that he had been on the long distance telephone calling all the canneries along the Skeena and had tracked Old Sarah down to the Cassiar Cannery which, of course, was the one farthest from Prince Rupert.

I was booked to leave for Vancouver the next day at noon, so whatever I did had to be done quickly. There was no train to Cassiar that day and no steamer and apparently no way to get there at all but the agent told me to take my paints and go to Port Edward and somehow there would be conveyance from there to Cassiar. The drenching rains continued and it would have been pleasant to remain in the warm hotel but I grabbed my kit and made for the depot. I was lucky enough to catch the noon bus to Port Edward.

There are days when magic is in the air, when you can't go

wrong—days when you just step out in faith and things begin to happen. You simply accept what comes and make the most of every golden moment. This was one of those days. When we reached Port Edward a fish packer was just leaving for Cassiar. I walked straight aboard and in less time than it takes to tell we were sailing out into the wide, island-studded Skeena—a part of the life and motion of that broad and restless waterway. Through the rain came fleeting views of rocks, mountains and trees. To the right, scarcely visible, was historic Port Essington. Then, to the left, came Sunnyside, a place that seemed at that time to be singularly misnamed. We made a couple of brief stops and I was invited to go below where one of the crewmen was making hot coffee.

The mists and the clouds combined to curtain out the scenery around us as we skirted sand banks or tooted greetings to passing fishing boats as we chugged steadily along. Presently we reached Cassiar, merely a name for a cannery. It constituted the entire community.

The obliging agent had called the cannery manager on long distance telephone and he was expecting me when I arrived. He sent a messenger to bring Sarah to his office to meet me. She grinned happily from ear to ear when she agreed that I could paint her. Quite obviously she felt complimented.

The manager led us along the wet, slippery board roadway down to the waterfront where we entered a large frame building and climbed a ladder to the floor above, emerging into an expansive net loft. It looked like a ready-made studio to me with a fine big skylight all along the roof. Suspended at various heights from the ceiling in graceful loops and curves were huge fishing nets waiting to be repaired. Two men were working on them.

It was easy to see that Sarah was in her natural element here. She bent over one of the nets and her quick, supple little hands were soon weaving the strands together in their proper order. I found a small box to sit on and propped my canvas board up against a pile of old ropes while Sarah deposited herself on a large mound of netting. We were all set for work in our impromptu studio. The giggles and chuckles subsided as Sarah relaxed.

In repose her face took on something of the sadness and sorrow she had known so many years ago when fate had dealt her a cruel blow. She had been young and happy then and doubtlessly very

attractive also. Two half-breed trappers, who had used insulting language to her, were found dead and the police thought her outraged husband had taken the law into his own hands, settling the score quickly and thoroughly in the Indian manner. It was murder, according to the white man's law, but simple justice from the Indian point of view. Simon Gun-a-noot knew the police would soon be on his heels so he took to the mountains for safety. Knowing every rock and tree and trail in the rugged, wild terrain around Kispiox, he felt secure. All nature conspired to shelter one of its own children. By comparison, the white man's knowledge of this sombre, brooding land was feeble and impotent. The Indian, wise in the ways of the woods and natural lore, had little to fear.

There were times when he watched the police in secret satisfaction, so near that a cough or a sneeze would have betrayed him but as safe as if he were behind Gibraltar's frowning flanks. He could foresee their movements and predict their plans. He could outwit, outwalk and outmanoeuvre them every time. With easy confidence he could counteract their every effort to waylay him.

For thirteen long, gruelling years he played the game of hide and seek with the police, living the life of a hermit, getting his food and rest surreptitiously as the occasion warranted. His own people doubtlessly knew where he was, but there were none who would betray him. Under cover of the night, by rough and devious trails, they took him food and clothing. To a man they were faithful to one of their own who had been greatly wronged. In the white man's world too, there was much sympathy for Gun-a-noot.

On one occasion the beloved missionary, Dr. G. H. Raley, was in the little village. He was startled to hear far off in the mountains a strange, weird cry unlike any creature's he had ever heard. He listened intently and the haunting call came again—faint and far-off. "What is it?" he asked of an Indian companion.

"It is Gun-a-noot," was the reply. "Gun-a-noot calling for food. He is hungry." All the grief and sorrow of the long, bitter years were in those echoing cries.

The tragedy of it all was written on the face of Old Sarah as she sat there pensively in the net loft. Was she remembering when Simon, finally wearied of the fugitive life, came to the police to give himself up?

He was taken to Victoria to be tried for murder of the two men.

94

News of the event swept over the province like a forest fire. Sympathy of the people went out in a great surge of warmth and friendship to the Indian. Talk of the trial was everywhere.

Stuart Henderson, one of the ablest lawyers in British Columbia at the time, made history in one of the most eloquent and impassioned defences in the annals of the province. With glowing words he etched in the outlines of the dramatic story in an appeal that brought tears to the eyes of all who heard him.

Simon was acquitted and allowed to return to the land of his fathers and to his people. He and Sarah were at last reunited. Seven years more he lived to enjoy the majesty and solitude of his beloved mountains that had so long shielded and protected him, before he left the scene of his tribulations forever.

I worked swiftly in the quiet net loft as all these things drifted through my mind and, just as I was finishing, I was invited to have tea with the wife of the manager in their attractive home.

I was just beginning to feel the blessed languor of relaxation when I heard a warning toot from the fish packer approaching the dock for the return trip, so hastened to the little pier in order not to keep the benevolent crew waiting. They had gone further up the river to pick up a load of fish and were now on the way home. Soon the buildings of Cassiar, along with Sarah, the net loft and the manager's wife were swallowed up in the distance and the enfolding mists of the evening.

Daylight was fading when we came alongside a small boat that had signalled us to stop and take on their catch. It had been a poor day for these men. They had been out since early morning with only thirty salmon to show for their efforts. With steel pitchforks they tossed them into the great iron scoop on our boat, weighed them and dumped them into the hold. The catch that day would do hardly more than pay their expenses, but perhaps tomorrow they would have better luck. I fervently hoped so as I watched them, two Indians and a white man, slip away into the gathering dusk with a long wake of lacy foam trailing behind them on the glassy surface of the river.

Little lights came into view and winked us hail and farewell as we sped along. In and out among the islands we wove our way and presently the lights of Port Essington came into view. Then we could see Port Edward. Would there be a bus at this late hour? How

could I get back to Prince Rupert and my hotel? Oh well, time would tell. I would wait and see and besides, luck had been smiling on me today.

Three cars were standing there in the rain. People were piling into them. For a consideration I could go too. What luck again! And what a joy to return triumphant with my treasured canvas safely under my arm! I could hardly believe my good fortune. It seemed as though I had lived weeks in the past twelve hours and here I was with my hopes fulfilled and ready for a good night's rest with plenty of time to catch my steamer tomorrow as planned.

So that is how I came to paint Sarah Gun-a-noot, for whom murder had been done. I never saw her again but her portrait is in my collection and the memory of her calm, deep sadness is with me still.

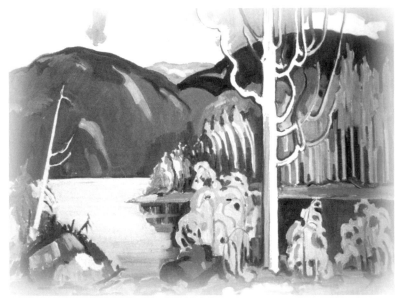

Prince Rupert

Sen-ah-haed,
Head of the Eagle Clan

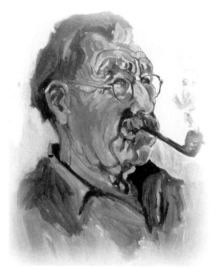

Chief John Bolton

Tremendous things are happening today [circa 1947] in the vicinity of the old Indian village of Kitamat. Once the most remote of places, it is now on the doorstep of the huge aluminum project of Alcan.

It was very different when I visited there some years ago. There was no boat service then. One had to thumb a ride on an Indian fishing boat to get in—unless you were lucky as I was, to go on a government Indian Agency boat. I was staying at Bella Coola when Mr. Pruden, the Indian agent, received word that a murder had been committed up there and his presence was requested immediately.

"Immediately" might mean anything, for someone had already made the long journey down the channel to Butedale to send the message by radiophone. Mr. Pruden had no means of knowing what had occurred in the meantime. His engineer, Teddy Levalton, read-

97

ied the ship, laying aboard ample supplies of food and fuel. With Mr. and Mrs. Pruden, Teddy and I made a complement of four. The *Brendan* was formerly a very plush luxury yacht which had been converted to government use. She was beautiful to look at and comfortable to travel in. It was a long journey, first to Ocean Falls, then to Bella Bella and thence on to Butedale before we could start on the last lap to Kitamat.

We arrived at Butedale in the dark and, after some manoeuvring, secured to a small wharf. Lights from the big cannery twinkled, casting their images on the water. The muffled monotone of a waterfall, like an audible backdrop, mingled with the metallic jangle of the cannery and the shrieking of hordes of gulls. Little boats lay tightly wedged around us. Many of them were from Kitamat where there was no store. All supplies had to go in from Butedale. The residents got their mail by any traveller who might chance to be going in. Everybody was everybody else's messenger or proxy, as the case may be.

We were seven hours chugging up Douglas Channel, a long arm of the sea that penetrates the Coast Range, reaching many miles inland to Kitamat. Against the purple-blue mountains snowy gulls glided about in graceful loops and curves like giant snowflakes. Now and then we saw a feathered "skipper" and his crew, as a drifting log passed by bearing a long row of stolid gulls, as if drawn up for inspection, all facing the same way.

The water was constantly changing. Sometimes it was tumultuous with lacy filigrees of foam embroidering each rising crest. Sometimes there were smooth patches, glassy and shining like a mirror. Golden poplars along the shore bowed to their glorious reflections in the water. Wild crabapple trees added a dash of colour among the sombre evergreens. Long whips of kelp coiled in ever-changing circular patterns. A school of blackfish suddenly appeared on our bow as they raced the boat, their sleek black bodies rolling and tossing in the churning water, swimming swiftly, neck and neck with us, their stumpy dorsal fins sticking up like short sails.

Here and there, in quiet eddies, were hundreds of wild ducks clustered in noisy little groups. Some of them rose heavily as we approached, then settled back, too fat and unalarmed to fly. Filmy scarves of mist wreathed the topmost peaks of the mountains or drifted lazily through the valleys. Big trees, roots and logs had been

washed into the channel at Kitamat where they bounced and jostled each other until the next tide took them inshore again.

We tied up at Clio Bay, the safest place to be when the water was rough. It was pitch dark, pouring rain and the tide well out, as we prepared to go ashore. Mr. Pruden, who weighs about 200 pounds, gave me one of his huge oilskin suits and a pair of high rubber boots to go over my own. I may have looked ridiculous but they kept me warm and dry.

Our flashlight showed a strip of narrow iron ladder descending down from the darkness above us. One by one we clambered gingerly up and arrived safely on the wet planks of the pier. In single file, we tramped along a sopping weed-grown path to the village, stepping over puddles and pushing slimy black branches out of our way. It was a wayward little path that angled and turned hither and yon, but it knew where it was going and we finally arrived at our destination.

While Mr. Pruden went about his business next day I was on the prowl looking for Chief John Bolton, head of the Eagle Clan and one of the very "highest" men along the coast. I found his little cabin quite near the docks.

All his life John had been a miner and prospector, but now, at ninety-five, he was just sitting by his fire, taking his ease. His father had been chief at Klemtu before he was born. John claimed that he and Chief Moody Humchitt of Bella Bella, whom I had already painted, were the two biggest chiefs (in terms of prestige) of all the coast tribes. Chief Humchitt was his cousin.

John's Indian name is Sen-ah-haed. "Some chiefs have low father," he explained, "but my father was high—don't get married to low people. My mother was high lady like a queen because her father a chief too."

John Bolton had been a great leader of his people and a noted orator, as most chiefs are. He was never at a loss for words and is a strong supporter of the Native Brotherhood because he thinks it is a good thing for his people. "Haven't much money now," he says but he is always the first to give if money is needed, shaming many younger men who are more prosperous but not so generous as he. He says he knows he will never reap any benefits from the Brotherhood, that he is an old man and his life is nearly over but he

has many grandchildren and he is thinking of the good they may derive from it.

In his day John was a physically mighty man—stronger than anyone else in his tribe. Tales of his strength had been told by many a fireside. Once he was in Victoria when many Indians from different parts of the province were gathered there. They were talking of feats of strength and one of Bolton's clan boasted that John was the strongest Indian alive.

A man from the Cowichan Reserve said it wasn't so, he was the stronger of the two, and challenged John to prove his superiority. So they wrestled and old John put his arms around his opponent and squeezed him like a grizzly bear does. The man crumpled at his feet. When he regained consciousness he got up and walked away without a word. Later on he died.

Another time a Tsimshian from Port Simpson challenged John and wrestled with him also and the same thing happened. The man was never the same again. He was a cripple for the rest of his life.

Old John, the Indians say, didn't want to harm anyone but he just did not realise his own strength and, after all, his challengers had asked him to prove it.

John believed his people formerly lived in the Queen Charlotte Islands and told me the story of how they got started on the mainland. "Very long time ago, in the time of the great flood, the eagle made up his mind he must come to the mainland from the Queen Charlottes to see what had happened when the waters covered everything. His heart was brave, his wings were strong and his eyes could see a long way off. Over the islands he flew. Days and weeks passed and the people at Skidegate waited and wondered. Every morning they would shade their eyes against the sun and look into the eastern sky. And every evening, after the birds had gone to their resting, they would watch for the eagle's return. But when, at last, he did not come, the chief and the head men made up their minds someone would have to go to find him.

"Next morning three of the bravest chiefs set out. They started paddling for the mainland. For many hours they paddled without resting and, at last, they came to the place which is now known as Klemtu. Here two of the chiefs decided to stay. But the third chief, who was braver and stronger than the other two, said he must go farther.

"Northward he paddled, all alone but with a song in his heart and, at last, he came to the head of this [Douglas] channel. Ahead of him he could see the mountains north of the Skeena River. This was because there were no trees at that time. He went up the Kitamat River in his canoe and, at last, he came to an Indian village on the river bank.

"Among the people there were Indians who had come from the Queen Charlotte Islands and some others from Owekano. These people had lived at Kitamat since before the flood and had come back to try to find their old village. This they could not do because the flood had changed everything, so they just stayed there on the banks of the river. In the course of time all these people came to be known as 'Kitamats' and the chief, who had found them, became their chief. His name was Sen-ah-haed, same as mine."

The people of Kitamat did not engage in elaborate ceremonials to the extent of other coast tribes, nor did they carve so many impressive totem poles. Only one crudely carved pole is standing in the village today. It has a certain legendary meaning which is not very clear to anyone. At the top is the figure of a giantess, a frog that had turned into a woman. She carries a cane on which is carved a halibut. There is a song in connection with the legend and the pole. Both the pole itself and the song belonged to John Bolton, head of the eagle clan.

Salish

There are two groups of Salish Indians, the coast tribes and those of the interior. The Coast Salish are found on the lower shores of the mainland and the southeastern part of Vancouver Island. The Interior Salish consist roughly of the Shuswap, Lillooet, Thompson and Okanagan tribes. Farther north, and completely separate from the rest of the Salish people, are the Bella Coolas, related to the coastal and interior groups through similarities of language but in tradition and customs having much more in common with their immediate neighbours, the Kwakiutl.

The Coast Salish were not so warlike as the northern tribes. They were famous for their fine basketry and blankets made from mountain goat hair. They had stone, jadeite and horn tools and utensils. Their carvings were fewer and inferior in workmanship to those tribes to the north. They built huge plank houses and serviceable dugout canoes, both made from the towering cedar trees.

Interior Salish followed a different pattern of life. They bartered hemp bark, berries, skins, furs and goat wool for shells, slaves and other things from the coastal tribes. Their winter dwellings were large, circular, partially subterranean structures, entered by a ladder from the top. In summer they occupied lodges made of rush mats spread over a framework of poles which could be quickly dismantled and taken away.

All the interior tribes made frequent use of the sweat bath (unknown among coastal Indians), utilized mainly for ceremonial purification. Clothing was of skin and furs. They used dugout and bark canoes.

The Interior Salish are noted for their beautiful baskets made from the root of the cedar tree and some of birch bark, decorated with Native symbols, the meaning of which is largely lost to the present generation.

Mary Capilano

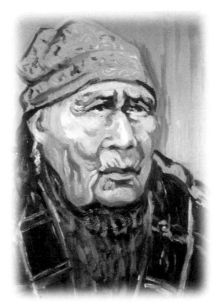

Mary Capilano

Capilano. There is mystery and magic in the name and in [its] relation to the city of Vancouver. Ki-ap-a-la-no was the original word as it fell melodiously from Indian lips.

Artists have painted the lovely Capilano River, poets have written of it and countless visitors have been thrilled by the view from the suspension bridge that today swings, at a dizzy height, above the swirling waters of its deep and narrow canyon.

High in the great mountains, cavorting with the clouds and the sunshine, the river came to birth. Nearby the lofty peaks known as The Lions looked down in frozen silence like two watchful, ageless godparents. Here too, lies the sleeping beauty in her eternal slumber, the actual mother of the little stream, bred of snow fields and glaciers which come hurtling down from her austere flanks, gathering momentum and volume as it ploughs its way through a great gash in the side of the mountain.

Through hidden channels and precipitous heights it pushes

onward over wilderness ground. Leaping from rock to rock, from gorge to gorge it goes singing its wild song of tumultuous freedom and thundering its derision, pausing now and then to rest in deep green salmon pools of utter silence and overwhelming beauty, then rushing on again toward the sea.

At the mouth of the river, where it widens out to be devoured by the hungry maw of salty tides, an Indian village called Homulcheson once stood. No trace of the old plank houses remains, no hint of the palisade of cedar trunks which the cautious Capilanos built long ago, from which to do battle against marauding tribes from the north.

Squamish Indians today proudly recall that it was their ancestors who first laid eyes on Captain Vancouver, the first white man to sail into Burrard Inlet. Legend says Natives were completely mystified by the unfamiliar sight and thought masts on ships were trees coming toward them on a supernatural island by supernatural means. It is said, and I like to think it is true, that they paddled out in their dugout canoes and scattered eagle down over the water before the approaching vessels. This was the traditional and beautiful symbol of welcome and goodwill among many British Columbia tribes.

Mary Capilano was the granddaughter of Paytsmauq, the most famous of all Squamish chiefs. Chief Joe Capilano was greatly respected by both Indians and white people. Pauline Johnson, the Indian poet, looked upon him as a well-loved friend. Mary was one of Vancouver's most picturesque characters, living to the great age of 108.

Despite teachings of the white people, Mary had her own views on religion. When asked to which church she belonged, she answered: "Old Mary, no 'ligion, just one Sagh-a-lie Tyee" (God).

She must have been the mother of many children, for the little cemetery at north Vancouver records their internment, two by two as follows:

> Children of Chief Joe Capilano,
> Cecile and William.
>
> Felix and Susan,
> Children of Chief Joe Capilano.
>
> Charles and Felix,
> Sons of Chief Joe Capilano.

Poor little "Mary Ann, daughter of Chief Joe Capilano," had to sleep all alone and must have felt somewhat slighted.

Many years ago I sought Old Mary out, in her home by the sea. She was sitting in her doorway braiding mats in the clever way the Indians do, without sewing them, quite unlike those made by white people. She took me into her spotless house and showed me piles of old clothes that had been given to her. These she had washed and sorted into bundles of different colours for her work.

She was willing to pause for a while and sit for me on the front steps. I admired the ear rings she was wearing. They had a quaint antique look and I thought it possible that I had stumbled on a bit of Native metal work. When I asked her about them she threw back her head and roared with laughter. "I buy from white pedlar," she chortled, "one day, long time ago—fifteen cents."

When Old Mary was moved to hearty laughter, her mouth widened into a deep red cavern, of quite formidable proportions, that revealed many things not ordinarily visible.

The portrait finished, I tried to get the old woman to tell me something about herself. Her name was Lay-hu-lette, she said, which means "the beginning of the world"—that moment when all inanimate things took breath and voice and entered into a higher realm of being. It was an old family name and no one else could use it.

When Old Mary was a little girl the Indians wore practically no clothing at all—only that which they made of the inner bark of the cedar tree or of mountain goat hair. They were healthy and clean then, everyone, young and old, used to swim and bathe in the sea, night and morning. They never suffered from colds or rheumatism.

When Mary Capilano was four or five years of age she went with her father to the old Hudson's Bay Trading Post at Fort Langley. She could recall how frightened the Indians were of the strange white people with their long beards and dark overcoats coming up to the chin and with their faces sticking out on top. "Coffin coats," the Indians called them and the word had an ominous sound to folk who were accustomed to the bright sun and the wind and the rain on their naked bodies.

Mary's father had brought a load of elk meat to the trading post and he exchanged it for clothing. She could vividly remember seeing him don his first pair of trousers. How odd he must have felt and

looked to the untrammelled children of the wild and how they must have marvelled at the strange customs of white men!

Mary Capilano was a capable woman of strong personality. She was never the lazy, shiftless type—not she! Around her little home at the water's edge were many berry bushes and fruit trees which she had planted. Strawberries, raspberries, currants, cherry and apple trees gave their bounty year after year and she gathered much wild fruit from the mountains. She also kept a large flock of chickens and sold eggs.

In addition to all this Mary used to gather clams in her spare moments. Three times a week she paddled across Burrard Inlet in her old dugout canoe with 300 pounds of them. She would tie up at the immigration sheds and pack her heavy burdens up to the Hotel Vancouver where the chef paid five cents a pound for them.

She knew how to save her money and at one time had over $2,000 in the bank—which represents a lot of fruit, clams and eggs—to say nothing of her toil! Because she was the widow of a chief and the descendant of a very important family, as well as a chieftainess in her own right, Mary felt she had a certain prestige to maintain and, in 1913, she did a very unusual thing for an Indian woman, she gave a big potlatch in her brother's vast house at Squamish.

Indians came from far and wide to do her honour. Everything was in accord with the best traditions of her people. She provided immense quantities of food for her guests and had lots of money and blankets to give away. Mary's potlatch lasted for three days and wound up with a big ceremonial dance as a grand climax.

Most of her guests were in full costume to perform the ancient dances and to take part in the secret, mysterious rites which attend such occasions, the significance of which are known in full only to the Indians themselves.

With the roar of the sea beating in lusty rhythm to their steps and their drums and the majestic mountains, protective and serene, looking down upon the revels, the scene must have taken on a wildly colourful note of grandeur and romance.

Somewhere, deep in the heart of the mountains, all the colour, all the magic, the echoes and the fantasy are locked away in timeless silence against that day when material things shall dissolve and crumple into dust and only the essence, the spirit of things, shall

remain. In that strange and mighty moment the Indian, much overlooked today, will stand forth in his true majesty—an artist, a musician, in every sense a creator of imagery without parallel in his own field.

In Mary's youth the Indians lived chiefly on fish and berries. "No berries now," she said sadly, "only high up in mountains. Used to be all over."

She remembered clearly the first white people she had ever seen. They had strange, different food. She had never tasted anything sweet until they gave her some molasses. "Good, good, good," she said with relish, drawing a gnarled old hand across her mouth in gustatory recollection.

"Everything change now," she told me. "Young women not make baskets any more. Lots and lots of Indians can't speak my language now. Mathias (her son and present chief) speak my language but his children not speak it. Some day nobody, nobody speak my language." The prospect of her language dying out was a real grief to the old woman.

Mary had the strength of an ox, even at an advanced age. She had an old dugout canoe such as the Natives have used for countless generations. When she wanted to visit Vancouver she did not waste time or money on ferry and tram service but hauled out her trusty water-steed and paddled off into the choppy, treacherous waters of the First Narrows and Burrard Inlet.

The currents in the middle of the inlet are extremely dangerous, especially when the riptides are flowing. Few white people would care to be caught in them but they didn't mean a thing to Old Mary. The stout timber of her old dugout took them like a salmon at play.

The sea was in her blood. She was as much part of it as the fish that leaped at the stroke of her paddle or the gulls that screamed over her bare, grey head. She knew it as a mother knows her baby and had just as much control over it. Fear was no part of her philosophy.

Mary had a mind of her own—as may be imagined. When she grew aged her people tried to reason her out of her hazardous expeditions across the inlet. Her prompt response was to plunge, without hesitation, into the turbulent tide. She would show them—the young upstarts!

She chose a wild and windy morning to demonstrate her skill, in defiance of anxious relatives and ominous weather. Whitecaps

were racing madly over the deep blue-green of the boisterous sea and the waves leaped joyfully at her dugout. Mary's stalwart heart swelled with exaltation as she met the onslaught, bouncing along like an autumn leaf on the crest of the billows. She knew every vagary of the currents and she paddled her fragile craft with incredible speed and dexterity until one mighty comber, too quick even for her expert seamanship, caught her broadside and over she went into the rushing waters.

Never daunted, the old woman gave herself up to the motion of the sea and allowed both herself and her canoe to be washed up on the sandy beach with the incoming waves. She was roundly scolded for this thrilling exploit and, to avoid further anxiety, her relatives took the old dugout and hid it securely far inland where Mary could never find it again.

But the combined force of all her kin could not curb the spirit of adventure in Old Mary's breast. They never knew what she was up to or where she would be found next. Neither weather nor relatives were likely to deflect her from her chosen purposes. In the end she tried to wade across the Capilano River when the water was high instead of going across on the bridge but, for once, she had to bow to superior force and turn back, thoroughly soaked.

It was late, cold and very dark. She wandered about most of the night trying to find her way home, finally arriving at her own fireside by the light of early dawn. Such exposure in cold weather was too much even for her iron constitution and it was not long after this experience that Old Mary ceased her adventuring for ever.

Chief Mathias, the Carver

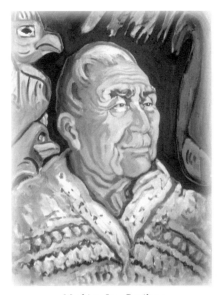

Mathias Joe Capilano

Mathias Joe Capilano, chief of the Capilano Indian Reserve, West Vancouver, is a jovial man who stands with one foot in the past and the other firmly anchored in the present. For a person suspended between two cultures he shoulders his burdens with hearty nonchalance. He takes life as he finds it, not wasting valuable time and energy in vain regrets over past glory but keeping ever on the alert for immediate opportunities.

Justly proud of the name he bears, well versed in the legends and lore of his tribe, he has a fertile imagination. What he cannot remember he glibly invents and talks with so much gusto as almost to convince himself.

His reserve lies directly under the famous Lion's Gate Bridge of Vancouver and his home stands on the site of the ancient Squamish village Homulcheson.

▸ *colour plate page 154*

Non-Indians scan this extremely valuable property with avaricious eyes, but the chief, from a memory of unhappy experience, views all their overtures with profound distrust. He says land on which the bridge rests was never surrendered—that it really belongs to the Indians—and refers to its use by white people as "the big steal."

Mathias looked around for his war club recently when authorities offered him a paltry $750 per acre for additional land which he claims is worth at least $5,000 per acre and more. He likes it where he is. Why should he move? The sea is at his door and he could not prosper without it.

Mathias is a famous carver. When he wants to make another totem pole, he just waits until the "salt chuck" brings along the sort of log he needs, then, on the next high tide, he steers it up to his front yard where he can hew and carve to his heart's content. Stray logs are always floating about the inlet. All he has to do is corral them.

Mathias can outtalk and outshoot any two Indians on his reserve. His hearty "Kla-how-yah" booms across Burrard Inlet like the nine o'clock gun.

Few of his race remain who can wield an axe as lustily as he. Near his home he has built a large community house where his people meet in council. It is roofed with smooth cedar shakes that the chief split himself, just as his forbearers had done for countless generations in the past. No modern sawmill could do a better job.

The council house also serves as a shelter for winter work. Almost any time you visit Mathias you may see a great totem pole being carved—outside in the summer or indoors in the winter. The tall totem pole at Prospect Point, which has been photographed by thousands of visitors to Stanley Park, is proof of his handiwork.

Years ago he had an attractive show place on Marine Drive where he displayed and sold his totem poles, large and small. Mathias is a born showman. His magnanimous spirit would not permit him to charge extra for the weird and wonderful tales that accompanied every sale but his customers went away feeling a little ashamed, thinking that they had got more than they paid for. Mathias has an inexhaustible verbosity and seldom repeats himself.

Since he abandoned his highway store the chief works all winter at home, building up his stock of curios and souvenirs for summer sale. When weather and roads permit he packs his family and

his possessions into his capacious, antiquated Packard and heads straight for the United States. He is looking for bigger fish than can be caught around Vancouver.

A time-honoured provision allows Indians to cross the international border either way without restriction. While others must submit to customs and emigration clearance, visas, passports, identification cards, etc., the old Packard proceeds importantly past, going merrily on its way.

Arriving at an American town, Mathias is in his proper element and knows exactly what to do. He wastes no time on small fry but decks himself out in buckskin, beads and feathers, and hies himself speedily to the mayor's office.

"Hello," he booms with his contagious grin. "I'm big chief. I got totem. I got tepee. I can sing. I can dance. I can put on a good show." Straightaway he begins to demonstrate his abilities. The mayor blinks his eyes in astonishment, jumps out of the seat of authority and before he knows it, he is pumping Mathias by the hand, bidding him welcome and, figuratively speaking, offering him the freedom of the town.

"That's what it amounts to," says Mathias. "They say to me, 'Sure Chief, you go ahead, put up your tepees, show us your totem poles, get out your drums and do your stuff. We are glad to see you and you can jolly well stay as long as you like.'" No taxes, no license, no restrictions of any kind.

Mathias and his family get ready to perform. All have colourful costumes and everyone does something, down to little grandson Joe, who can sing and dance like a troubadour.

Not every day are the toiling, work-harassed citizens regaled with such a joyful spectacle as Mathias is able to present. When it

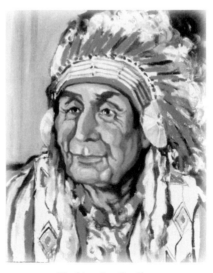

Mathias Joe Capilano
[attired in plains Indian costume]

▸ *colour plate page 155* 111

comes to attracting attention, Indians in full ceremonial costume, walk off with the prize every time. Mathias knows this and is clever enough to capitalize on it. He knows perfectly well that Indians of the West Coast never traditionally wore the beaded buckskin and feathered headdress of the plains tribes, nor did they have tepees— any more than the prairie Indians had totem poles, but the public expects a storybook Indian, so he gives them what they want.

His travels net him a neat profit each summer so that in the long winter months he can take his ease, if so minded.

Up the coast in beautiful Princess Louise Inlet stands a very posh hostelry built by an American capitalist. To lend colour to the scene Mathias was commissioned and well paid to carve immense totem poles to welcome jaded millionaires who come willing to spend any amount to see something new and different.

The chief won't budge an inch without his rotund, happy-hearted wife. When working on contracts, he insists on taking his whole family with him. While he and his son, Buffalo, hew, carve and paint, the others dress up in their costumes and enjoy the scenery.

Once Mathais had an opportunity to land a big contract in Texas. His prospective employer made him an attractive offer to carve several large totem poles and would pay his fare by plane to Texas to do the work there but Mathias flatly refused to go unless Mrs. Capilano, his son, his son's wife, his daughter and all his grandchildren could accompany him. The client did not feel disposed to charter a special plane so the deal fell through.

Mrs. Capilano is a sweet, lovable woman who was born to laugh at life. Along with her levity she exhibits a becoming respect for her husband's position in the tribe and always refers to him as "the Chief."

She was born on a reserve near Chilliwack and has many tales to tell of the Sasquatch, the legendary great, hairy giants who are supposed to inhabit the mountains near Harrison Lake and who have been said on occasion to carry off luckless Indians. Mrs. Capilano knows several people who firmly believe they have seen the Sasquatch, of whom they stand in mortal fear.

Chief Mathias has staged many picturesque performances. He was born to entertain people and loves the feel of a platform under his feet. Also, he has absolutely no inhibitions—a somewhat doubtful asset. In his youth he was trained as a dancer in the old traditions

of his people. Far from being subdued by this long, gruelling initiation, Mathias emerged from the experience shorn of all illusions, stripped of emotional conflict, bereft of conventional limitations but never losing his sense of humour, though sometimes in danger of losing his sense of proportion. He was that rare phenomenon, an emancipated soul.

Mathias succeeded to the chieftainship the year King George V came to the throne. [The author probably errs here. The coronation must have been that of George VI.] His father, Chief Joe Capilano, had attended Queen Victoria's Golden Jubilee, so Mathias thought it fitting that he should attend the coronation of the new king. He did so and almost burst with pride at being received in audience by the king and queen at Buckingham Palace.

He was profoundly impressed by the rich and gorgeous scene. Here he was, in the actual presence of the "Great Skookum Tyee," His heart thumped like a tom-tom. A mighty wave of pride and exaltation swept over his soul. This was an occasion worthy of one who occupied his own high station. For a brief moment he breathed the air of the gods as he shook hands with the king. He would never be the same again after that epochal event. He looked at his own right hand with awed veneration as though it were something sacred. He was loath to wash it lest the royal distillation should vanish. When he returned home, as a great privilege, he permitted people to shake the hand that had shaken the hand of the king.

The climax of his career came when interested people made it possible for him to attend the coronation of Elizabeth II. For months before the event the chief had hoped and planned and worked for the trip which was quite beyond the reach of his own resources. Money was hard to get. The outlook was very discouraging. When, at the eleventh hour, funds were raised for his expenses, Mathias for once was strangely silent—but not surprised.

"Well," he said soberly, "I prayed to God about it every day and I knew He wanted me to go. He would find a way. I thank you good, generous white people for giving me the money, but God arranged it."

For the first time in his life the chief, impressively arrayed in buckskin and feathers, climbed aboard a big airliner while a goodly number of his people, in tribal costume, waved goodbye to the big

bird in which he soared away high over the mountains and far over the sea. Crossing the ocean mightily tested his warrior heart. "Oh, that was the worstest thing I ever saw," said the chief afterwards. "All that water down there and me with no canoe."

The sight of an Indian chief in full ceremonial regalia, proudly marching down Picadilly, shouting his victory song and loudly thumping his decorated tom-tom, delighted the multitudes of old London who were waiting for the coronation procession to begin. Mathias was besieged by eager throngs who wanted to shake his hand and get his autograph. Hundreds of cameras clicked their first snaps of an Indian chief—television picked up his swarthy features, London papers carried articles and pictures of him, he caused a stir wherever he went.

It was a great day for Mathias—all that he had ever dreamed of in his wildest moments, and more. Every glowing detail was described with true Native eloquence at a banquet given for the chief when he returned.

Safely back from his soul-shaking experience, Mathias settled down once more to his carving and tribal business with an overwhelming admiration for the Royal Family, a new sense of self-esteem and a backlog of rich memories to pass to the campfires of future generations.

Tommy and his Totem Poles

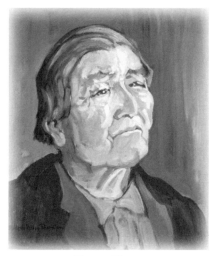

Tommy Moses

Tommy Moses and I have been "Tillikums" for many a year. He is one of the best carvers in the Squamish tribe of Indians. Tommy is getting old now, nearly eighty, he is blind in one eye but can see more and carve better with the sight of one eye than most carvers can with two.

My first encounter with Tommy was long ago on a rainy morning. I wondered who was ringing my doorbell so timidly. When I opened the door, there stood Tommy, wet and smiling, with two brown paper bags under his arms.

We went into the kitchen and, while I brewed him a cup of tea, he showed me his treasures. Totem poles they were, large and small and carved as only a few of the older people are capable of carving nowadays. [Since this was written over fifty years ago, West Coast Native carving has undergone a remarkable revival.] I bought one for myself and two for friends who had asked me to acquire something of the kind for them. This warmed the old man's heart as much as the hot tea warmed his body.

It struck me that this would be a good time to paint Tommy. Rare indeed, are the occasions when I am permitted to paint an

Indian in the comfort and convenience of my own studio. These old folks are seldom in a hurry and why should they be when they have all the time there is to do anything they wish to do? Soon I had Tommy sitting demurely in a chair by the window and I was busy trying to catch some of the things I saw and felt about him. We did not make hard work of it that morning, Tommy and I. I think I imbibed some of his philosophy of leisure from his close proximity, for frequently we stopped to talk and laugh and exchange jokes. In between, if it became too quiet, Tommy would take a little snooze, coming to with a start when his head fell over on his shoulder.

Tommy is a true artist and says he likes to carve for the same reason that I like to paint, which should be reason enough for anyone. There are certain distinguishing characteristics in his work—the deep carving and distinctive contours. For making small totem poles he prefers yellow cedar but finds it more difficult to get and tells me that he goes high up to remote places in the mountains to find it. No matter where Tommy happens to be he always has a wary eye peeled for yellow cedar.

Once, when he was working in the cannery at Rivers Inlet, he found a short, thick yellow cedar log. I can just imagine the almost holy joy with which he rolled the precious timber down to the wharf and got it aboard the steamer to Vancouver.

Coastal [steamship] captains have a heart when it comes to the Indians. "They good to me," declared Tommy, "not charge me to bring it back, not cost me anything."

When he got it to the city he had to pack the log to the ferry [across Burrard Inlet], then again, over a mile to his home on the reserve, but what did that matter compared to the ecstasy of having all that yellow cedar to work with?

Tommy is more than a carver, he is a creative artist; he does sculpture in wood. Totem poles for the tourists are often cheaply made with little carving but much crude paint and it is doubtful if Indians have anything to do with them. Tommy's creations are carved almost in the "round." His thunderbirds, owls, wolves, bears, beaver and blackfish are really lifelike—they all but breathe.

No art school ever taught him the secrets of anatomy, but Tommy knows. Form flows out of his fingers like honey from a jar. It comes without effort, as all true art does. He has his own ideas about paint-

116

ing totem poles, with some of which I do not agree. Once I bought a small one from him and repainted it nearer to the traditional colouring—as I thought.

The time came when I asked Tommy to make a minor repair to the pole. I hardly recognised it when he brought it back. He had painted it all over again to his own liking and that time it stayed that way.

Once, in October, I ordered six small poles for Christmas gifts. Christmas and New Year came and went and nothing happened. I just kept quiet, knowing that if the old man was able, he would eventually appear. Sure enough, he came one Sunday morning in February, not with six small totem poles, but with four large ones—twice as large and twice as much money as my order.

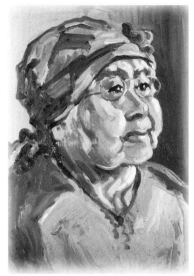

Rosie Moses

I paid for them without a whimper. You simply take what Tommy thinks is right for you and like it! He informed me before he left, however, that he still intended to make the small ones.

Tommy's memory goes back a long way. He can remember when Haida Indians from the Queen Charlottes came in their big war canoes to raid the Squamish. Tsimshian Indians from Port Simpson did the same thing.

One day Tommy asked me if I remembered the big fire which destroyed Vancouver in 1886. I had difficulty in convincing him that I wasn't even born then, but Tommy remembered. "Big, big fire," he said. "Burned everything but Europe."

Like most old Indians he is very weather-wise. He explained it this way. "West wind, she is open, covered over, open again, stay open. East wind covered all time."

A few years ago Tommy got married. The first time I met him after this important event I hardly recognised him. His hair was cut and brushed neatly. He was wearing smart new trousers and a bright red sweater. In fact, he looked so spruce and chipper that he seemed years younger. All this due to Rosie.

Tommy explained to me: "You see, Rosie all alone. I live all alone too. Rosie not have anybody to chop her wood. I not have anybody to wash my clothes, so we get married—do it for each other." Tommy and Rosie were determined to have a honeymoon, just like other folks, but they were financially embarrassed. Lack of funds did not deter them, however. Careful scrutiny revealed that their combined resources amounted to exactly five dollars. They were jubilant over so much wealth and took the tram to New Westminster for one whole, glorious day of sightseeing and came home tired and happy and perfectly satisfied with their trip. Many newlyweds have spent thousands of dollars and got less out of their honeymoons than did Tommy and Rosie with their five-dollar hoard.

The Indian [Affairs] Department built them a nice, new little home and there they lived as comfortably as could be. It is the tidiest, cleanest little house you could ever wish to see. The only things that mess it up at times are Tommy's [wood] shavings and Rosie's wool when she is at work on her famous Indian sweaters. Between them they make little sums of extra money, doing the work they love to do—what more could anyone ask of life?

"We always got money," Rosie told me proudly. "Tommy get new teeth, we pay for him. Sometimes old Indian people go hungry—not us."

Sometimes the pair of them come to call on me and it may be so early in the morning that I am aroused from my slumbers. What of it? Early or late they are always welcome, for no matter what the cares of life may be, I fling them joyfully aside whenever Tommy and Rosie appear.

When I have an order for Tommy to make a totem pole, Rosie always comes along to collect the money and thus forestall his being lured into a beer parlour. Tommy usually obeys her like a child and thinks she is truly clever. So do I.

One day they came and she pointed to Tommy's hat with scorn. "Second-hand store," she said disgustedly. "Some time I buy him nice new hat last week and somebody steal it when we go to church." Rosie was not going to have her man walking around in a makeshift hat if she could help it. Now that she had money in her pocket she would march him right down town and buy him a new one.

Under the stimulation of a stout cup of tea, conversation flowed

merrily. Many unfinished tasks were calling to me but I pushed them out of my mind and contentedly delivered myself up to the pleasure of the moment with my two uninvited guests. Strange, wonderful and often hilarious, are the tales the old ones tell but some of the best of them would not look well in print.

Both Tommy and Rosie had been married and widowed before—and they had few inhibitions. They could look back on life without bitterness or remorse and enjoy it all in retrospect. Their sense of humour differs from that of most non-Indians but is none the less genuine.

Rosie thought she had a capital joke on Tommy and proceeded to tell me about it. "Poor Tommy," she said between shrieks of laughter, "never have no baby all his life. Tommy tell me he never have no baby. Then one day I'm with him and lots of other Indians and there is fine young man, nice young man, and his name Tom Moses—all same Tommy. I tell Tommy, 'there's your baby,'" said Rosie triumphantly.

She knew jolly well that this might be a coincidence, as Squamish Indians use the same names often, but circumstantial evidence was strong and Rosie was making the most of it. Meanwhile Tommy sat there, helpless and inarticulate, with a sheepish grin on his face. He glanced admiringly at Rosie from time to time and probably thought her a real genius for being able to make [the] shrewd deduction.

Matches & Tobacco

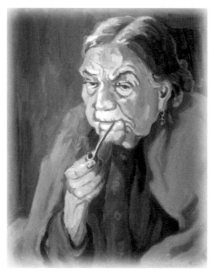

Siamelaht

There are times when, looking for a subject [to paint] among the Indians, one has a particular person in mind and goes straight to the goal—provided always that the goal is where you thought it to be. But I like better simply to be prepared to take whatever the gods may offer. There are many advantages to this attitude of mind. It involves no preliminary mental strain; it eliminates the possibility of disappointment. It is economical of time and nine times out of ten the results are satisfactory.

Go among these people often enough and, if you are receptive, you may imbibe a little of that spirit of release from the toils of the world which is the Indian's happy heritage and about the only thing others have not taken away from him. Theirs is an easy-going philosophy. "There is always time enough tomorrow for the things that cannot be done today." It is the complete reversal of the Caucasian creed. The Indian's ideology is the gospel of relaxation—an art that most of us have forgotten ever existed.

In the mad scramble to accumulate material things, the poor, deluded white race has forfeited the ineffable luxury of indolence,

▸ *colour plate page 147* 120

the unadulterated joy of dawdling, which is still, by the grace of God, the priceless heritage of our Native brothers.

It was in this rarely attained but altogether satisfying frame of mind that I meandered along the quiet lanes of the reserve in North Vancouver one summer afternoon, when whom should I chance to meet but the young priest of the local parish. As we walked he told me of Siamelaht, a very old woman, over 100, who lived not far from the church. "Go to Rose Williams who lives next door to her," he advised, pointing to the house, "and she will interpret for you."

Fortunately Rose was at home, also her daughter. They were bright, good-looking women, most courteous and kind. At once they accompanied me to Siamelaht's house and we walked in without knocking—a ritual the Indians consider superfluous.

The old woman lay on her bed, partially dressed. She seemed glad of an interruption in her long hours of monotony and solitude and told Rose that I might paint her the next afternoon. There seemed to me no earthly reason why I should not paint her at once but Siamelaht had spoken—and who was I to question the wisdom of her decision?

I arrived on the scene in good time next day, accompanied by a friend who was much interested in the Indians. I had been told that Siamelaht was accustomed to smoking a pipe and I wanted desperately to paint her whilst engaging in this pastime.

Again, Rose Williams and her daughter came to the rescue. They helped me pull the bed around into a good light. Then we fixed the old lady in a comfortable position. Her pipe lay on a chair beside the bed. I looked at it hopefully but hesitated to ask her to smoke it, as some of these old folk are exceedingly sensitive and, not for worlds, would I offend one of them. Being a nonsmoker myself, I could not offer an example.

Very discreetly my friend pulled out her cigarette case, lighting a cigarette for herself and offering one to Siamelaht as a sort of bait. She smiled and took it but I could plainly see that it was not her customary fare. She chewed, rather than smoked it, spitting pieces out from time to time and finally throwing it away in disgust. Then, to my great delight, she reached for her trusty pipe.

I was not long getting to work in earnest and seldom have I been so completely absorbed in painting anyone as I was in doing

Siamelaht. My friend thoughtfully went off for a walk. Rose and her daughter went home and I was left alone at my fascinating task. I say alone. I mean alone except for the kittens. Siamelaht loved cats and the room seemed to be literally alive with little black kittens that squirmed and sprawled all over the place. There was a pile of old newspapers lying loosely on the floor and an intermittent rustling told me that the kittens were playing hide and seek in its mysterious folds. Occasionally they would add variety to their capers by staging a race around Siamelaht's bed. One precocious little chap made off with the strap with which I fastened my paint box. I recovered it after a wild scramble. Another became quite inquisitive about my work and tried to climb up the leg of my chair to see what brand of paint I was using.

Peacefully smoking her pipe, Siamelaht was lost in her long, long dreams and I soon became oblivious of everything but the page of history which was revealed to me written on her face.

The priest came along and looked in at the open door to see how we were getting on but the old lady said something to him in no uncertain tones and he immediately bolted. She had told him to be off, as she did not want spectators.

A grand old face, had Siamelaht. Calm, resolute and full of character. When I was finished Rose acted as interpreter again. Siamelaht was older than Mary Capilano who had died a short time previously and she could easily remember when there were no white people. As a young woman, however, she had married a white man, by name of Alexander Merrifield, of whom the city archives relate was a sawyer who worked at the old Hastings Mill. They had what was considered a fine home in those days and two daughters who had married and gone to distant parts. Then Merrifield died and Siamelaht married Chief Harry, a man of high repute in his tribe. Back on the Indian reserve again, she lived according to the customs of her earlier days.

When I was leaving I asked Siamelaht what I should bring her on my next visit. Her request was for matches. Some weeks later I was back on the reserve and I had not forgotten my old friend. I intended to get Rose Williams to talk for me, as before, but a great, ugly dog barred my way at her gate. He planted his feet squarely in the middle of the path and if ever a dog swore at anyone, he swore at me. There are some things you can understand in any language

122

and this was one of them. He was in no mood to be trifled with, so I did not stop to argue with the brute and retreated as speedily, albeit ingloriously, as my dignity would allow.

I waited hopefully inside Siamelaht's gate, thinking Rose might come out to investigate the noise but she must have been away, for she did not appear. Then, mercifully, the dog disappeared. So it was on this occasion I went to Siamelaht's house alone. She peered up at me for a moment, then remembered who I was. I handed her the matches I had brought and, to my utter astonishment, she began to talk in very good English. "Good, good, good," she said, "and thanks," and then as an afterthought she sagely remarked, "matches are not much good without tobacco."

Now I do not smoke myself and I dislike tobacco in any form but I saw to it that Siamelaht had a sizable donation of the noxious weed next time I went to visit her.

The Power Dancer

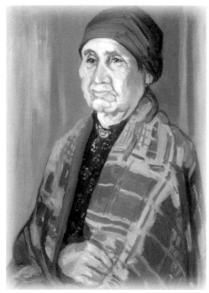

Mary Ann (Mrs. August Jack)

August Jack, hereditary Chief Khatsahlano, is the last of forty great medicine men or witch doctors, the ancient Order of Dancers of the Squamish Indians. They were called Snarhum dancers in the Squamish language. Snarhum means power. These medicine men were believed to have supernatural endowments which enable them to heal the sick and cause the blind to see, to restore broken bodies and bruised limbs.

August Jack is the last of these medicine men to be alive today. "Others of the order have power of a kind," explains the chief, "but not the power of the medicine men."

Indians know who the great ones are and no member of the order would ever turn his back on such a person, so highly are they and the power of Snarhum regarded.

August's grandfather had thirty-two wives but only six were living at the time of his death. August, himself, was born in Stanley Park, Vancouver, and his father, Supple Jack, had a herd of cattle in

the park in the early days. His mother, Sally, used to paddle her dugout canoe all the way to Moodyville to sell the milk.

Sally was one of three sisters, all of whom lived to be more than a hundred. She had the power of the Blackfish. Harriet had the power of the King Salmon. Long ago she was drowned in the Squamish River but the King Salmon, knowing she was an important person, saved her and brought her back to life. Ever after Harriet had his power.

When August's grandfather died none of his sons wanted to be chief, so it was left to Aunt Harriet to decide what they should do. August was only nine years old at the time but his uncle gave a big potlatch for him at Moodyville when they gave him his name and he was acknowledged chief.

When he became a young man his aunt decided that the time had come for his initiation into the Power Dancers. She conferred with her husband and, according to custom, they prepared for a potlatch. Meanwhile August had been very ill for six months and was actually dying—so people thought. As he lay there he was whittling on a rattle to pass the time away and every time it moved it rattled. His wife, Mary Ann, put it in a drawer and it continued to rattle. One day she went to the door and said, "Look what I see. I see your aunt coming."

Aunt Harriet came in and said to August: "You are a dancer. Dancers are born. If they do not dance they die. You are acting like a white man, which kills you. You need to go back to the Indian way and you will get well. The Musqueams are coming. I will speak to the chief."

So Harriet arranged with the chief for a potlatch to be held in the longhouse. Here August was to meet his tests, gruelling and severe, for his initiation into the Power Dancers. Picture, if you can, this scene of wild and fearsome splendour. The smoke-blackened logs and beams of the old house and the painted faces of the people illuminated only by the light of a flickering fire, the chiefs and wise men wearing their ancient masks and ceremonial garb made of mountain goat hair. All eyes were focused on August who was about to undergo the most terrible ordeal of his life.

They danced round and round him. They pushed him and pulled him. They screamed at him and beat him. They threw him to the ground and pummelled him unmercifully. They worked on him this

way for hours until it seemed there was no life left in him. Then they left him—for a time. Next morning they stripped him naked and put him against the wall. Then they took ten buckets of water, five hot and five cold and threw them at him alternately. For hours the exorcism of torment continued until his tormentors themselves were ready to drop from exhaustion. August was now like a being demented. He did not know where he was or what he was doing.

They made bracelets of goat hair, which they put on his wrists and ankles, and a breechcloth of the same. Otherwise he was naked, as they shoved him out the door. Eight naked men chased him many miles into the mountains. He was utterly bereft of his senses, a veritable madman, as he ran wildly into the woods, jumping over rocks and fallen logs, leaping from crag to crag with a power that was not his own, until he had outdistanced his pursuers.

Many hours later, after the long agony was over, he came to his senses and found himself on the edge of a cliff. He was alone in a wonderful new world that was bursting with song and melody. The sweet smell of the evergreens, the wide, clean sky, the delicious cool air on his poor, bruised body—the presence of all these intangible things were merged in an indefinable way with the rapture that he knew at that supreme moment.

Everything was singing—all nature had a voice and it was a voice of ecstasy. The fir tree had its own song, the rocks had their songs, the birds and animals, even the little insects all had their own songs. Every leaf on every tree was part of the mighty chorus. It was a world of song and, wonder of all wonders, August was singing his own song with high exaltation, the song that would be his, and his alone, for the rest of his life.

Then the braves came marching toward him. They took him down to the valley and put a dancer's dress upon him. They painted his face according to ancient tradition. He had passed his first tests. He was now a novice and he wore the robe of a novice. He must always wear it underneath his other garments until he attained the great power. He must go alone into the wilderness, like the prophets of old, until the power came to him.

Some Indians go for seven years before they get it, some for ten years, and some never get it at all. It took August three years and he has been a Power Dancer for more than half a century.

The novice knows he has the power when he can see the souls of the dead moving about as small as bees. He stretches out his hands and draws it to him—draws the power into himself. So the Indians believe.

August says many people are initiated but few get the power. He knows a lot about herbal cures and what can be used to treat diabetes, rheumatism and heart trouble. He has the healing hands of a great medicine man and understands the "laying of hands." He has the power to heal.

"Life is power," he says. "You have life and you draw your power from God."

August has a very old and valuable ceremonial mask. When the priests on Kitsilano Reserve ordered all the Indians to burn their masks, August took his and hid it far away in the woods and kept it to this day.

August has a dispassionate, deeply significant philosophy of his own, He says: "Life is like a long road. Everybody go to end. You can't stop. Some go past you, some come behind, but all go. Sometimes people fall down. You pick them up. You help them. Sometimes you fall down yourself but you don't cry—you get up, just go on. At end is big gate, everybody go through and when you go through you see everybody you have loved who went before."

In the old days, going to Victoria from Vancouver was a journey of three days, so August recalls. Always many Indians went together. Five or six big canoe loads of people would put out from False Creek and, paddling around Point Grey, would make Steveston the first day. There they would camp for the night. The next evening they would pull into a sheltered bay near Plumper Sound and camp again. The third day's paddling would take them to Victoria.

They were up very early in the morning on these trips and would be on their way by sunrise, travelling as long as they could see, without a break for food or rest. Though it was hard work, it was all in the nature of a huge picnic. At night they would build a big fire and everyone partook of a good hot meal, sharing each other's food.

Each canoe carried a little barrel of fresh water so they could camp anywhere. They had no matches and made fire by friction. On these journeys they always brought along some cedar that had been in fresh water and thoroughly dried, not by fire, but by the sun. This

would easily ignite to make fire. Later, they carried a live coal with them in cedar bark. On the journey they kept it facing the wind so it would stay alive. Then, when they went ashore, they could quickly get a fire going.

"In the old days," said August, "we don't have Safeway, Eatons and Woodward's to get food. Go into woods and shoot deer, get ducks, berries, everything we need for ourselves, not need much money."

August Jack is one of the few people living who knows the true story of Chu-schwalton, the Prophet of the Squamish.

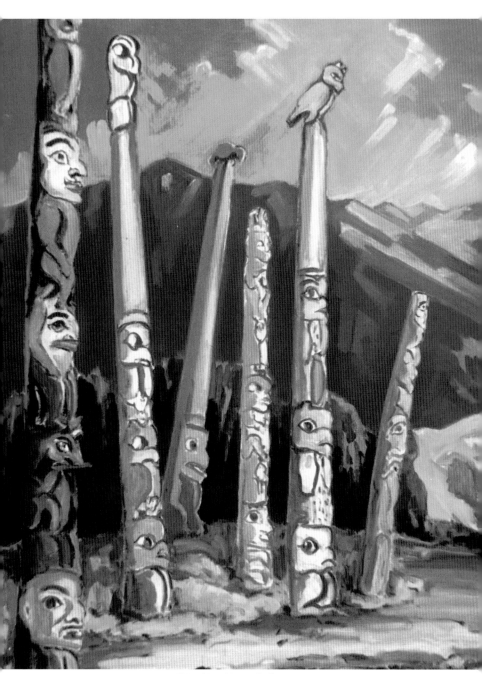

Tsimshian Totem Poles

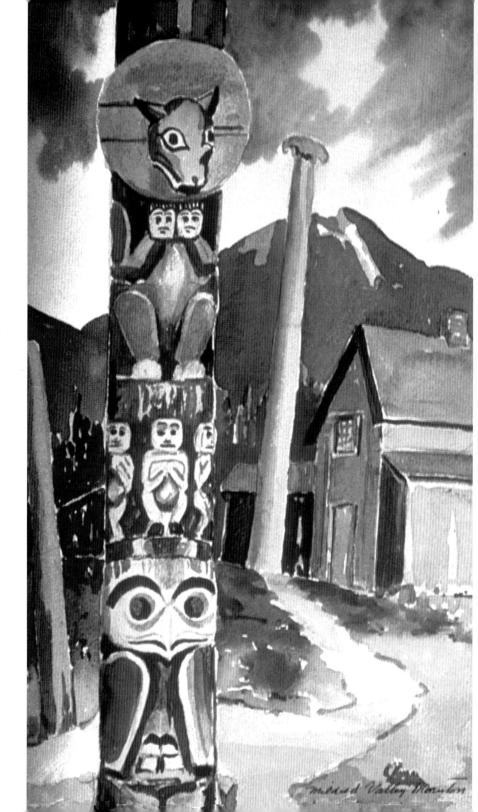

Mildred Valley Thornton

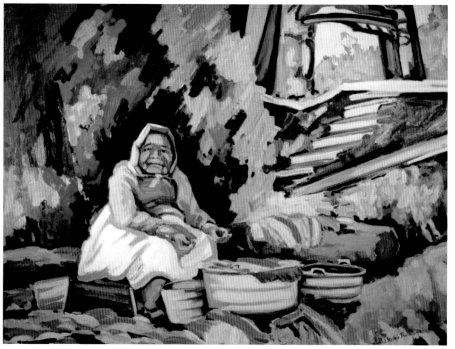

Kwakiutl Woman Cleaning Salmon ▶ *text page 15*

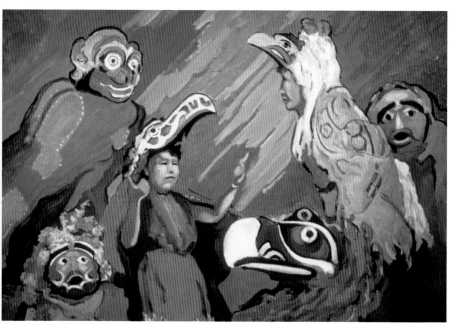

Mask Dance of the Bella Coolas

Opposite: *Bear and Moon Pole, Tsimshian* ▶ *text page 291*

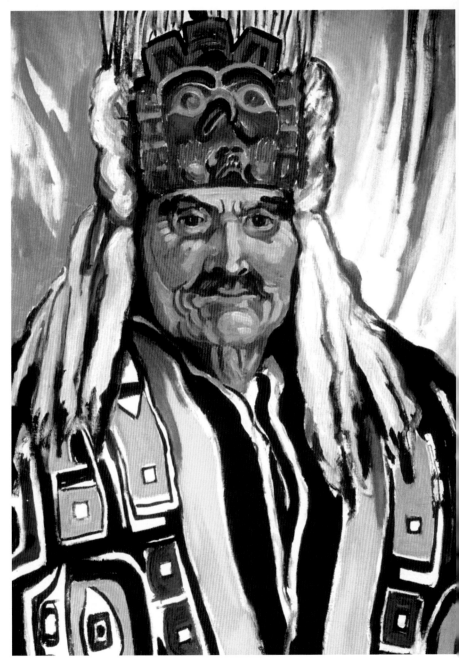

Chief Billy Assu, Kwakiutl ▸ *text page 24*

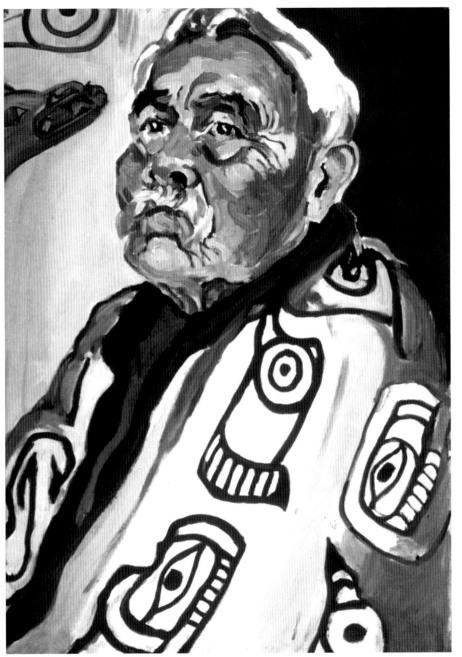

Chief Moody Humchitt, Kwakiutl ▸ *text page 21*

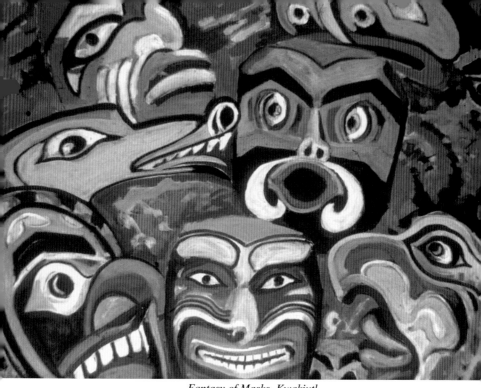

Fantasy of Masks, Kwakiutl

"Rain Call" — Thunderbird Dancers of the Bella Coolas

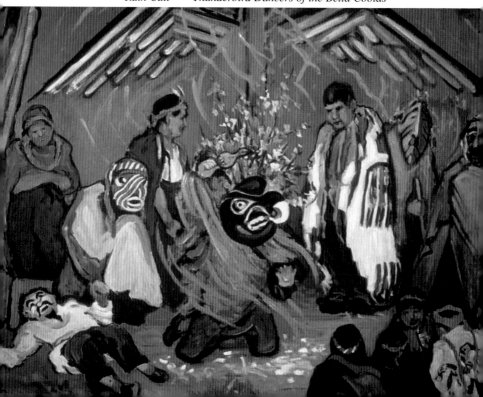

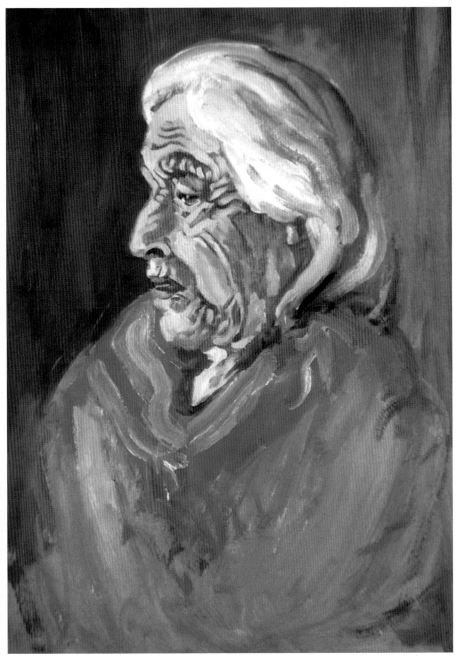

Susan Gray, Haida ▸ *text page 63*

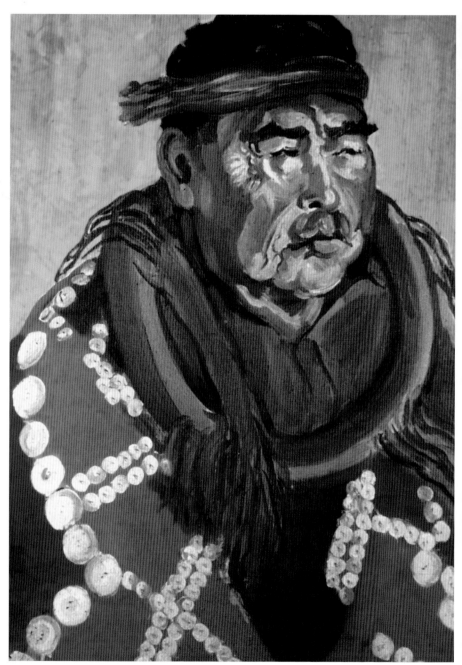

Chief Hemos Johnson, Kwakiutl ▸ *text page 32*

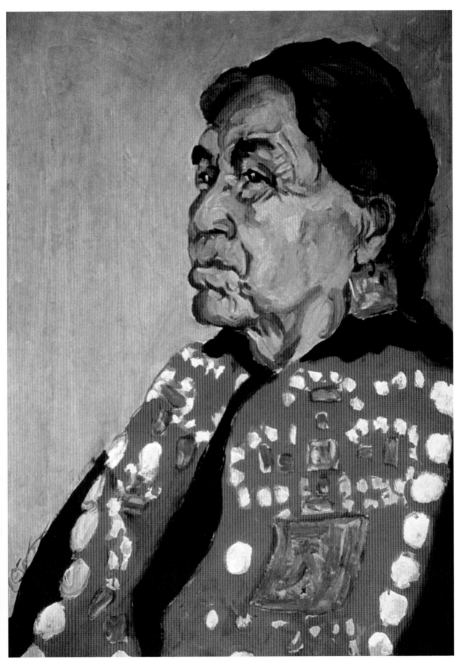

Mary Moon, Kwakiutl　　　　　　▶ *text page 44*

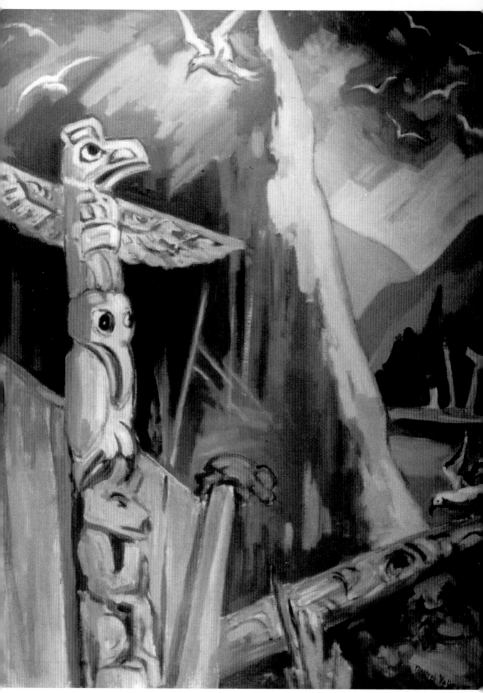

"Where have all the people gone?"

Opposite: *Leaning Totems, Tsimshian*

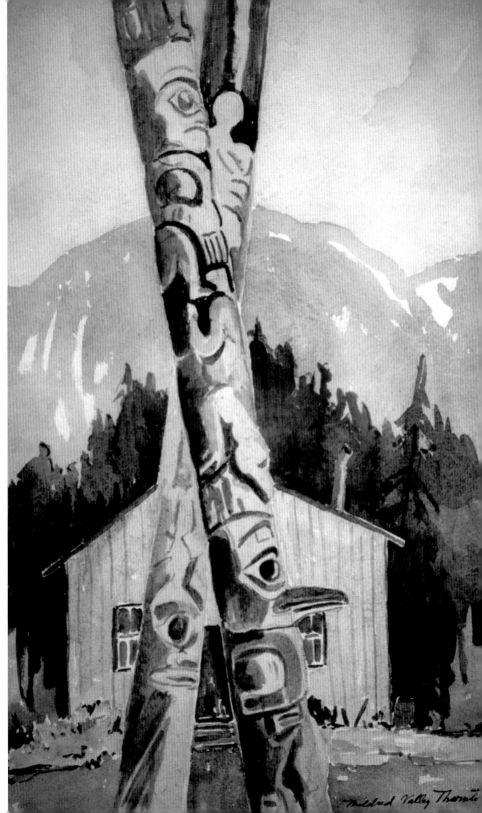

Mildred Valley Thornton

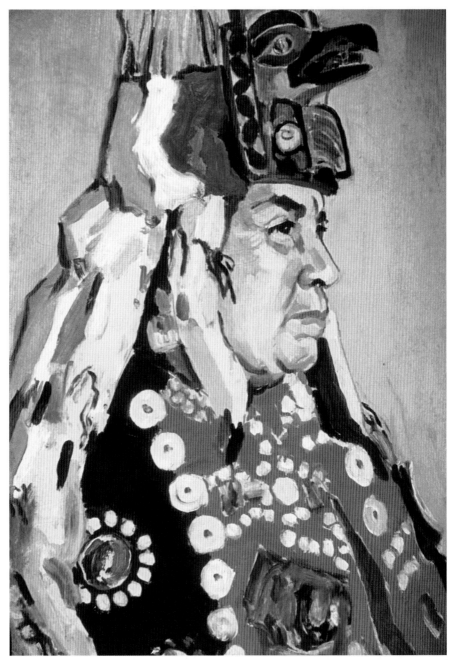

Mrs. Andy Frank, Kwakiutl ▸ *text page 50*

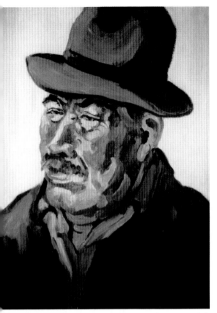

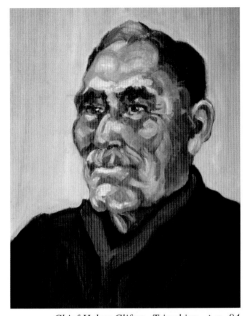

Chief Napoleon Maquinna, Nootka ▶ *p. 53*

Chief Heber Clifton, Tsimshian ▶ *p. 84*

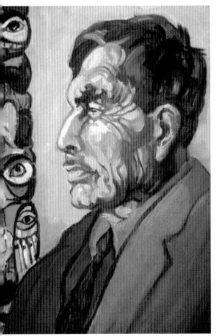

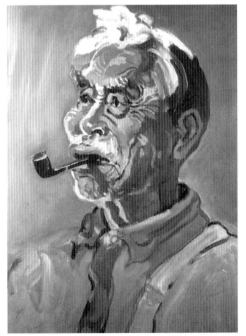

Mark Spence, Haida ▶ *p. 74*

Chief Amos Williams, Tsimshian ▶ *p. 81*

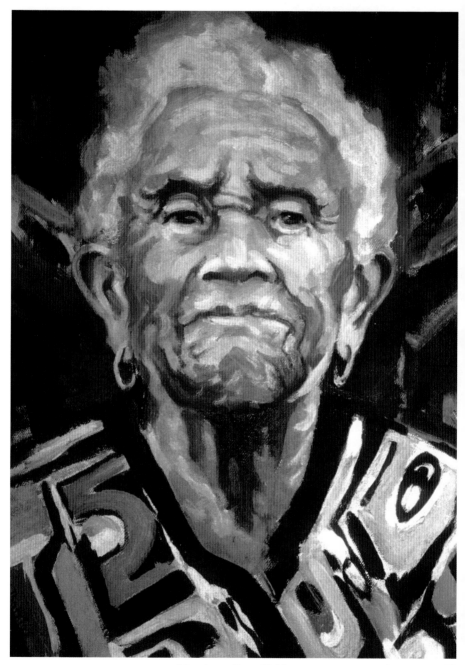

Mrs. Agnes Russ, Haida ▸ *text page 63*

Graves at Bella Coola [watercolour sketch]

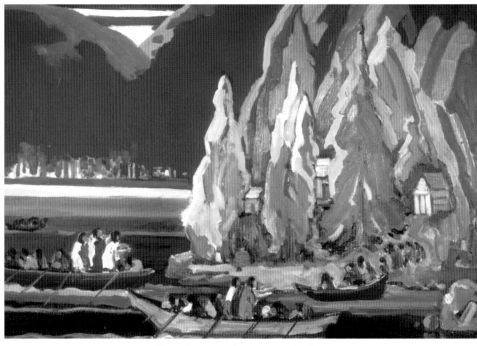

Bella Bella Funeral Party, Kwakiutl

▸ *text page 291*

Graves at Bella Coola

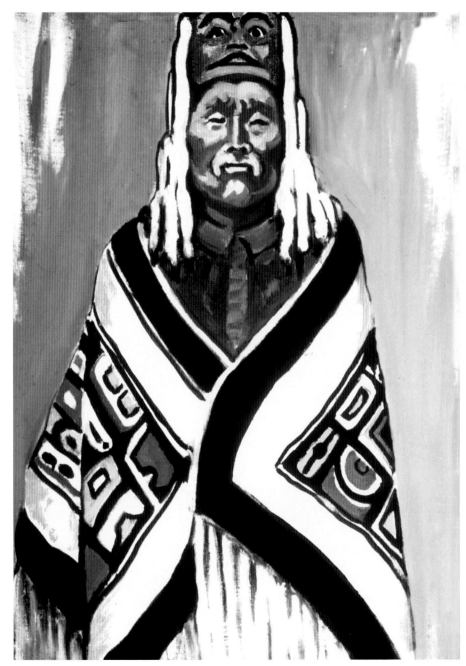

Chief Billy Williams, Tsimshian ▸ *text page 79*

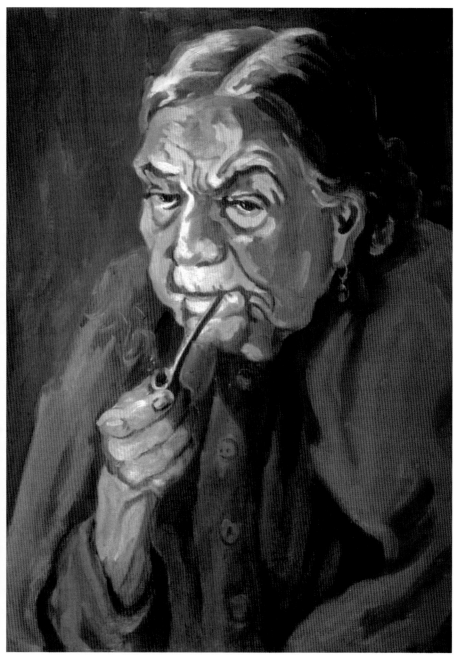

Siamelaht "Aunt Polly," Squamish ▸ *text page 120*

"And the Creatures Came to Life"

Tsimshian Totem Poles

Kwakiutl Initiation Ceremony

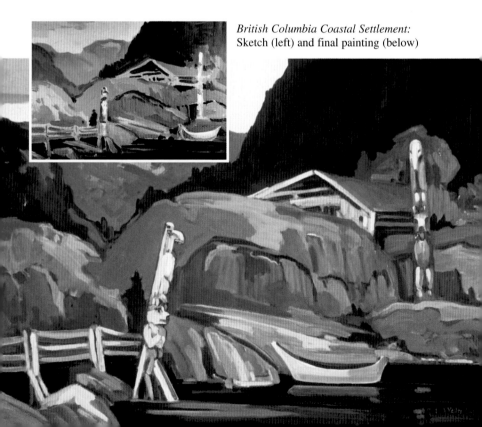

British Columbia Coastal Settlement:
Sketch (left) and final painting (below)

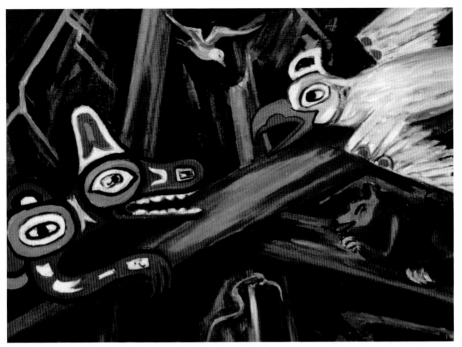

Confrontation

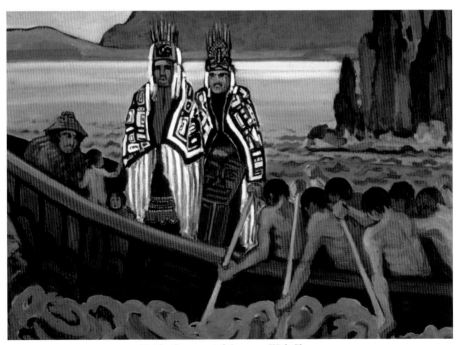

Haida Ceremonial Journey With Slaves

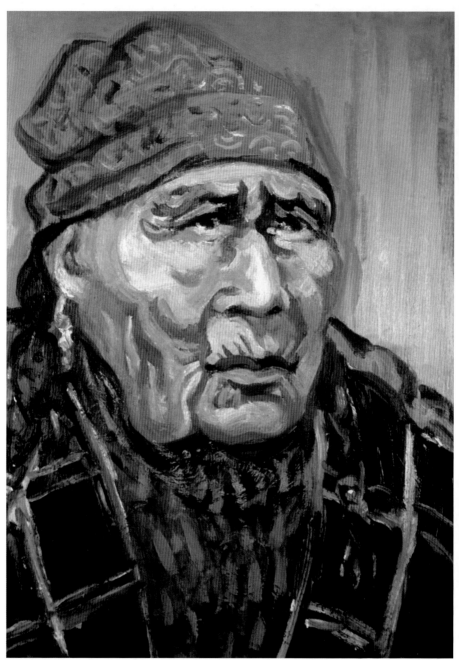

Mary Capilano "Lay-hu-lette," Squamish ▶ *text page 103*

"The Lions," North Vancouver

Trees, Stanley Park

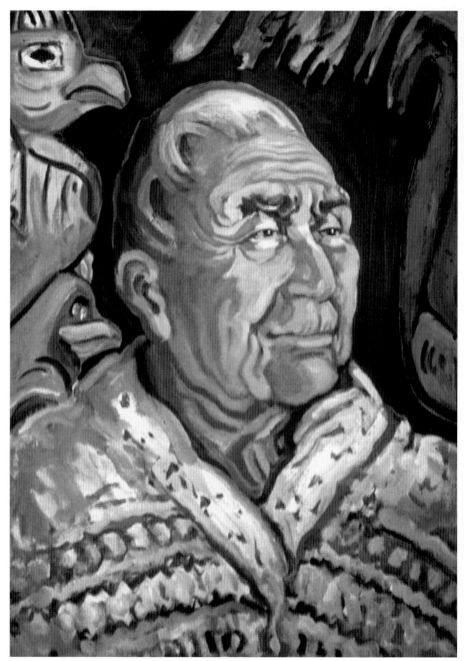

Mathias Joe Capilano Wearing His Cowichan Sweater, Squamish ▶ *text page 109*

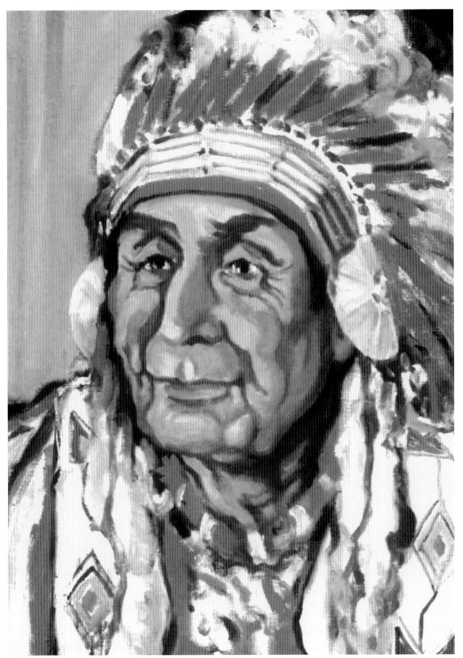

Mathias Joe Capilano Wearing Plains Indian Costume ▸ *text page 109*

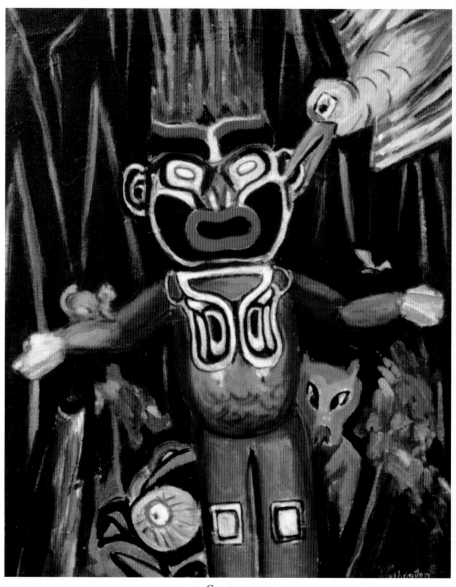

Creatures
[Fantasy painting of D'sonoqua/"Wild Woman"]

Opposite, top: *Cedar Bark Dance, Kwakiutl*

Opposite, bottom: *Longhouse, Squamish*

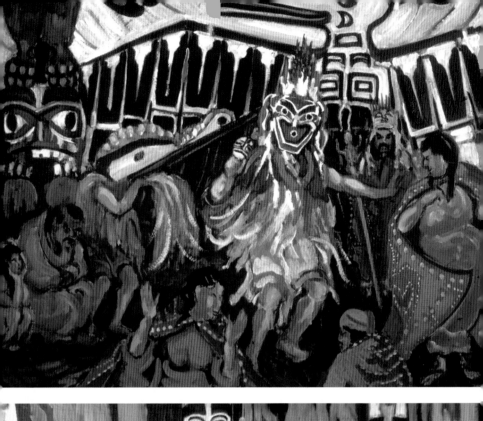

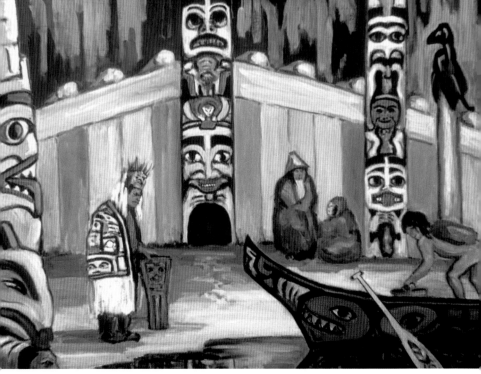

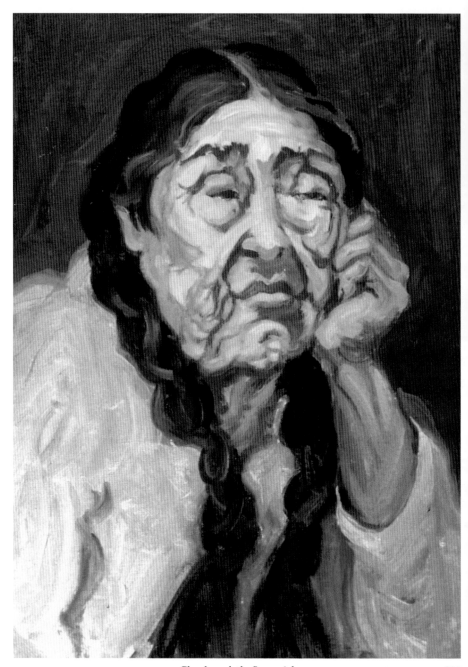

Chuchoweleth, Squamish

▸ *text page 180*

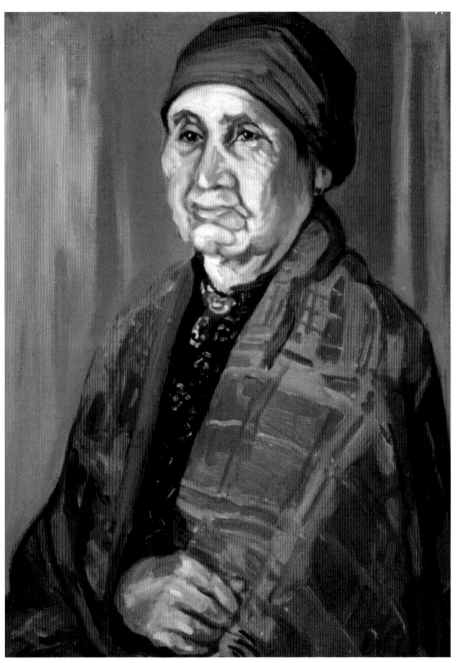

Mary Ann (Mrs. August Jack), Squamish ▸ *text page 124*

Above and below: *Arriving at the Potlatch, Squamish*

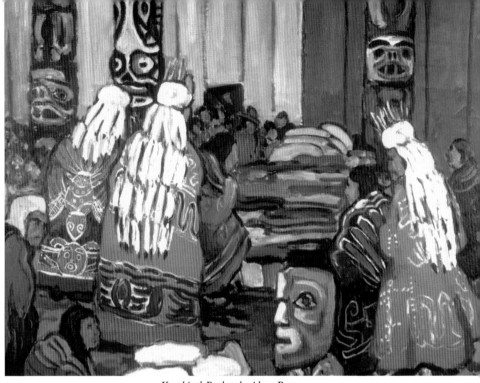

Kwakiutl Potlatch, Alert Bay

Squamish Nation Makes Peace With Comox Tribe

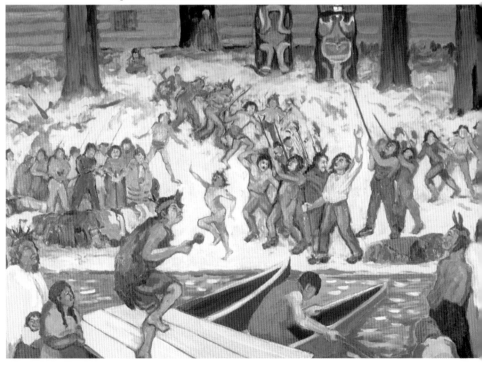

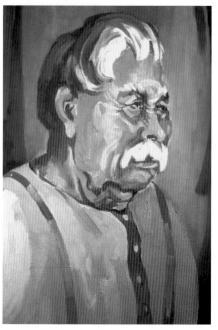

Tommy Pielle, Cowichan ▶ *p. 206*

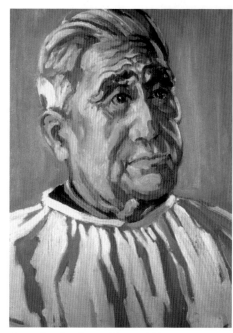

Isaac Jacobs, Squamish ▶ *p. 211*

Madeline, Squamish ▶ *p. 202*

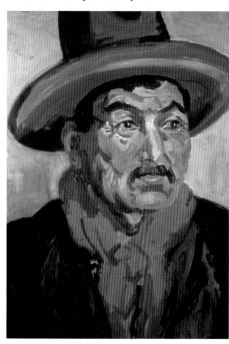

Manuel Louie, Okanagan ▶ *p. 240*

164

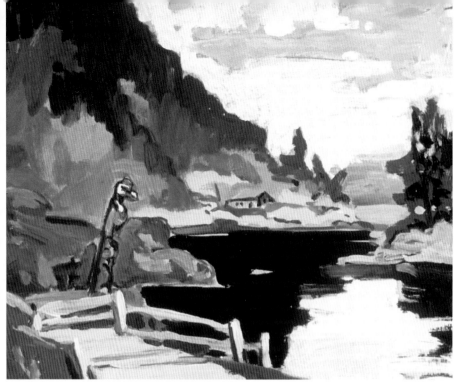

British Columbia Coast ▶ *text page 13*

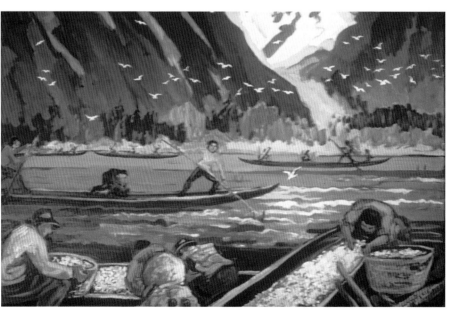

Oolichan Fishing, Bella Coola

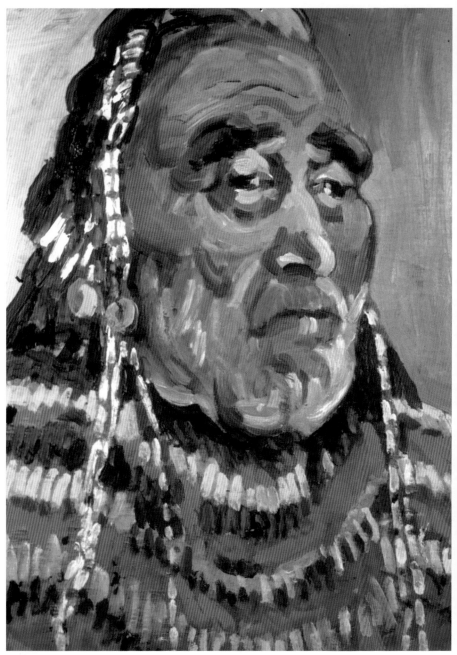

Big William, Chief of Salmon Arm Reserve, Shuswap ▸ *text page 231*

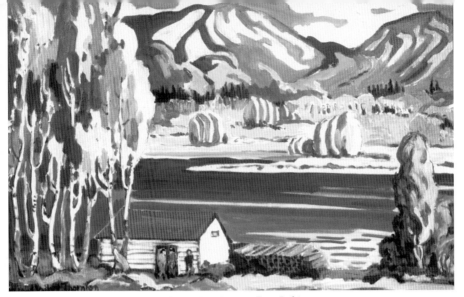

Hudson's Bay House, Fort Babine

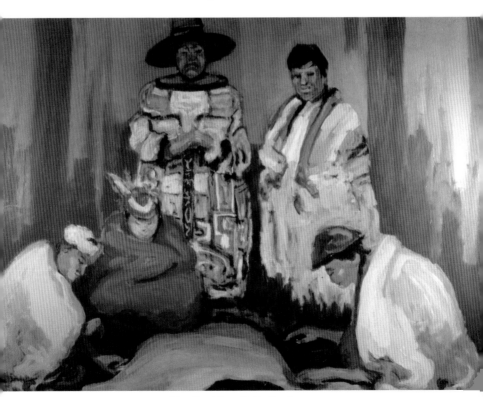

The Gamblers, Bella Coola

167

The Hao Hao Dance of the Bella Coolas

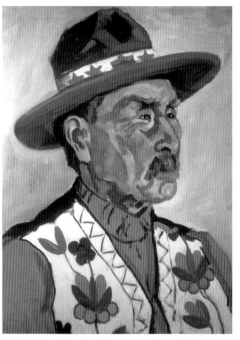

Chief Joseph Louie, Okanagan ▶ *p. 247*

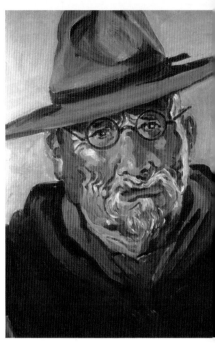

Chief William, Carrier ▶ *p. 272*

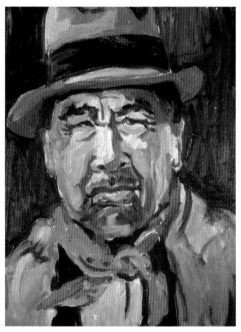

Dominic Jack, Okanagan ▶ *p. 235*

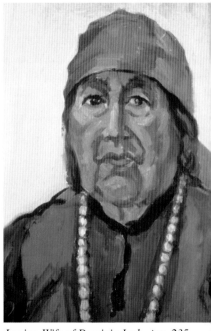

Louise, Wife of Dominic Jack ▶ *p. 235*

170

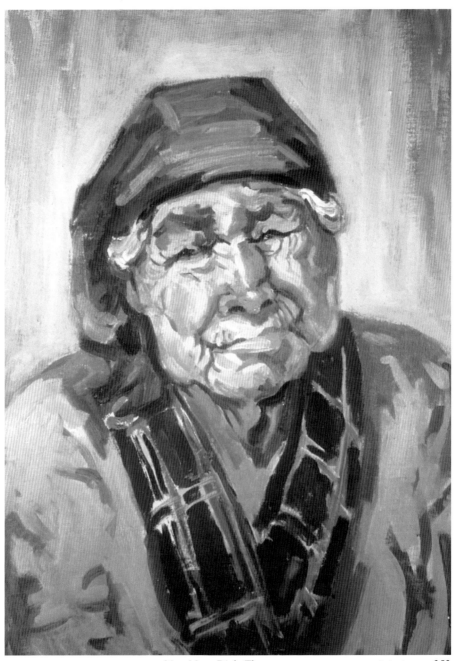

Mrs. Mary Dick, Thompson ▸ *text page 252*

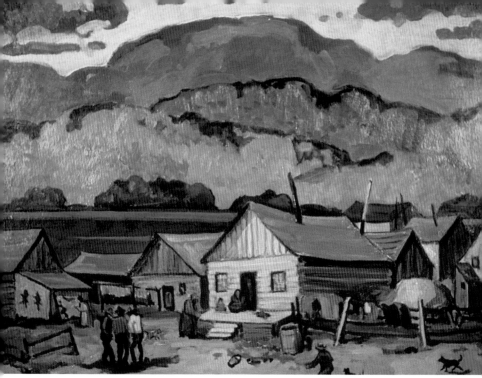

Indian Village Near Fort Babine ▶ *text page 257*

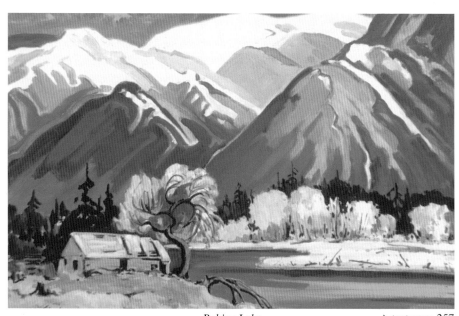

Babine Lake ▶ *text page 257*

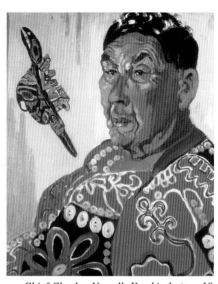

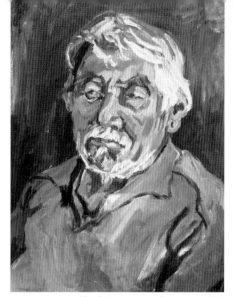

Chief Charley Nowell, Kwakiutl ▶ *p. 18*

Chief Tom, Cowichan ▶ *p. 195*

Haida Totem Carver

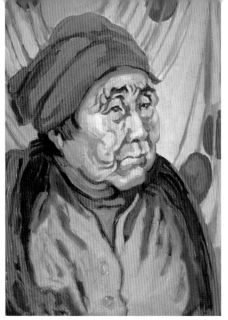

Sarah Gunanoot, Tsimshian ▶ *p. 91*

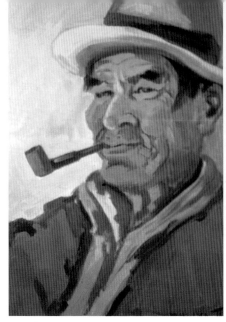

Chief George, Cowichan ▶ *p. 198*

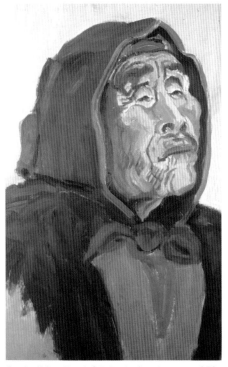

Rosie (Mrs. Daniel Leion), Carrier ▶ *p. 272*

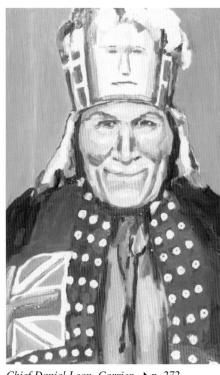

Chief Daniel Leon, Carrier ▶ *p. 272*

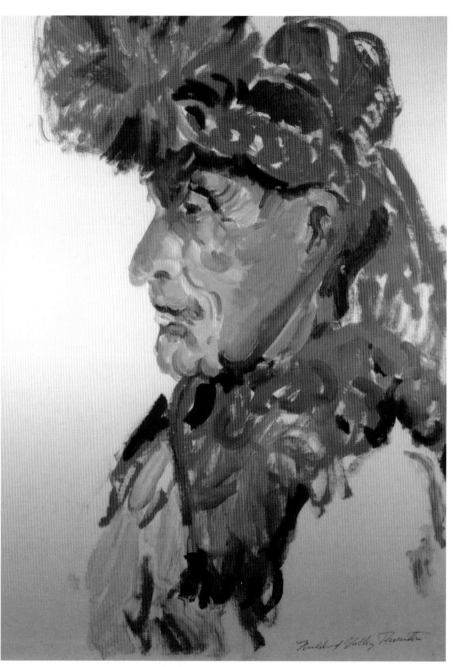

Chief Tommy Paul, Cowichan

175

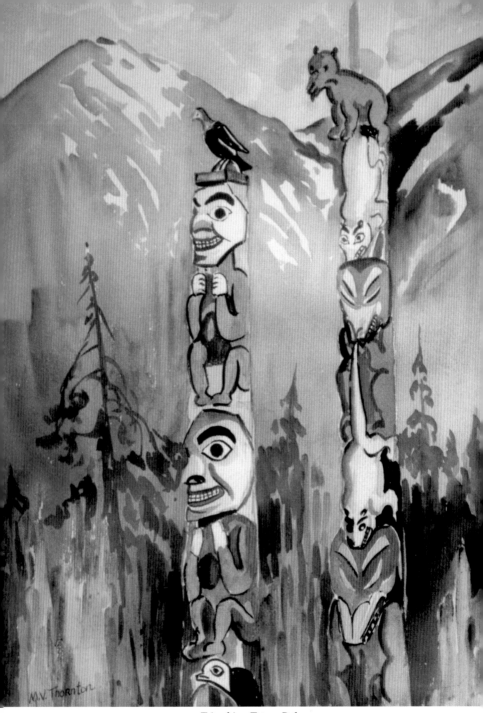

Tsimshian Totem Poles

176

Prophet of the Squamish

In the distant past, so the story goes, there was a Squamish Indian named Chu-schwalton who, after ten years as a novice, had received the great power. He went up into the mountain to hunt goats and, having killed five of them, he prepared the meat and was very tired. It was now night time, so he lay down with his back to the big fire he had built to warm himself. After a while he turned over to warm his face and suddenly he heard a voice saying, "Are you awake?" He answered, "Yes, I am awake." The voice said, "Get up from the fire and kneel down."

The man looked around for the person who was speaking but could see nobody; he could only hear the voice talking. Presently it said again, "Look this way. Look over your fire. See what's there." Chu-schwalton looked where he was commanded and saw a roll of something about three feet long hanging from the branch of a tree. It could have been of bark or hide. He knew not which.

The voice said, "You listen to me. Read everything that is written on the roll three times." And it asked the man, "Do you think you can promise to do that?" The man said he thought he could, so he read the roll through three times and wrote down in his mind everything it said.

All the time he was doing this the little branch kept swaying mysteriously back and forth, but there was no wind and he could see no human hand that moved it. The voice continued talking and teaching Chu-schwalton. It said, "Don't forget one word. Write it all down in your heart and tell it to your people, your good friends of the Squamish. This is the word of God." All about him Chu-schwalton felt the great power as he listened to the voice and he knew it came from someone more than human.

After he received these instructions the man walked sixteen miles across Garibaldi Glacier, over the vast alpine meadows and many lonely trails until he came to the Squamish River, which he swam across. He was now a changed being—purified in body and mind, filled with the great power, with a great mission to fulfil. He went to his own village, Yoo-koots, and called all the people together. He told them to build a longhouse, a vast temple of immense

177

cedars, beautifully fitted together without a nail. They came by canoe and over trails to do his bidding.

When it was all finished, the roll containing the word of God was hung from the great beams of the house. No eyes but Chu-schwalton's had ever beheld the sacred word. The women came in and prayed on their klis-kis cedar mats. The men stripped naked, danced in circles about the house, always keeping their arms in the air.

The prophet pointed to the word of God with his staff and told his people of the coming of the pale face race that had caught the good Cheam, the chief of all chiefs, and killed him. But he had overcome them and gone to heaven above. He said the pale face people would come over the water in big canoes and through the air like mighty birds in strange machines. They would even come under the water like the blackfish.

He taught the people to be men and women of peace, to be good carpenters and carvers, and how to build better houses and fine canoes. He told the women, if they were good when the pale face people came, they would eat fruit which grew in the ground (potatoes) and have large red and green fruit off trees (apples). All the wild fruit would be bigger. He told the men they might have as many wives as they could support, so long as the wives were good providers, making fine blankets and caring for their families.

The prophet lived many years as the spiritual leader of his people until about the time Captain Vancouver came in 1792. When he died, he was buried according to traditional Squamish custom. All the tribes came from many miles around with chiefs wearing the ceremonial robes of their orders. They put Chu-schwalton's body in the death box that had been prepared for it, with knees drawn up to the chin and the hands clasping the precious word of God.

At funerals in the old days there were always professional mourners. Now their sad voices rose in wailing tones as the chieftains walked slowly four times around the grave box. Then they placed it high above the ground in a mighty tree where it would be safe from marauding animals.

August Jack is the traditional "Keeper of the Graves" for the Squamish people. Many of their dead had been laid to rest in Stanley Park before the white men came and here lay the body of his father, Supple Jack, in a small house with a neat little fence

around it. Over the canoe that contained his remains was the chief's blanket and some of his most precious possessions. It had lain there undisturbed for many years.

Because of the danger of disease, the government, long ago, ordered the Indians to bury all their dead under ground so August Jack and his stepfather, Jericho Charley, gathered up the bones of their ancestors in big boxes and transported them by dugout canoe to the Squamish burial ground. Once a year August visits the eighteen burial grounds of his tribe. It takes many weeks to make the rounds and see that everything is in good order.

And once a year it is his very special duty and privilege to visit the grave of the prophet of the Squamish about sixty miles north of Squamish town. He makes the long journey up the river by canoe and on foot, packing food and supplies on his back. Over rocks and logs and lonely weed-grown trails the old man makes his way to the sacred spot where the body of the prophet and the precious roll are lying. The grave is surrounded by a little fence painted in faded colours. The chief is one of only four people in all the world who know where it is.

In reverent silence he parts the bracken and removes the fallen branches. A tiny chipmunk watches him in bright-eyed curiosity. He steps softly on the rich soil and talks to himself in low tones—or maybe it is the prophet to whom he is speaking. When he is through, he stands hatless and with bowed head beside the grave as though before a shrine, then slowly turns away.

No one sees him come and no eye beholds his going, save that of a great eagle soaring majestically above him. No sound echoes his footsteps but the sighing of the wind in the tall cedars that close in behind him as he passes. August claims his ancestors did not come across the Bering Sea as anthropologists like to believe.

"God made them where they are," he says, "and they stay in their own place, make man and female. It's God's work. When they get crowded, they moved out, but it was that way in the beginning."

She Did Not Live
by the Clock

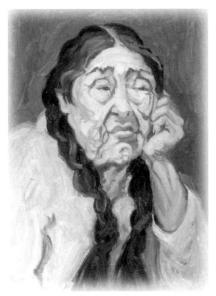

Chuchoweleth

It was August and a lovely afternoon, I thought, for an excursion to the Indian reserve in North Vancouver. Such a warm sunny day! I walked leisurely through the narrow paths, picking wild blackberries as I went along, looking for Old Denny's home.

He was said to be very old and no longer able to walk over to the church, which he could see from his door.

Finally I found the house and Old Denny was in it. He was an odd, humped, furtive little man with a battered hat pulled over one eye. Looking like a frightened animal when I asked to be allowed to paint him, he shielded his face with his arm, saying that he was too old.

I could not persuade him to change his mind, even with the help of a neighbour who came to make sure that he understood what I wished to do. Very disappointed, I started off in search of Dick Isaac

as a second choice. Dick was on the point of leaving for a jaunt into town and no amount of coaxing or persuasion on my part could deflect him from his purpose.

Here was a situation without precedent—turned down twice in one day! Truly my stars were not favourable—or were they? As I walked slowly along in the bright sunshine, pondering what to do, I saw an aged Indian woman sitting on the ground, near her door, with a group of younger people about her.

With the unquenchable fires of hope still burning strongly within me, I strolled over to make their acquaintance. We chatted gaily about the weather and other things of equal import and finally I ventured to say that I would like to paint the old lady.

Promptly she refused my request. I said I would only be a short time doing it but that made no impression when the young folks explained to her. "White people are always longer than they say they will be," was her reply. They had deceived her before. Someone had painted her and had promised to give her the picture. He (or she) had not kept his (or her) word, and she would not be caught again.

Humbled but not dismayed, I lingered on, talking to the others, a man and a woman with their four children. They told me that the old lady was "much over ninety years of age, she might be a hundred." I remarked how well preserved she was and they explained that hers had been an easy life. "She never had any children and she did not live by the clock as white people do."

She ate when she was hungry and at no other time, no matter what the hour. At this juncture she interrupted in her own language which the man interpreted to me. "She says she can remember when she was a little girl all her clothing was either of skin or cedar bark."

She had beautiful hair that hung in two long, thick braids, black and shining, except for a tiny tinge of grey at the temples. I spoke of it in genuine admiration and the man told her what I said. This seemed to have a softening effect, for she said that "when she was young she had the most beautiful hair of any woman in the land and that you could not span her braid with your two hands."

Sensing that I had touched a vulnerable spot, I was quick to follow up the advantage gained. I showed her my watch, pointing out the half hour and then held up some money. Suddenly her resistance broke—she would let me paint the portrait!

Down came the long, black braids, to be carefully combed and

plaited afresh. A child poured water on her hands from a tin cup and she patted the water gently on her hair. She called for one of her woven cedar baskets to be included in the picture.

Speedily I set to work. I was delighted to have my patience rewarded with so splendid a subject. She took a comfortable position and kept perfectly still. Presently she spoke to one of the girls and handed her the basket. The girl interpreted: "She says there will not be time to do the basket." I was grateful for her thoughtfulness, for I could not possibly paint it in the time at my disposal, yet I did not wish to hurt her feelings.

I asked about her Indian name. "Chuchoweleth," she told me. I enquired as to the meaning but all she would say was, "It is an old family name."

As I worked, I could easily visualize the beauty of my sitter in her youth. Even now she had tiny, delicate ears and small, shapely hands. Her mouth was full and round and boasted lovely curves, which belied her advanced age.

I looked at my watch when I had finished and saw that my model had sat exactly forty minutes. I walked over and put the money in her hand, allowing extra for overtime. It was worth many times the amount given to see the look of surprised joy that suffused her face as she realised that I had been perfectly fair with her. She grasped my hand in both of hers and, for the first time, she spoke English, saying "Tanks, tanks, tanks."

Chuchoweleth's husband had been a great chief at Sechelt. When he died his brother, John, succeeded him. Then I discovered that I had already painted Chief John, whose wife was dead. Chuchoweleth had brought up his motherless boy and it was he and his family who had come to take her to Sechelt to live with them.

Much as she loved them, she refused to go. The older Indians are like that. They will not leave their own homes. They have a horror of going to a hospital and wish to die where they have always lived. Chuchoweleth did not want to leave the place where her father and mother were buried.

Several weeks later I was in the locality again and saw a neighbour, Molly John, coming from Chuchoweleth's door. The old lady was confined to her bed and Molly had taken her some hot soup. The young people were away hop picking but would be back in a

day or so. I fervently hoped they would hurry, as I did not like to think of old Chuchoweleth lying there alone and ill.

I saw Molly again a month later and she told me that the grand old Indian woman was no more. As quietly as the sun steals over the horizon, she had closed her eyes and slipped across mortality's borderland to join her husband and others who waited for her there. She had been jolly and bright until the last, Molly told me, and one day, knowing that the end was near, she had said: "I am not afraid to die, I have no fear. I have never in all my life done anything that I knew was wrong."

How many of us could say that?

Denny Liked Salmon

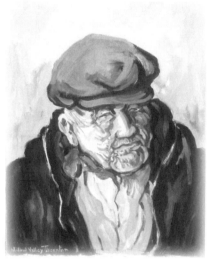

Old Denny

The first time I asked to paint Old Denny he turned me down cold. He looked at me with terror in his eyes and, raising his arm to cover his face, said he was too old.

I tried to tell him it was only the wonderful old people in whom I was interested. But he began poking at a fire that really did not need poking, then turned his back and pottered about over nothing at all—which was a plain invitation for me to go. I went.

Still, I was not quite sure that the old man had understood my request, so I explained my mission to a young fellow whom I met outside. I followed him back into the house while he spoke to Denny in his own language. But Denny had understood well enough and he knew his own mind. He repeated that he was too old and that ended the matter.

This happened some years ago, but I never could quite dismiss the subject from my mind. The priest had told me that Denny had a very interesting history behind him and that he was said to be 116 years old.

Later on, just before Christmas, for some unknown reason, I

suddenly thought of Denny again and decided I would have one more try for a portrait of him. Calling the priest on the phone, I explained matters to him and asked him to use his powers of persuasion on my behalf. He was a young man in whom the Indians placed great trust, and I knew if anyone could convince Denny of my honourable intentions, he could. He promised to try and said: "Call me at twelve Sunday noon and I will tell you what he says."

Promptly on the stroke of twelve, I phoned. "You can paint Old Denny any time you want to now," was the good news.

"I shall be over one day soon," I replied delightedly.

"I would not leave it too long if I were you," advised the priest. "He is very old and ill and he may not be here long."

"When I come, I shall pay him, of course, but I want to bring him something to eat. What do you think he would like?"

"Anything, just anything. He has so little and will be glad of anything you can bring."

"Anything," I ruminated. "Well, I have plenty of that."

Hastily I filled a small suitcase with mincemeat patties, shortcake, some sugar, canned milk, tea, a tin of salmon, pork and beans, an orange—anything I could lay my hands on.

The day was certainly not inviting. Rain was coming down in torrents but, rain or no rain, I was not going to risk losing that portrait. I threw on some wraps, seized my painting equipment and the little suitcase and, by the grace of God, just managed to catch the ferry to North Vancouver.

It was not much fun tramping through the rain with my heavy load going to Denny's home but I pondered on the beneficence of moisture, in this favoured land, and that helped a lot.

Denny had retreated into a tiny room at the front of his house to be warmer and here he ate, slept and lived. It was just large enough to contain a cot, a stove, a table, his trunk and a chair.

I put Denny on the chair and I took the trunk. He was all muffled up with sweaters and coats because he said "his heart was bad" and his circulation poor. He even had his cap on. Come to think of it, I have never seen Denny without his cap. I think he sleeps in it.

Wishing to disturb him as little as possible, I took him as he was and got to work without further ado. Denny's disabilities would not permit him to remain quiet for long. He constantly shifted his posi-

tion and kept peering around the canvas to see how I was getting on, telling me he was cold, so cold.

I captured as much as I could as quickly as I could, then, to get his mind off his misery, I gave him the contents of the suitcase. He was like a little boy on Christmas morning and could hardly wait to begin eating. It was the tin of salmon that thrilled him most. He opened his old hip-roofed trunk and, after rummaging around, to my utter amazement, produced a brand new can opener of the latest vintage. He showed it to me with pride and wondered if we could find someone to manipulate the marvellous contrivance. He had no idea how it worked and thought it would require a strong man to operate it.

I took the gadget from him, fastened it to the can and turned the key. Denny laughed with joy to see the lid come off so easily. Promptly he put the open tin on the stove to heat the salmon. When I was a child, we were taught to empty canned goods immediately or the results would be disastrous but Denny was not taking any advice from me about the salmon. He heated it his own way and, since he survived, I marvel at the perfection of modern canning methods.

He seemed to have so few comforts that I asked him if he smoked. Without answering, he went again to the old trunk which proved to be a repository for all his treasures and from its cavernous depths he extracted a very old, very black pipe. Tenderly he fondled it. He poked and tapped and puffed at it for a while, then looked at me triumphantly. "Yes, she works. The wind goes through her." I made a mental observation that he should have something more substantial than wind to go through her.

When I turned to go, Denny said, rather wistfully, "You come again bye?"

"Yes, Denny," I promised. "I shall come again." I left him happy and busy with the food but I could not forget the lonely old man. I knew that I should not enjoy Christmas festivities in my own home unless Denny had a bit of cheer too.

Soon I hurried back to the reserve, accompanied by a friend who wanted to contribute to Denny's comfort. We had food, tobacco and a hot water bottle. I had been told that Denny hardly ever left his home and fully expected to find him huddling over the stove in his cramped quarters. There was no answer to my knock on the

door, so I went in. A fire was in the stove but there was no sign of Denny. Someone told me that they had seen him making for the town quite early.

Then I guessed what had happened. Denny had the money which I had given him and he was not letting it burn a hole in his pocket. He had taken advantage of the first fine weather to spend it. I left the gifts on the table and went away, glad that I had been able to give him this small pleasure.

A few weeks later I was in the vicinity again and dropped in to see how he fared. He opened the door a crack, looked me over, then remembered. "Oh, you make picture." Then he let me in.

I enquired about his health. "All sick inside," he said, "and cold, so cold, my heart sick."

We were standing in the back of the house where he kept his wood and I noticed an old clock which had been discarded. "Where did the old clock come from Denny?" I asked.

"It's no good," he replied. "It stopped ten years ago when my wife died and never went any more. You can have it. You take the watch home. I'll find the key." He went over to the wall and took down a brass key that had hung there by a bit of ribbon for ten long years.

The clock was dirty from long neglect and I supposed it was quite useless, but I did not want to hurt his feelings so we wrapped it up. Denny was glad to be rid of it and, I think, he also wanted to be rid of me because he handed it to me and said once again, "Take the watch home, my feet's cold."

As I trudged along the road toward the ferry the clock steadily increased in weight and by the time I boarded a street car for home, it was a veritable burden. Every time I moved it gave a chummy little dingle which made the other passengers look around with curiosity but, so far as I was concerned, it was Denny's gift to me and I hung on to it firmly.

Finally, I deposited my burden on my kitchen table and decided to wash it. The more I scrubbed the more interesting the clock became. My family stood around, offering well-meant advice, warning me not to put water on the face, saying that it was made of paper composition and would disintegrate. Determined to know the worst, I went after it with brasso—which was a lucky choice. When I was through with my labours, behold, I had a beautiful old clock, made

as only artist craftsmen knew how to make in Europe many years ago, of polished mahogany and with solid brass works. Moreover, it had chimes. I took it to a man who knows his business, and he cleaned and repaired it so well that it has ticked and chimed merrily ever since in its new home.

Sometimes I wonder if, when Denny's wife died, in the sorrow and confusion, he forgot to wind the clock. Then, noting later that it had stopped, he had concluded that her death had mysteriously something to do with it and it had been discarded all those years. I like the old clock far better than a new one because Denny gave it to me and whenever I am on the reserve I continue to take him things I know he needs in an endeavour to balance my account.

When I next went to the reserve, I enlisted the aid of an Indian friend, Emma Lackett Joe, to talk to Denny in his own language as I wished to have information on his early life and often his English was hard to understand. As usual, I had a parcel for him under my arm. Denny knows now that I am his tried and true friend so he does not hesitate to let me in. He was looking ever so much better and seemed quite bright and cheerful. He sat with his two feet on the top of the stove when Emma began to talk to him, while I stood by with paper and pencil, waiting for any crumbs that might fall.

I was really envious of Emma, the way she could converse with him. It sounded so exciting and I was just a third party, a rank outsider. Occasionally she would repeat what he said in English and I scribbled furiously to record it. As Denny became more reminiscent of the long, distant past, the years seemed to fall away from his shrunken shoulders. Age departed from his face as it grew animated and alight under the magic wand of memory.

He could recall when there was no Vancouver and New Westminster was only a small community. He spoke of Gassy Jack who owned the first hotel in Vancouver and who had married an Indian woman who was still living. The Indians lived on both sides of the inlet then and he had helped Chief Paul Pierre clear the land for the present reserve. He told of Chief Sinnot of New Westminster who had collected money and built the first church for the Indians. Later it was destroyed by fire and replaced with the present structure. The reserve was much larger then but the greed of white men had nipped off parts here and there, bringing it down to the dimensions of today.

He had worked in the mill at Port Moody as a young man, getting fifteen dollars a month for hauling sawdust in a wheelbarrow and dumping it into the inlet. Later he dumped the sawdust in the furnaces to get rid of it.

The Indians tell stories of Denny's wonderful feats of strength. Though he was a small man, he could lick his weight in wildcats. He used to do hand-logging all along the coast—at Powell River, in Jervis Inlet, the North Arm and Squamish.

The afternoon slipped away as Emma plied the old man with questions. Suddenly she burst into a hearty laugh.

"What did he say?" I asked eagerly.

"Oh," she answered, "he said the last time you were here you brought him something to eat."

Which reminded me that I had not delivered my parcel. It was my turn to laugh. "Yes, Denny, and I have not forgotten you this time either," and I proffered the parcel to him.

He put it on the table and, satisfied with his little joke, resumed the conversation, telling many weird and wonderful tales of the long ago. For three hours he sat there, looking down the years, living over again their mystery and magic. Suddenly his eyes fell on the parcel. He brought his story to an abrupt end.

"I talk too much," he said. "It's five o'clock."

He jumped to his feet, made a dive for the can opener and would not say another word. Thoroughly content, I departed, leaving him to his memories and the anticipation of canned salmon.

Tah

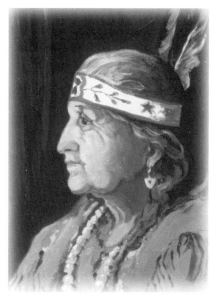

Mrs. George

On the shore of Burrard Inlet lives a gracious Indian woman who was born on the site where the CPR depot now stands in Vancouver. [Today (2000), it is the terminal of the Sea Bus and SkyTrain.] No large city was [located] there in those far off days. Lordly firs and enormous cedars looked down on the scene of primeval grandeur for which there were few equals in all the world. It was very still. No sound but the voices of nature disturbed the silence of the forest. The Indians were the children of nature. Few human feet but theirs trampled on the long grass and the autumn leaves.

A dark-skinned man and his wife had come down from Squamish in their dugout canoe to visit their relations who lived on the waterfront between what is now Granville and Richard Streets. While they were there, an infant daughter was born. The child was to return in later years to live the rest of her days as the wife of Chief George, head of the tribe on Burrard Inlet.

190

These people are usually called the Burrard Indians, but Mrs. George says that Schlawaltuch meaning "no passage" is the proper name. They are a part of the great Salish family but are not amalgamated with the Squamish Indians with whom they have so much in common. They consider themselves an individual group.

Looking back over those early days she reflected that it all seemed like a dream or a story told from a book, so many and so great are the changes that have taken place in her lifetime. She can remember when there were just six houses at the old Hastings Mill, one of which is now a museum. A small [steam] boat, an old side-wheeler, was lord of the inlet. With much curiosity the Indians used to watch it going back and forth. It seemed quite large to them then, but must have been very small by modern standards.

Of course, there were no Indian reserves then. They were surveyed much later. Indians lived without restriction on both sides of the inlet. Mrs. George has vivid memories of the trees, so tall and thick "that there was hardly ever any wind.... No west wind, no south wind, no wind at all," she said.

In her great-grandfather's day, the Schawaltuch were known far and wide as the bravest of warriors. Fierce enemy tribes from the north came frequently in their grotesquely decorated war canoes to raid them.

Just below where the George family lives [today], there used to be an enormous fort which the tribe had built for their protection—and from which to give battle. It covered an immense area of ground and was constructed of whole logs with a palisade of tree trunks staked closely around it. No trace of it remains today.

Mrs. George had thirteen children, ten of whom are living on Number Three Reserve. They are a talented and industrious family, well known as exponents of tribal dances. Though well over eighty years of age, Mrs. George herself can still perform some of these in a manner that would put to shame many of the younger generations. Her grandchildren speak their Native language and devote much time and energy toward preserving their Native culture. All of them have splendid skin costumes, each making his (or her) own. It is said that the young chief is especially expert at this difficult art.

Mrs. George encourages these crafts in her children and takes part in all their activities. This gentle, sweet-faced woman occupies a position of respect and affection in her household that many oth-

ers might envy. It is a delight to hear them calling her Tah, the beautiful Indian word for mother.

One day she appeared at my door. "I come to see my good friend," she told me smilingly. "I have chance to come to town so I come see you."

During our conversation she said she had just finished picking 2,000 pounds of cascara bark in the country surrounding her home. This she had sacked herself and her sons had sold it for her to a firm in Vancouver for well over $200. Not bad for a woman over eighty!

Mrs. George said in the old days men of her tribe never married young. They waited until they were nearly thirty years of age before assuming the responsibilities of home and family. Girls, however, married much younger. There were many men who remained bachelors all their lives. Old Ignatius Honas, who rests in a little cemetery by the roadside, lived to be 150, the Indians say, in single blessedness—a convincing argument in favour of celibacy.

Mrs. George's husband died some years ago and one of his younger sons succeeded him as chief. The selection of a chief is an important matter in all Indian tribes. Among the Schlawaltuch the choice is always made by the old chief who is thought to have divine guidance in this solemn matter. He does not necessarily choose one of his own sons, though it is nearly always someone in the family or a close relative. His sole object is to provide a leader who has the right qualifications. He must be tactful, wise, discreet and have the goodwill of his people.

For many long years the old chief has been watching the actions and listening to the words of those who are eligible. No one knows what is going on inside his mind until, as his life draws to a close, he names his successor. So infallible is his wisdom in this matter that his decision is never questioned and the government, as well as the Indians, always abide by it.

As Mrs. George expressed it: "Dying man can see,"—and he always chooses wisely.

All Indian tribes have fascinating legends that have been handed down from generation to generation. The flood, the fall of man and the creation of the world feature in these as they do in the legends of most peoples in every part of the world.

I asked Mrs. George to tell me something about the thrilling

snake story to which I had often heard the Indians refer. It differs with various tribes but the Schawaltuch version is as follows:

After the flood, when the waters were receding from the earth, they left a gigantic reptile, which the Indians know as Scnoki, suspended like a huge one-span bridge over Burrard Inlet in the vicinity of Belcarra Park where there used to be an Indian midden.

The terrible monster had heads at both ends which were fastened to the rocks. No one dared to come near it because all living things that approached it would curl and twist up and die instantly. People who wished to pass the dreaded spot had to portage their canoes around it at Brighton Beach and Buntzen.

Great was the fear of the people. The abode of the awful creature was a place of evil, to be avoided by all. Even the wild habitues of the forest crept stealthily around it, letting their padded feet fall in the utmost silence. All the birds that flew near there hushed their singing and escaped frantically to safer branches.

When storms rolled over the mountains there were sounds of hideous portent mingled with the howling gale and the fire of the lightning itself was not more deadly than the scorching rays of the reptile's glittering eyes.

Only the gaunt old eagle, soaring at dizzy heights above, dared to gaze upon it and even he flew over with a wild scream as swiftly as his great wings could carry him.

The hearts of people were cold with fear and they longed for deliverance from the accursed monster but none dared to approach it, much less attack it lest, in some vague, mysterious manner, vengeance should be wrought upon them.

A brother and sister lived together near where Belcarra Park now is. The sister was the older of the two and daily she bathed and cared for her little brother until he was big enough to bathe himself. Then he went in [the inlet] to swim alone. Once, while his sister watched him from the shore, he disappeared from sight. Greatly alarmed, she called for help. Men launched their swift canoes to go to his rescue.

Once they caught sight of him swimming far beneath the deep, clear water, but, though they paddled with all their might, they could not catch up with him. When they neared the [future] site of the city of Vancouver, they saw him for a moment, waist-high, above the

waves. Then he disappeared and was seen no more—one more victim of the dreaded Scnoki.

The sister went sadly about her tasks at home but never gave up hope that her brother would one day return. Every night she made his bed in readiness for him and listened for the sound of his footsteps at the door. And so time passed until a whole year had gone by since he sped away beneath the rushing waters of the inlet. Then, one night while all the people slept, he came back and went to bed as though nothing had happened. Great was the joy of his sister to behold him again.

When he arose in the morning, he said he had been all over the world. He had been to many countries and had seen wonderful things. He had come back to kill Scnoki and to deliver the people from its fearful presence.

He went into the woods and made eight spears of pitchwood. Very carefully and very strong he made them. Then he addressed the monster: "Depart from my people forever and take your curse with you," hurling the spears as he spoke.

His hand was steady and his sight was sure. One after another the spears found their mark and, as the eighth went straight to the target, Scnoki relaxed his hold on the rocks, slowly drew his colossal body across the inlet, climbed over the mountains, disappeared into Lake Buntzen and was seen no more.

For the incredulous ones who doubt the truth of this story, the Indians will show the rocks on either side of the inlet which still bear the marks where Scnocki's awful heads were fastened. It is said that on the ground over which his frightful body crawled as it travelled to the lake, no living thing has ever grown. No blade of grass and no moss can thrive there to this day. And that is the story of Scnoki.

Plauswa

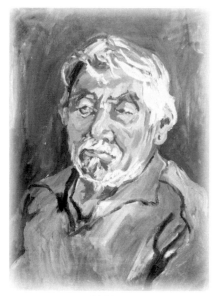

Old Tom

I was looking for Chief Tom at Sechelt when a little Indian girl fell into step beside me and said she would take me to his home. A padlock on the door told us he was away, so we took to the road, enquiring of everyone we met.

"He went down the road toward the store a while ago," said an Indian man. "See that old lame man way down there? That's him."

I wanted to catch him before he disappeared but could not run fast enough with all my equipment, so I said to the little girl, "Run ahead and get him to wait for me. Don't let him go until I catch up. I'll pay you to do it." She was off like a shot and, in a short time, overtook Old Tom and, true to instructions, kept him right there.

He looked at me with a curious expression in his pale, bewildered eyes. I talked to him but I was not at all sure that he knew what I was saying or what I wanted to do. Anyway, he was on his way to the store to buy a file and he had to attend to that first. I was determined not to let the old man slip away on me, so I left my things with the little girl, telling her to wait until I returned.

▶ *colour plate page 173* 195

Strangely enough, little Indian girls seemed to appear suddenly from nowhere, eager to be of service at the sight of a silver coin.

Meanwhile Tom and I departed storewards. I helped him up the steps and into the building. "Where are the files kept?" I asked a busy clerk.

"Over in the corner," she pointed to a shelf.

Taking Tom by the arm, I steered him into a quiet eddy while I began lifting down boxes of files of every shape, price and description. He knew what he wanted and rejected them one by one until he found the exact file he was after. "That's it. That's the one," he smiled. I put the rest back and went with him to the counter and, before he had time to think, I had paid for his purchase.

He stared at me in amazement, his jaws fell open like an old suitcase, then slowly a wide grin spread over his wrinkled face. "Ha, ha, ha," he laughed aloud, then "ha, ha, ha," some more. Nothing like that had ever happened to him before. He kept on laughing while he walked over to a roll of paper on the counter, tore off a strip and carefully wrapped his file in it. Not every day did the old man go to the store to buy a file and certainly not every day did a white woman pay for his purchase, so he wanted everything that was coming to him—even the wrapping paper.

Outdoors again, I dared him to race me to his home and that made him remember his rheumatism. "One leg was all right," he said, "but the other wouldn't work."

As we walked along, we met a young Indian man who could not resist a jibe at Tom's expense. "Hey, Tom," he shouted, "where are you going with the young woman?"

Tom said nothing but glared at him with profound contempt.

I asked the old man about his wife. "Wife die two and a half years ago." He shook his head sadly. "Long, long time; no good for me (meaning it was too bad for him). She ninety when she die."

"And how old are you, Tom?"

"Next coming again I'll be hundred; my children all dead, I am alone."

When we got to his house, he still didn't know what I proposed to do, so I pushed him gently into a chair and began to get my paints ready. When he saw the brushes the light began to dawn. "Oh, you paint 'em like the church."

Only that summer the Indian church had been freshly painted,

so now, at last, Old Tom knew what I was about. While I worked, I asked the old man how he was getting along. His house was "no good," he said. "Too much wind coming in. Some time Indian agent build new house for Indians. War come, no make him house. One, two, three, four, five, six years I think, no make him house. All shut down; no make him house."

I had seen the nice, new little homes which had been built for some of the Indians before the war and had heard of plans for more which were urgently needed but, like so many other projects, the work had been suddenly halted.

"How long have you been chief?" I asked Tom.

"Long time, I think it's eighty years ago my name Chief Tom. Too old now—get release (relief) $4 one month, not very much. Sometimes I think white man gets $20 one month. I have only two eats one day; one month, no good—too much nothing."

Poor old man. He had plenty of just that—nothing. I took the lunch I had prepared for myself and handed it to him. He ate it greedily. "Release, no give like that, thank you, thank you, thank you."

Then he told me of a white woman, staying at Sechelt, who had been good to him. "Good, good woman," he said. "Good woman." He looked up at a cheap coloured print on the wall and, with the simple faith of a little child, he told me, "Good woman go to Jesus bime bye."

He was very much surprised when I paid him for sitting and told me that a man from Vancouver had painted old Teresa and hadn't given her anything. This, I think, is grossly unfair. Old Indian people, as a rule, have so little that compensation should always be made in return for their goodwill. Aged Indians used to be provided with fuel, flour, sugar, tea, etc., by the government in addition to a small cash payment each month. Today they receive the old age pension every month in common with all citizens of Canada. Their needs are few, they have no rent or taxes to pay and no hospital or doctor's bills and, as a consequence, are better off now than many non-Indians in the same category.

Chief George of Sechelt, B.C.

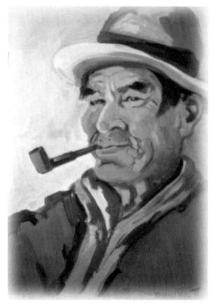

Chief George

It was a long time ago that the patient hands of some dark-skinned craftsman had hewn and wrought and moulded the weird, fantastic figures on the three tall totems overlooking the water at Sechelt, British Columbia. Very grey and weather-beaten they are today, with little pieces of the stout old cedar broken off here and there and the merest hint remaining of the brilliant colours that once had been their glory.

Honoured far above his fellows was the man who carved them. Like the Greeks and the Romans, the Indians esteemed highly the gifts of the creative mind. Only the artists among them were capable of converting into endurable form the precious gifts of their talents. They, alone, were able to preserve the historic continuity of their laws, their religions and their customs. For this reason, art from the B.C. coastal tribes reached a degree of perfection that is unique among the Native peoples of the world and which finds no parallel except among the freedom-loving Maoris of New Zealand.

Very different, in many respects, to all other North American

▶ *colour plate page 174*

Indians are those of the coastal British Columbia tribes. While the Plains Indians and some of the eastern tribes were true democrats in all essential matters, the people on the coast presented as stern a form of autocracy as the world has ever known. Here, wealth and position meant everything and the individual counted for little. They had royalty, commoners and slaves. Class rules were rigidly enforced. Once a slave, always a slave—though the same slave may have boasted noble lineage in the tribe from which he had been captured. In the periodic raids warriors brought back as many captives as they were able to lay hands upon, as legitimate spoils.

The ceremonial robes of a few of high degree, though weird and garish to modern eyes, were very elaborate but the people, as a whole, never had the beautiful costumes of beadwork, feathers and buckskin which are associated with the Plains Indians.

The history of totemism is very complicated and sometimes obscure. The totem pole was similar to a family crest and the symbols on it had great tribal and family significance. Ceremonials of the Indian and his totem were closely related and its influence was seen in wide ramifications.

The strange decorations, which seem so bizarre and ugly, were full of meaning to their creators. These people were not given to adding extraneous ornament without thought and order. Every symbol and form that they used had its place in the design and was an essential part of the idea they wished to convey. Perhaps the full meaning of their symbols is only intelligible to the Indians themselves, though others may have a superficial understanding of their import.

The old arts, together with the old thoughts and the old customs, are rapidly receding before the onslaught of modern life and few, indeed, are the Indians today who have retained even a fragment of the skills which made their fathers famous. Occasionally, however, one may still chance to find a grey-haired man, busy with his knife, carving on a piece of cedar or birch, fashioning small replicas of the majestic and awe-inspiring emblems that revealed the ancient heraldry and traditions of a proud and gifted race. [As previously noted, since this was written Indian artistry has undergone a notable resurrection.]

It was my good fortune, some years ago, to make the acquaintance of just such a man. I was spending a weekend at Sechelt, a

199

place that has been associated with Indians longer than anyone can tell. One sunny afternoon I found my way to the home of Chief George. His house stood on a steep hillside, commanding a fine view of the village and the sea. As I toiled slowly up a precipitous little path I could see the debonair George sitting on the step of his verandah in the midst of a pile of shavings and pieces of wood.

Through an open door I glimpsed a clean, well-swept room, sparsely but comfortably furnished. "Good morning," I ventured cheerfully and, I must add, hopefully. George favoured me with a glance and a grunt and went on carving.

"Very nice work you are doing," I said as I admiringly stroked the slim lines of a little handcarved canoe.

"Yes, good work," he agreed, "nice work."

Though he could not understand much of my language, nor I his, he was quick to sense my approval and I could see that he appreciated my praise. This, I thought, was a good time to present the purpose of my visit. I showed him my paint box and my canvas and, with a swirl or two of my brushes, conveyed to him what I wanted to do. He pondered long and deliberately over the prospect as if seeking an excuse not to leave off his leisurely and pleasant occupation of carving. His granddaughter, with the inevitable baby in her arms, was my interpreter. I urged my cause, explaining that I had made the trip from Vancouver for no other purpose. George continued the heavy process of thinking while his ponderous wife sat by in silent and stolid indifference.

Finally a decision was reached. He said he would pose for me if I, in turn, would buy some of his work. George thought this a most ingenious solution of a ticklish problem but to me, it was a very happy one. I did not mind in the least paying considerably more for the sitting if I could take away some of his handiwork as added treasure.

I selected a small canoe and a couple of bows and arrows. They were beautifully made. No one can contrive these weapons like an Indian, so smooth, so sleek and strong and so skilfully fashioned. Something of the very essence of their own nature seems to go into the object. Not for nothing have generations before them sustained life, protected property and upheld their honour through reliance on the bow and arrow.

Perhaps there are but few Indians today who can make these as

they did of old and fewer still, who can use them with the skill of their forefathers. Our misguided paternalism has robbed them of pride and initiative; the skill and cunning have been wholly lost.

I put George on a chair in the shade of the verandah. For best results I always try to make my subjects as comfortable as possible before starting my work, so George was delighted when I said that I did not want him to part with his trusty pipe and his old slouch hat.

I never painted an Indian who seemed to enjoy the operation as much as Chief George. Perhaps it was the thought of a bargain well driven, for he took it as a lark. Perhaps he was amused at this white woman who would go to so much trouble and expense to immortalize his swarthy features on canvas. At any rate, I had the feeling that he was secretly laughing at me all the time. And not so secretly either, come to think of it, for other Indians seemed to pop up from nowhere to watch the strange and unaccountable proceedings that were afoot on George's verandah.

They stood around me in eager interest, peering over my shoulder and watching every stroke of my brush. Occasionally they would address a remark to George in their own language and then laugh hilariously while George strove vainly to keep a decorous expression—as would befit a chief of a long and proud lineage.

I thoroughly enjoyed the experience for I could not help participating in the merry mood of those around me and I was not surprised, when I looked at my work later, to discover that the genial countenance of Chief George smiled back at me from his portrait with a warmth of suppressed humour which was as genuine as it was delightful.

Not long ago I was talking to someone from Sechelt and I was grieved to learn that George was no more. He had been tinkering with an old car in a closed garage and had been overcome with monoxide poisoning. His deft hands were no longer busy with their carving. They were still for a time. I say "for a time" because I like to think when the Indians lay down their tools to follow the golden trail into the sunset, that a beneficent Providence will see to it that they find, in their celestial habitations, the work they love to do and carry to fulfilment the talents which found expression on earth.

Madeline

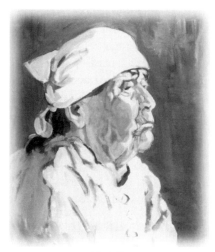

Madeline

It was no easy undertaking to get a portrait of Madeline. She lived at Squamish and only came to Vancouver on her annual peregrinations for berry picking at Steveston. On these occasions she visited her numerous relations in the vicinity.

Some years ago I started making enquiries about her but never managed to catch up with her in her travels. I was informed that she would surely be around at berry picking time next summer. When that season arrived I was away, painting prairie Indians, but on my return I immediately set out to enquire about Madeline.

"Yes, she is here, staying with Emily," was the good news. So next day I took my paints and went to Emily's house [on the reserve]. But Madeline was not there. She had gone to Steveston to pick berries, saying she would not be back until the middle of the month.

Patiently I waited for the fifteenth, which was a Sunday, and arrived at Emily's house bright and early. This good woman is no relation to Madeline. She has a large family of her own and is very lame but she said: "Madeline likes to stay here. She comes when she likes and goes when she likes. She knows there is always room for

her here." That is the Indian way—always room for whoever comes, no matter what the circumstances.

But Madeline had not returned, nor had they heard anything of her. Determined not to leave until I had some satisfaction, I lingered around, talking to the Indians. All of a sudden there was a great commotion and the clatter of a truck. Emily jumped to her feet. "There's Granny now," she exclaimed. "That's the truck bringing them all back from Steveston."

An incredible number of Indians rolled out of that truck, including Madeline, or Granny as Emily called her. She came in with numerous bundles in which were her bedding, clothing, cooking utensils, etc., all of which the Indians take along to go picking. She was very tired, having risen long before daylight, to pick in the cool of the morning. Since she was well over eighty, the early rising and the hot sun had been too much for her and she was "half sick."

Knowing that this was no time to talk about portraits, I suggested that she lie down for a rest and then have a good lunch. Meanwhile I went off and painted an old man I had long wished to do, going back to Emily's at about two o'clock but she said to "come another day."

Monday, Tuesday and Wednesday went by. I concluded that Madeline might be on the mend by Thursday and went back [to the reserve] on that day to find her busy, pottering about, getting ready to go to Sardis. I asked Emily about her and wanted to know how long she had been out of bed and was informed that the two of them, the sick woman and the lame one, had spent all day Monday "over town" answering the call of [pursuing] bargains on "ninety-five cent day." So much for the power of modern advertising.

Madeline kept me in suspense most of that morning before I could persuade her to pose for me.

"She's as stubborn as a mule," whispered Emily in my ear.

"That's no lie," I whispered back.

When Madeline finally came around to the point where she would consider the matter, she wanted plenty for the favour. I did not mind that so long as I had the wherewithal and when I left triumphantly for home, some time later, my purse was empty but I had a good sketch of Madeline's determined features to compensate for my depleted exchequer.

And why was it so important that I should paint Madeline?

Ever so long ago she had been the wife of John Deighton, then known as Gassy Jack and one of Vancouver's most colourful pioneers. He owned one of the first three shacks to be built on the waterfront. The City Archives record the arrival (by canoe) of this unique character at Stamp's Mill, where he landed to build an inn. He had been a Fraser River steamboat pilot and, the story runs: "It was in 1867 that he arrived at his destination in the afternoon of the last day of September, in the drizzle, with his Indian housemaid, her mother, her niece (who was the motive power of the canoe), a yellow dog, two chickens and a barrel of whisky."

Lookers-on remarked that he was a doubtful acquisition to the community. Their apprehensions were without foundation, however, for Deighton set about with a will and great industry to establish himself. It was not very long before the inn was completed. Very soon it became the centre of community life.

John Deighton was an amiable fellow, full of good cheer and never lacking for words. Because he talked so much they called him Gassy Jack, from which sobriquet Vancouver got its first name, Gastown. Indians today refer to Madeline as the widow of the city's first mayor.

Gassy Jack is said to have been an astute business man, fairly well educated and a thoroughly good citizen. When his wife died, he married her niece, Madeline, the subject of my sketch. A little son was born to them, whom they both idolized.

Though she was very young at the time, Madeline was a woman of strong convictions. In those early days the inn was the scene of much carousing and drunkenness. Probably from noting its disastrous effect on her own race, she grew to loathe the very smell of whisky and all intoxicants. Her loathing grew to be an obsession until finally she decided she could endure living in such an atmosphere no longer.

"I'm going away," she told Gassy Jack, "going where there is no whisky. I am going back to my own people."

The doughty old pioneer must have had a magnanimous heart and a genuine affection for Madeline, for, old-timers tell, that when he saw she was firm in her decision, he did not try to restrain her nor did he harbour any resentment whatsoever. Not only did he grant [her] the freedom she desired, but he also furnished her with a paper

bearing his guarantee to pay for any expenses she might incur as long as she lived.

Madeline took her precious papers and went her way, no doubt with some misgivings in view of so much generosity. Gassy Jack was a wealthy man in those days and completely able to fulfil any commitments he might make.

The years went by and Madeline, still young, was wooed and won by a Squamish Indian. When they were married she proudly showed him the legal proof of Gassy Jack's devotion but it did not have the effect she had anticipated. Thinking it a reflection on his ability to provide for her, he seized the offending paper and tore it into shreds before her horrified eyes.

Dark days followed. From a life of comfort at the inn she found herself thrust into toil, want and hardship. Her Indian spouse died, leaving her to bring up their son alone. Brooding over the past, Madeline grew introspective, shunning contacts with white people who might know her history. Half-breeds she thoroughly scorned. She would live as the Indians do.

Many years have gone by since Gassy Jack passed from the scene of his labours. Tall buildings and the busy streets of a great metropolis occupy the site of his one-time property in the heart of Vancouver today. All his wealth went to his own people. There was none to care for the fate of Madeline, the Indian woman who could not endure the evils of whisky.

Kuper Island Interlude

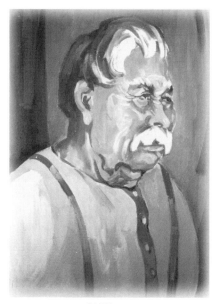

Old Tommy

Tommy was fat, good natured and full of memories. Peacefully, he dreamed, sitting there in his doorway, looking over the brow of the hill. Down below were the old houses where his kinsmen had sung, danced and bartered, according to their custom, on countless occasions in the fast retreating years.

From his home on Kuper Island, Old Tommy could see far out across the Gulf of Georgia to the beautiful islands that lay, like giant emeralds, on the scintillating sapphire of the sea. Valdez, Galiano, Gabriola—musical, romantic names that echo tales of Spanish adventurers and bold buccaneers who had been the first white men to sail among these secluded waters.

Tommy had been born on Kuper Island and there he had lived for close to a century. There he would die and go to that strange, mysterious land that is just one grand, unending potlatch for old Indians such as he.

Only Tommy, his wife and Old Mary remained of the genera-

tion that had witnessed the birth of the new order—and they were living on borrowed time. That did not worry Tommy. Life was a joke to him and he was just one great, rosy, rotund conglomeration of joviality. All seasons, things, people and conditions provoked his merriment.

Tommy's hair was heavy and white and he boasted that unusual adornment among Indians—an impressive mustache. It was white, too, and hung in a provocative bow over his loquacious mouth.

When I asked if I might paint his portrait he thought it was a photograph I wanted and, for once, he forgot to smile as he gazed in childlike wonderment at my paints and brushes. Like a true coastal Indian, Tommy had always suspected his own importance—now he was sure of it since an artist wished to perpetuate his features for posterity. He was clad only in his trousers and undershirt so asked if I would like him to "dress up."

"No, Tommy, just sit there and talk. That is all you need to do. I'll see to the rest."

This procedure exactly suited him. It was painless and comfortable—and cost no effort.

The principal of the nearby Indian school had accompanied me to the village, so he and Tommy settled down to conversation while I set to work to paint and listen. Father Camerund asked Tommy if he had once been a chief and then the flood gates opened.

"Not quite chief, Fadder," said Tommy, loath to confess his position on the social scale, "but Tommy just like chief; an under-chief and first councillor too."

Tommy's wife sat by, busily knitting a Cowichan sweater for which these Indians are famous. Her name was Mary but Tommy always referred to her as "him." In speaking of himself he rarely said I; he was Tommy. When he grew too garrulous, the old lady would break in and check him in their own tongue—but in a moment he would be off again. "Him smart woman, got lots of sense," he told us with connubial pride.

He wanted to make sure that if anything happened to him that his wife would inherit his possessions and he took this opportunity to make the priest responsible. The genial old face became very solemn as he spoke to Father Camerund.

"Some day Tommy die. All this," indicating with a sweep of his

hand the house and its contents, "belongs to him—all table, all chair, all blankets, all, all for him. You not let anybody take when old Tommy gone. All for him." Father Camerund nodded his head with understanding and the old man was satisfied.

The priest lit a cigarette and offered one to Tommy. "No, Fadder, Tommy not smoke no more; burn him belly, so Tommy no more smoke, Sometimes I smell—somebody walk by and smell but Tommy not smoke."

"Did you ever go to Vancouver in the old days?" I asked.

"Yes, yes," he replied with laughter. "When I'm skookum young man I go Vancouver. One whisky house there, two sawmills, one store Vancouver," and he laughed again uproariously at the memory. "All Indians work in sawmill, no white man work in sawmill. Stingy, stingy Vancouver people—all eat not give me any—all Vancouver people stingy," he said with conviction.

"I go Vancouver in my own boat. I row him like this," and Tommy held the (imaginary) oars again as he swayed about on his rickety chair. Then he continued: "Westminster little, little place long time ago. Lots of fish in Fraser—but Vancouver people awful stingy," he repeated sorrowfully.

I asked him about the old days.

"Tommy was rich man, very, very rich man—lots of blankets. One chief he make potlatch with 300 and 300 blankets. Ho, ho, ho, I say. I do more. I'm skookum big man, lots strong, plenty rich. Ho, ho, I tell 'em I make more big potlatch than you, you feel foolish.

"Lots of money I get, $900 and 600 blankets. People all come, all over, Cape Mudge, Nanaimo, Lummi, Musqueam, Songhees, I tell 'em all come. Tommy give one big, big potlatch. Lots of people come to Tommy's potlatch."

"What year did you give your last potlatch?" I enquired.

The old man pondered heavily for a moment then rose and waddled over to a calendar on the wall. He sat down with it and ran his fingers intently along the numbers. I wondered what he was looking for. Finally he looked up triumphantly. He had been searching for the year 1944. Once he made sure of that he counted back and said he had given his last potlatch in 1907!

He counted his age on his fingers. "Tommy getting old. Tommy old man now," and he laughed at that, too.

Watching the old lady knitting steered the conversation around

to the subject of sheep. "Did you ever keep sheep, Tommy, so your wife could use the wool?"

"Yes, one time Tommy have one sheep and she get four children then I have five sheep. I think I kill one for eat—but Tommy can't kill sheep. Another Indian man come—Tommy give him the knife and make sign of the cross but Tommy not look. Tommy not like to kill sheep."

A small fox terrier was running briskly about the place. The old man picked it up tenderly. "Little, little dog," he crooned, "never get full, eat all day," and Tommy laughed until the tears ran down his cheeks. "Belly all hard, eat all day," he reiterated between chortles.

Tommy was a good carpenter. He had built a neat little fence around the tribal graveyard and, because he had hung the bell in the tower of the Indian church, he had ever afterward felt responsible for it. No one else was permitted to ring it. That was Tommy's very special and sacred duty.

"Tommy Christian now—Tommy ring bell. Tommy not dance any more, no want dance now—Tommy not tell lie." Nevertheless, in the old days, he had built one of the great dance houses on the beach where the Indians still hold their tribal dances every winter.

Very exhausting affairs they must be, lasting over a period of several months. Each evening they begin as early as seven o'clock and last until five-thirty the next morning. Night after night old Indian songs float out on the still air as the Indians carry on with their ancient ceremonies.

A few years ago Tommy gathered driftwood from the beach and built himself a little shack flush against his old potlatch house. It had one window and a door and it looked like an overgrown chicken coop, made from all manner of boards in odd shapes and sizes, overlapping each other. It contained a bed, a stove, a decrepit rocker, a tipsy table and one dilapidated chair. This was his summer residence and here he and his old wife went for prolonged and leisurely vacations—just a stone's throw from his permanent quarters.

One day the priest was passing and saw Tommy go down to the beach, scoop up a pail of water, then slosh it across the floor of his little shack. "Good for you, Tommy," he commended. "You keep the floor nice and clean."

"No," said Tommy, laughing until his plump sides shook, "just wash fleas out."

True to the instincts of his race, Tommy loved possessions. Indians of the Pacific Northwest coast placed a value on all things. The more possessions a man had, the more important he was in the tribe. Wealth and position meant everything and there was never ending struggle to outdo one another in lavish display. Blankets had been currency here just as furs and wampum were in other regions. I sensed that there were things of interest behind the closed door of the next room and asked if they had any blankets now. Tommy hobbled over to the door and went in. At one end of the room was a rusty iron bed on which he and his old wife sat like a couple of delighted children, gloating over their treasures. On the floor opposite, piled halfway to the ceiling, was their precious hoard of possessions.

Out in the kitchen stood a little buffet, which they had bought at an auction at Chemainus. I had noticed that its shelves were absolutely bare—nary a cup or a plate adorned them. Here, on the floor, however, were dishes enough for a dozen cupboards. Pots, pans, kettles, tools and knickknacks were stacked in one enormous heap on the floor. Crowning everything were several blankets and some beautiful baskets for which the Squamish Indians are famous.

Tommy and his wife fingered the baskets lovingly. Kuper Island folk did not make many baskets—they were weavers and spinners who made the unique Cowichan sweaters, much in demand by tourists.

The old couple paid as much as thirty dollars to Sechelt Indians for one of their baskets. Of course they never used it—but it was theirs, they owned it and it represented wealth to them. They glowed with visible pride every time they looked at it and to touch it was unadulterated bliss.

Few Indians of Tommy's generation are left. They are remnants of a romantic period in the history of this country—which is all but over now.

Isaac and Lizzie Jacobs

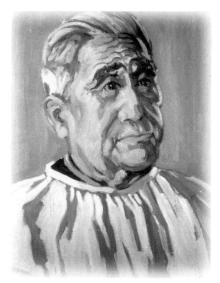

Isaac Jacobs

Isaac Jacobs' Indian name is Ta-chel-kha-new, which means "one who is highly respected by the people." He lives at Swi-ya-wee in West Vancouver and he is a direct descendant of Paytsmaug, one of the highest ranking Squamish chiefs.

"We came from the highest class," Isaac told me. "Our people were not allowed to marry those of a lower class. My great-great-grandfather, Paytsmaug, was like a king among the Indians. He was a very wise man and all the people obeyed him like they would a king."

Isaac must have inherited some of his famous ancestor's independence of mind, for it was he who dared to break away from the local church and build his own church in his own back yard. He is a builder by nature, having constructed his home on the reserve.

Many times at daybreak his white neighbours would be wakened from their slumbers by the sound of hammer and saw as the industrious Indian laid plank by plank and beam by beam for the unique little sanctuary.

Isaac earned the money that paid for the lumber. Often he was

held up for lack of supplies, but as soon as funds would permit, he went ahead again. Even now [circa 1943] there are a few things he would like to add but all the essentials are there and the building has been in use for several years.

This is a most unorthodox church in a bleakly orthodox world. It is conducted with the most delightful informality. If enough people turn up, services are held. If no one appears on a Sunday morning, Mr. Jacobs, who is an ordained minister of the Indian Shaker Church, gets an extra forty winks.

Frequently though, in such an event, he and his faithful wife, Lizzie, go over and have church together—just the two of them. Sometimes, in very bad weather, the little church is silent for weeks. Then, quite without warning, a whole contingent of brother followers may come over from Vancouver Island or from the United States for a weekend. When this occurs, they bring extra food and the Jacobs' comfortable home is turned into an improvised hotel. All the beds are in use, mattresses are laid on the floor and, if there is an overflow, shake downs are placed on the church floor.

That is the way it used to be before Isaac earned enough money to put up an additional building that contains a big range, long tables and extra beds. Now he can make his guests comfortable without disturbing the church. The new building is also used for banquets and special ceremonies from time to time. For years Mrs. Jacobs has saved all her spare pennies to buy cups and saucers. They are all brought out on these occasions. The teamwork between her husband and herself is inspiring. She always refers to him as Mr. Jacobs.

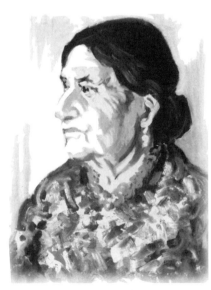

Lizzie Jacobs

"I help Mr. Jacobs in all his work," she said. "I cook food and care for the people when they come. We work together and do all we can, for it is God's work."

One Sunday afternoon

several years ago I heard slow, steady and determined feet ascending my front steps. It was Isaac and Lizzie coming to pay me a friendly call. They wanted to see some of my Indian paintings. I had painted both of them in their home and also many other Indians whom they knew.

First we had tea and cake. All Indians like tea and Isaac and Lizzie were no exceptions. Then they enjoyed looking at the portraits. Isaac looked around and commented, "You have a lot of nice frames too."

"Oh yes, they just accumulate through the years," I replied.

He pondered deeply on a picture hanging over my desk. "I have a frame at home pretty much like that," he observed. There was a moment of silence and he continued as if talking to himself: "Wouldn't it be nice if I had a Jesus picture for my frame to hang in my church behind the altar?"

That was all he said as he gazed at the frame with his big solemn brown eyes, tender in contemplation of a dream that lay close to his heart. No spoken request but I knew, well enough, what he was thinking and quickly changed the subject.

I did not forget about it, however. The matter kept recurring in my mind; it bothered me and finally I decided I had better go and find out just what it was that Isaac had in mind.

He brought out the frame with some pride. It had certainly seen better days but he took it to the church and showed me just where he would like to see a picture of Jesus hanging behind the altar. As soon as he had money enough he would put in electricity and have a light shining full upon it from above so that it would be a focal point for all to see.

"Oh," he said earnestly, "all the people would sure like to see a picture of Jesus hanging there." There was no doubt as to what he wanted.

"Isaac," I said, "I have never painted a picture like that in my life and I won't promise you anything but I will see what I can do. If you were a white man and asked me to do this it would cost you a lot of money, but we shall see."

When I got home, I found I had a better frame than Isaac's of the right size, and a canvas to fit it. I gave the frame a fresh coat of paint and got busy on the painting. How should I paint the Master of Galilee to fulfil the dreams of this humble and sincere Indian? I

213

thought of the many fine paintings that had been done in the past and felt unworthy even to make the attempt. But Isaac had faith in me. He was expecting me to produce a Jesus picture. There was no alternative. I must paint something, so I began.

Gradually the painting evolved, the head, in profile, with a strong light coming down from above, as Isaac had visualized it. To my surprise it turned out better than I had expected and I finished it in time [for it] to be hung in the church for the Easter services.

All this was several years ago and the Jesus picture still hangs in Isaac's little church. He has the electricity in now, and it looks exactly the way he had hoped it would. Isaac's joy in having the painting more than compensated me for all my work but he insisted on presenting me with a piece of his own carving to show his appreciation. "I have your work," he said, "now you have some of mine."

The Indian Shaker Church

Mr. Jacobs told me of the founding of the original Shaker Church by the Indians of Washington State, over sixty years ago.

There was a young Indian man, John Slocum by name, who had great power and influence among his people. He was very clever and so popular that the medicine men were extremely jealous of him and decided to put him to death. In some mysterious manner they carried out their evil design and the grief of the people was overwhelming when they heard that John Slocum was dead.

The traditional weeping and wailing over the body took place, continuing for several days. Then some of those who watched noticed that the legs of the corpse were moving and also the hands. To their utter horror and consternation the dead man slowly sat up and looked around with an odd dazed sort of expression on his face. Presently he spoke to the few who had not taken to their heels in stark terror at the amazing phenomenon.

He told them not to be afraid of him but to come near and hear what he had to say. One by one they crept closer, in wonderment and awe, to receive his message. God had brought him back to life, he said, that he might give a new religion to the Indians. He was being given four years of added life to establish it among them.

He called the people together to help him build a church where they might worship according to the divine command. Many were filled with a new sense of power and exaltation. They worked with so much zeal and industry that, in exactly four days, the building was ready for their use.

When the people gathered together for the first service in the church, it was so filled with the power of the Holy Spirit that everything shook with the vibrations. The building itself trembled as with the impact of a mighty wind and all the people were shaking. The altar and the seats were moving and the windows rattled in their new casings. Some of the people ran out of the church in terror, thinking it would collapse about their ears, but most of them recognised the cause of the vibrations and remained undisturbed. It was from this occurrence that the sect received its name, "the Indian Shaker church."

One of the strongest claims of the new church was its ministry of healing. No sickness and no offence was too great for the redemptive power of God to those who believed. Old people tell of many who were carried [infirm] into the services and others who came on crutches and [all] went away whole, even as people did when the Master Healer of all time was upon the earth. To this day many wonderful tales circulate among the Indians of what transpired. Mrs. Jacobs says that when the medicine men killed John Slocum they had broken his neck and he showed the people where Jesus, himself, had made it whole again.

John Slocum carried on his unique ministry for exactly four years, as he had predicted, then, quietly and painlessly, departed from this earth with his mission fulfilled and his work accomplished. Other hands took up the charge and the church has flourished with undiminished fervour to this day. Not all the Indians subscribe to it, by any means, but those who do are sincerely consecrated to the cause.

Isaac Jacobs told me of a beautiful song that had been given to one of the followers. "This man was in the church and suddenly he came under the power of the Spirit. He rose in the congregation and told the people: 'My soul has gone over into the next world. I have the power to call my soul back if I want to stay on earth. God has given me that power. I don't want to stay, so I am going to follow my soul. But Jesus Christ, himself, has given me the words of a song which I am to leave to you.'

"He wrote down the words of the song and gave them to the people. Then he just sat down quietly, laid his head upon the table and passed away, just like that—no pain, no sorrow."

There are a great many members of the Indian Shaker Church on Vancouver Island. Peter Joe was appointed the first bishop there. When he died his nephew, Bert Underwood, was elected to succeed him and is the present bishop [circa 1943].

The church members in British Columbia and those of the neighbouring state of Washington fraternize to an unusual degree, for the Indians recognise no international borderlines of the spirit.

The Indian Shaker Church undoubtedly fills a need for self-expression. It appears to offer, also, a satisfactory alternative for those complicated, mystical rites and ceremonies with which the early religious beliefs of these people were associated.

Writing on the subject for the Smithsonian Institution, T. T. Waterton says: "No Shaker will swear, no Shaker will drink. The one virtue of non-indulgence in alcohol has served to make the members of the Shaker Church the most prosperous of Indians. Outwardly their homes are clean and cheerful and inwardly they are filled with a kindly feeling which cannot be mistaken, for it actually radiates from their faces. It makes them, to my way of thinking, more closely resemble the Christian of our ideals than is the case with any people I have ever seen, Indian, white or otherwise."

A Wise Father

Like so many of the Native people who revered their ancestors, Isaac had the greatest respect for his father and treasured all his wise sayings in his memory. On one occasion he said, "There was a great thing my father told me—a great thing that happened on the Chekamus Reserve near Squamish.

"A young man lived there who used to swim in the river every day to keep clean and in good condition. One morning when he was in the water he saw something moving in the bushes and he heard a strange sound so he looked to find out what it was. He saw something that looked like a big, white rock and the sound seemed to come from that. He hit it with a stick and the rock split wide open. It was hollow inside and in it was a little Indian baby.

"The young man picked the baby up and took it to his home. He was just a young man—got no wife. He lived alone and there was no one to look after the baby. He was away for days at a time, hunting, and there would be no one to care for the baby in his absence.

"The young man puzzled his brains for a long time and then he thought he would give the baby to the animals to raise. Indians had a great respect for animals and knew that some of them had supernatural powers. Animals are the friends of the Indians. He was sure they would take care of the baby.

"There were lots of animals around, among the rocks, and wolves among them. The young man came to think maybe they can raise this baby better than he can. He knew where the home of the wolves was, so he took the child in his arms and carried it to them. Very gently and carefully he laid the baby at the door of the wolves' home, then hid in the bushes nearby to see what they would do.

"Presently a big wolf came out and saw the baby. He was very curious about the strange creature. He went over and smelled it and touched it with his paw. Then he went inside his home. Lots of other wolves were in there and he told them what was at the door, so they all came out to see. The man kept perfectly still and watched to see if they would kill the baby, for wolves are very fierce animals, but they carefully took the infant inside their house. There they kept it and cared for it.

"Every once in a while the man would steal back and peer

through the bushes to see how the baby was getting along. The wolves would bring it out into the sunshine on nice, warm days and the child would kick and squeal with glee.

"After a few months time, when the man went to look, he saw the baby creeping out of the wolves' den and playing with the cubs as though they were children. Then, later, he could see that it was walking. The man kept going back to watch and he grew to love the little child and wished he could get it back again. He wondered and wondered how he could do this, for the wolf is a terribly fierce animal and would surely pounce upon him if he went near the child. Even if he could not see any of them about, he knew they were watching devotedly at all times.

"One day, as he watched the child, all the wolves suddenly went inside [the den] for some reason. The man ran quickly, grabbed the little fellow, and ran as fast as he could to the river where he had hidden his canoe. He jumped in and reached for his paddle. The river was very swift just there and soon he was quite a distance from the land.

"When the watchman of the wolves came out [of the den] and found the child missing he uttered a wild scream of alarm. All the wolves rushed out and cried pitifully when they saw what had happened. They looked all around every rock and tree but could find no trace of the baby. In their sorrow they all started howling and the sound was terrible to hear. But wolves are clever animals and, after a while, they discovered where the man's house was. They would go in a pack and howl all the night through, calling to the little boy to come back to them.

"Years went by and the little boy grew up to be a man. He married and had a large family and was a famous leader of his people. That is why the Chekamus people adopted the wolf as their crest because he is a clever and powerful animal and because the wolves had cared for one of their great ancestors."

Isaac's father gave him a place at Squamish and said to him, "I am going to leave you, my son, but don't worry; you got big land and house—it's all yours. I want you to go to Capilano. There is going to be a church there and you are going to look after it. You are going to be a leader of your people."

His father had planned to give a big potlatch to bestow his most honoured ancestral name upon his son but he died before he could

do this. Later Isaac took the name Ta-chel-kha-new because all the people knew his father had wanted him to have the name. "My father could see things a long way off," explained Isaac. "He knew what was going to happen. He knew when he was going to die and sent for me to come, so I hired a boat and went to Squamish.

"For nine days and nights my father had been sitting in his house with no clothes on—he wouldn't cover himself and he said, 'I'll tell you when I am finished.' He feels bad, can't eat, but says 'I'm all right. I will tell you when I am going.'

"Towards morning, about four o'clock, we got up early and my wife and I prayed for him. She said, 'O God, you're the boss. Whatever you do is the right thing.' My father said, 'That's what I want to hear. We are all facing God.'

"He tells my wife, 'Get my hat and my coat and my cane. I am going now. All the children (angels) are coming to meet me.' He got up, dressed himself and immediately passed away."

Jim Pollard

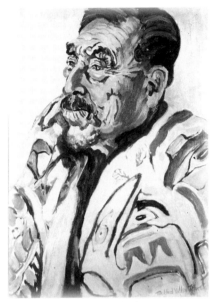

Jim Pollard

Jim Pollard had been a giant of a man—a giant in physique to begin with, and a giant in intellect as well.

I sometimes wonder what might have happened had Jim been born where his talents could have found full expression in the political arena of a great nation. Of one thing I am certain, he would have made his way to the top, regardless of where fate had cast his lot, for he was of the stuff of which leaders are made.

Among the Indian tribes of the Pacific Coast, where wealth and position meant everything and personal enterprise could achieve great objectives, a man with Jim's accomplishments was bound to move to the front. In addition to his shrewd mind and determined will he was not encumbered with too many scruples—those annoying little nettles of conscience which harass the soul and cramp the style of many sensitive folk. His code was simple and effective—"the end always justifies the means."

At Kimsquit, where Jim spent the early part of his life, he had

not belonged to the nobility but through sheer force of character he had raised himself to chiefhood and wore his honours with becoming pride and dignity.

Not everyone acknowledged his position or approved his methods but no one had the courage to argue with him or question his dealings. It was easier, and much wiser, to adopt a policy of noninterference than to protest and wake up one fine morning minus your head.

Such things had happened before. Jim's enemies had a curious way of disappearing suddenly and completely as soon as they became too troublesome or numerous. There were dark forebodings and smothered aspirations—whispers of extortion and even of murder, culminating eventually in a trial before the white man's court of law.

A slower-witted man than Jim would surely have been hanged long ago, but rumour says Jim was so much smarter than the prosecutor that he secured a favourable verdict with conspicuous ease.

Jim used to have a store at Kimsquit and Indians, for miles around, brought in their furs to him. He was liberal with credit. Since most of them were chronically in his debt they could not question his evaluation of their catch.

Jim bought at small prices and sold at high ones—this much he had learned of the white man's technique. As his wealth accumulated his confidence expanded in direct ratio to his prosperity. Anyone who wished might go to him for a loan. Pulling a thick roll of bank notes from his pocket he would say, "Sure, I loan money—one percent."

That sounded much more magnanimous than it really was. One percent to Jim meant that he would loan you five dollars and you would pay him back ten—once as much again! Money flowed to him like rivers to the sea. He always had more than enough for his needs.

It was said that the only person who could put the fear of God into Jim's heart was his resolute and purposeful wife. No matter whom else he fooled, he could not put anything over on her—and he knew it. She knew it, too.

An interesting story was told of Mrs. Pollard by Mrs. G. Draney, whose husband opened the first cannery on the coast years ago. Mrs. Draney was a young wife at the time with two little daughters in

222

whom the Indians took a great interest. The time arrived when she was going to Vancouver for the birth of her third child. It was October and she intended to spend the winter in the city.

While she waited for the steamer, Mrs. Jim Pollard and two other elderly Indian women approached her. Said Mrs. Pollard: "You go Vancouver, get baby?"

"Yes," answered Mrs. Draney.

"You not take beaver coat. No good for you to take beaver coat."

"Oh," protested Mrs. Draney, "I'll be there all winter. I shall need my beaver coat."

"Just same, you not take him," declared Mrs. Pollard with authority in her voice. The Indians had caught the beavers for this particular coat themselves. They had chosen only prime skins. It was a mark of their affection for her.

"Why do you not want me to take my beaver coat?" Mrs. Draney asked with much curiosity.

"You take beaver coat, you get another girl. You not take him, you get boy," was the answer.

To please them she started to unpack her things to find the beaver coat, much to the disgust of the steamship agent. "Mrs. Draney, you are a damn fool to listen to them," he snorted.

"Oh well," she replied, "I would do a lot more than that to please them when they have been so good to me."

Some months later when she returned with a fine baby boy, Mrs. Pollard and her pals were there at the dock to meet her. There was a look of boundless satisfaction on their faces as they said, "We told you so. You not take beaver coat, you get fine baby boy."

Jim Pollard was ninety-six when I painted him in his little house at Bella Coola. Time had relentlessly caught up with him, robbing him in some measure of his ambitions but slowly carving its story on his rugged face and powerful body. An impressive looking man still, he had a head that might have been hammered out of bronze. His shirt was open at the neck revealing the muscles of a mighty chest and his thick, bushy hair stood up stiffly, iron grey, above his fine wide brow.

As I talked with him and learned something of his past history I could understand why Professor McIlwraith, author of two large

volumes on the Bella Coola, had rated him as one of the four most intelligent men he had ever met in any walk of life.

Only the summer before he had been fishing all season with a young lad as an assistant. Though badly crippled with rheumatism, he had netted more than $900 in three months—a noteworthy effort for a man of ninety-five!

Speaking of the origin of man, Jim said, "Long time ago an eagle came down at Kimsquit. God sent him there to bring the first man who was called Snowam. God gave him the sockeye to eat and now all time, sockeye stay in Kimsquit River. Now everybody eat him. The raven brought another man, Oon-quan-kli-ya. He made a fish club to catch the salmon. Bime bye Snowam get a woman, marries her."

There had been big doings at Kimsquit when Jim was chief there. He gave "lots of potlatches" to which he had called [invited] the Bella Bellas, the Bella Coolas and the Tallio Indian tribes. He said that he could not count the number of times he had given potlatches.

Seventy-two years ago he fished in the Fraser River at New Westminster. There was no Vancouver then. He had also worked at a big sawmill south of Seattle and he boasted that he had known all the coast peoples. He wanted to tell me this because, he said, "if I go home (meaning to die) nobody know."

He said, "I quit smoking thirty-one years ago. I don't drink, just use whisky as medicine sometimes, don't like it."

Jim Pollard gave me one of several Indian names I am proud to own. It is Quol-kla-cum. This was a name they called people who made pictures in the old days. "Indians paint pictures on old houses long time ago," he explained. "I call you Quol-kla-cum because all time you make pictures."

224

The Chief of Beautiful Valley

The Indians say that in the beginning, when God sent the first man to Bella Coola (Beautiful Valley), He came down over the mountain carrying the first fish dam and He carefully put it down in the Bella Coola River that the Indians might have food forever after. The dam has remained there to this day—always it has been in the same place.

In the middle of February the Indians began to fashion their nets of nettles and cedar ropes in preparation for the fish run in the spring. Catching the fish and drying it was a time of great rejoicing, a time for song and jest and merriment. When they caught all the fish they wanted for their own needs, the Bella Coolas generously allowed other tribes, not so fortunately situated, to come and help themselves and, when all had been supplied, they opened up the dam to let the fish go through.

Besides the salmon, which was their main article of food, they also caught oolichans. These were the fat little fish which, in earlier days, the Indians had dried and burned as candles with the result that they became known as candle fish.

The oolichans came up the river in shining millions to spawn every springtime. The Bella Coolas made enormous quantities of oil from the little fish. They kept much for their own needs and traded the rest to Indians of the interior in exchange for hides. This was the origin of the term grease trail.

The Bella Coolas used to pride themselves on their good grease. It was sweet and clean like lard. Other tribes kept it too long, they said, making it rancid and highly odorous. Another food, much favoured, was mountain goat meat. The Indians smoked and dried it and wove beautiful ceremonial blankets from the mountain goat wool.

Each person had his own place to fish and hunt and gather berries. No one else could use them without permission of the owner. One old Indian said, "If someone want to hunt in my valley, he ask me. I say OK, no trouble." But woe betide any man who went in without his consent. He would surely live to rue the day.

Long ago Adam King was chief of the Bella Coolas. His father had been born there but his mother came from Kimsquit. For gen-

erations the chiefs of the Bella Coolas had married women from Kimsquit. Adam inherited the eagle crest from his mother and was head of the Eagle Clan. He was a crow on his father's side and both these symbols adorned his totem poles.

He used to hold great mask dances and called the people from far away to attend them. His mother liked him to do this as it upheld the prestige and honour of the family. He had the biggest house in the village and one of his tall totem poles stood flush against the front of it. The other was a few yards away.

His name had not always been Adam King. His ancestral name was Pootlas, but when the missionaries came to Bella Coola, they called him Adam because he was the oldest man there. Later, when the Hudson's Bay Company opened a trading post, they called him King because he ruled the people. So, through a combination of circumstances over which he had no control, the chief became known as Adam King.

He was a wise and noble man who had two sons, Albert and Sam, whom he taught to be honest and good. "If your brother wants you to do something, help him as long as you live together. Don't quarrel, don't hate each other. Be like 'arm and sleeve', help each other all your life," he counselled.

Albert told me. "I do that. I tell him I help my brother lots. Never quarrel. I see lots of brothers get mad at each other. We never did that. That's why I miss him lots today. When he gets lonesome at his place he come to me and when I get lonesome I go to him. When he gets something nice to eat he calls me. I do same."

When Adam's son, Sam, was a small boy, Adam called all the people of Kimsquit, Tallio and Rivers Inlet to a big potlatch to honour Sam because he would be chief when Adam died. He wanted this public acknowledgement for his son before he passed on.

Sam learnt all the old Indian dances when he was very young. His father gave a dance for him in which he played the part of a ghost. After that he disappeared and every morning the people could hear an eagle screaming. They thought he had gone to the coast where he became an eagle. When he returned, one day, they thought he was the eagle's ghost but when they caught him they could see he was a man again.

Sam had other brothers by another marriage and, when his father died, the oldest wanted to be chief. Sam and Albert talked it

over and Sam thought, "Let him do it," but Albert reminded him he had promised his father he would be chief, so they decided to give a great potlatch in the old village to ratify his right and to celebrate the event.

Four hundred people came from surrounding villages. They stayed for a week with feasting, dancing and singing every night. Vast quantities of food, blankets, bracelets and other things were given to the guests along with $3,700 in cash. This was the last potlatch ever held in the old village of Bella Coola. After that Sam never missed giving a big potlatch every year in the new village because his father had trained him to do this. He and Albert were known and respected all along the coast.

When Sam became chief he took the name See-ash-kle-lack, an old family named. He had other names, too. His first name was Ak-ooks-ma-nike meaning "the sun above." Later he was called Qua-alk-kla. Every time he gave a potlatch he took a new name.

Sam's father had always liked the missionaries and sometimes Sam would talk about them. "Some of the Indians not like them," said Albert, "but I am not like those who hate them, because our father said, 'Preachers tell the truth. Some day you and your brother go to church. I don't like you to stay in old fashion. You change your life some day.'"

Twenty-seven years ago Albert gave up all the old ways. He used to drink heavily but said he would stop and never touched it (liquor) again. "One morning my brother came to my house. We had big party night before, but he see my smoke [from chimney] early so he comes to see me. He say. 'Why you not drink any more? You single man, got no wife, you no more drink?'

"I say, 'I believe the Bible what he say, give your heart to Christ, He help you, so I not drink.'"

Five years later Sam made the same decision and never changed. "Ever since he did good works (referring to his brother). Now he's gone. I know he's got good place. I think another six months I go. I want to be with him," said Albert.

When Sam became a Christian he was like a preacher among his people. He lived the good life to the best of his ability. Despite the fact that he was a very successful business man, who owned a large store in Bella Coola, he received scarcely any formal education. He understood very little English but he remembered Bible stories and

was devoted to the Bible itself. He listened attentively to every sermon he ever heard and never forgot anything pertaining to religion. He was never without his Bible. When he had time he would go about the village preaching the word of God. Sometimes the people would be drinking and would laugh and jeer at him but he did not mind, it never bothered him. He would go to "bad Indians" in their homes and tell them what the Bible said: "It is right to do 'so and so' because the Bible says so. This is the only book to go by." He was good to all, feared nothing, resented nothing and spared no effort in his self-appointed mission.

He was a man of great humility. For some reason Bella Coolas have an ingrained aversion to the word "proud." Sam thought the name King was a proud name. He wanted to be humble, as Jesus was, so he decided to change his name. Known and respected for many years as Sam King he did not take his rightful name of Pootlas until 1948, more than fifty years after he became chief. The name Pootlas, which means "plenty for all," was "lent" when Sam was a boy, to a family of Rivers Inlet who wished to borrow the name for one of their sons in order that, by acquiring such an honoured name, he might become a great chief.

Chief Sam's grandmother made the bargain on condition that, at the passing of the great chief, the name Pootlas would be restored to its rightful owner. With his usual humility, Sam did not feel he had the right to use the name when it was returned until, according to tradition, he had performed some great deed worthy of such a name. To justify his action, when the Native Brotherhood held their annual convention at Bella Coola in 1948, he donated $1,000 for the welfare of Native people and publicly reclaimed his hereditary name of Pootlas.

When the Governor-General, Lord Tweedsmuir, came to Bella Coola, Sam danced for him, gave him a totem pole and put eagle down on his head. This was the greatest gesture of respect he could offer—a gesture of peace and goodwill among all Pacific Coast tribes. Lord Tweedsmuir presented Sam with an engraved silver-headed cane, which became one of Sam's dearest treasures. He showed it to me, with obvious pride, when I painted his portrait several years ago.

Like so many of his race, Sam Pootlas was a born orator. I once heard him addressing the Native Brotherhood at Bella Bella. He was

a small man with jet black hair but what he lacked in height he made up for in dignity and earnestness. You felt that you were in the presence of some dynamic inner power. Burning zeal shone from his piercing black eyes that snapped and flashed, with lightning rapidity, as he spoke. Although I could not understand any of the torrent of words which poured forth, I could not fail to catch the spark of his fiery eloquence accompanied by natural and lively gesticulations. Absolute silence prevailed until he had finished.

Before he died, the chief had built a new home. The house was finished when he became ill but he had never lived in it. In his will he instructed that his son, Alex, should succeed him as chief and that his body be left for two days and nights in the new house.

The chief died in Vancouver and the whole village was at the wharf to meet the steamer that brought his body home. The people wanted to have the old Indian funeral ceremonies but Alex said no. The body was taken to the new house, as the chief had wished, and a crowd of silent mourners kept a constant watch outside. In sympathetic gesture, a choir from the neighbouring village of Bella Bella went in [the house] from time to time to sing the hymns the old chief had loved so well in their Native language.

Long before he died the chief had bought a new black suit in which to be buried when the time came. He had never worn it but, in the meantime, one of his people, a very poor man, passed away and the chief gave his new suit so that the man might be decently clothed for his burial.

Now that he, himself, was dead they tenderly dressed him in his old grey suit, befitting so humble a man, and wrapped an Indian blanket around him as a symbol of his chiefhood. They put the thing he valued most, his beloved Bible, on his chest. Then some one said the Bible must not be put there while the casket was open, so they laid it on a table near his head. Suddenly the book opened and the pages were leafed through, one by one, by an unseen hand, while the people watched, hushed and tremulous, in the presence of a strangely touching phenomenon.

Next day they carried him to the little church which had been his spiritual home. They could have held the service in the tribal hall, capable of holding a large crowd, but Alex said his father must be buried from the church. Only the immediate family went inside the little building—all the rest of the Bella Coolas, with the fine

courtesy for which the Natives are famous, remained outside, silent and bareheaded, that as many as possible of the visitors might go in.

They were there in their hundreds, white people and Indians, arriving from far places along the coast, to do honour to one whom they had ever held in the highest esteem. His passing was a great personal loss to each of them.

The night following the burial, in keeping with ancient tradition, the old Native funeral ceremonies were held in the hall. This was important to the people for it meant much to them to honour their chief in this manner.

It is now the desire of the Indians of Bella Coola to install chimes in the little church to the memory of Sam Pootlas. This would have pleased him more than anything they could do in his honour. When the people hear the chimes they will think of the greatest chief they ever had.

Catching Up with Big William

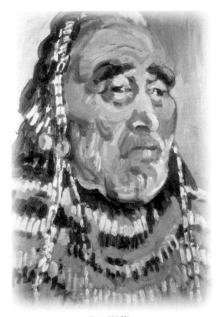

Big William

For several years I had wanted to paint Big William, Shuswap chief on the Salmon Arm Reserve. Two or three times I had been near to fulfilling my purpose but fate had always taken me in pathways which led far away from his little cabin in the interior of British Columbia. Time and time again people said, "You really ought to paint Big William." I was eager to do so but somehow it just had not worked out that way.

Then, as a mere afterthought when I was leaving on a lecture tour of the Interior, I slipped in [my luggage] a couple of paint brushes and a few half-used tubes of paint. I was to speak at Kamloops and Revelstoke, then travel down the Okanagan to cities there and, finally, to Trail and Rossland. "Who knows," I remarked to my husband as I fastened an overfull travelling bag, "but that I may catch up to Big William at last."

In Revelstoke I learned that [the tour organiser in the City of]

Vernon had been unable to secure a hall and therefore was obliged to cancel my engagement. Here was I with an extra day at my disposal. What luck! I would go to Salmon Arm and see what I could do about Big William.

Salmon Arm is a town with personality. You know that the moment you get a glimpse of its main street. Where else would you see two gigantic blue spruce taking so much valuable space and lording it over a bank on one side and a hotel on the other? There, to the north, is the Canadian Bank of Commerce, tall, aloof, sedate, looking a little like a small Canadian version of the Parthenon. To the south of the blue spruce stands the Monte Bello [hotel], wide, rambling, sitting squat to the earth and inviting you up its broad steps with open-hearted hospitality. You will not find its like elsewhere. I was given the key to a tiny room and after that, was completely on my own. Salmon Arm visitors are expected to look after themselves.

I tried the key right side up, upside down, outside and inside and eventually came to the conclusion that it was never intended to do business in that particular keyhole. It wasn't. In fact the key did not exist to fit it. When I remonstrated, I was told that it really did not matter; nobody ever bothered to lock their rooms and nothing was ever lost. Long ago, drowsy-eyed guests bent on catching early trains, had wandered off with most of the keys and never bothered to return them. What matter, since all the travellers who came under the influence of this remarkable town were scrupulously honest.

With Big William in mind, I asked the manager if he knew anyone in town who was interested in Indians. He pointed an expressive finger across the street, "See that window over there, full of junk? That fellow is interested in Indians."

I charged across the street and looked in the window. There were jade, chisels, arrow heads, stone hammers and nice old skulls. "This is my man," I told myself. Sure enough, Mr. Percy Ruth knew the Indians and was as much interested in their history as I was. He even knew Big William.

"Would it take you long to do the work?" he asked.

"Not long," I replied. "All I need is a chance to get at him."

"Well," he said, "I'll take you out to his home and will call for you [at your hotel] about 1:30."

Wonderful news! But I must still find something to paint on.

232

"Now," I asked, "can you tell me if there is a lumber yard here, or any place where I can buy a piece of board to paint on?"

Mr. Ruth went into a room behind his office and, after rummaging around a bit, came out with the very thing—the top of an old table that had been discarded. It had been waiting there all these years just for me and Big William. I walked jubilantly out with the board tucked under my arm and went to a drug store to get some linseed oil to rub over it. The druggist was almost in tears because he did not have any. "But I'll give you a bottle," he said brightly, for which he refused payment. Next I went to a hardware store and presented my bottle. The proprietor took it and filled it. As I opened my purse he said, "Oh, there's no charge. I would not think of charging you for such a small amount."

Am I still on this planet? I wondered, or have I inadvertently stumbled into some strange new blissful realm where service is coin and brotherhood mightier than gold?

I now had everything necessary to paint Big William, but I still needed a piece of heavy cardboard, the same size as my table top, and some stout string so I would be able to pack my wet sketch for travelling. I dropped into another store and a handsome young man came to serve me. He was not in the least annoyed or disappointed because I was not a prospective customer for a stove, plumbing fixture, linoleum or a refrigerator, but courteously searched around and eventually broke a [cardboard] box to give me what I needed. Another forage produced a handful of heavy string. "Mighty scarce, is string," he remarked, "but I can usually dig some up." Once again I was not permitted to compensate for the trouble I caused.

From all the foregoing it was inevitable that when Mr. Ruth and I went to the reserve we did find Big William at home and pleased to be painted.

The chief was a stockily built man of good height, possessing that unusual adornment among Indians, an impressive grey beard. You never see hair on the face of Plains Indians. In British Columbia one occasionally encounters a man with a mustache but here was Big William with the double distinction of both a beard and a mustache—a full set!

The chief's home was a comfortable, unpainted frame building with the homey atmosphere of simple living. A rousing fire in the kitchen stove sent forth both cheerfulness and warmth. Across one

corner of the room was fastened a tiny hammock in which a little future chief was resting. Almost everyone, in passing, gave it a slight push so the hammock was in continuous motion. The baby must have liked that for he did not awaken while I was there.

After some searching the chief found his ceremonial costume in which he wished to be painted. His tunic was heavily embroidered with brightly coloured tubular beads procured from a Hudson's Bay Company post many years ago. His headdress was entirely of beads and hung down over his shoulders. Put such things on a white man and he would look ridiculous but Indians wear them quite naturally and with the utmost dignity.

Since I was operating on a programme of improvisation, I had no palette on which to mix my paints. The chief's wife, with a woman's ingenuity, soon solved that problem by procuring a large dinner plate which served my purpose very well.

It never occurred to Big William that I would pay him for his trouble and he was as pleased as a child when I did so.

I carried the oil painting of Big William, wet and sticky, all through the Okanagan and up into the Kootenays and back home again, without getting so much as a smudge on his handsome, dignified face.

Shuswap

▶ *colour plate page 161* 234

DOMINIC JACK & LOUISE

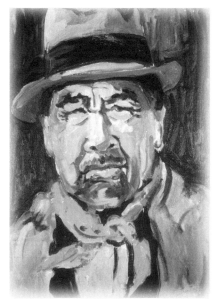

Dominic Jack

Dominic Jack and his good wife, Louise, live in one of the most beautiful spots in British Columbia.

Nestling between the Okanagan and Skaha Lakes near Penticton is the Indian reserve. It is cradled on every side by majestic hills which sweep, in undulating curves, up to the wide skies above them. Cloud shadows chase each other across the far peaks in swift succession, deepening their colour and clothing their contours with mysterious and ephemeral glory. A fitting place for Indians to live, for to them the hills, the winds, the sun and all the phenomena of nature are vested with symbolism and meaning which is hidden to others' eyes.

There, at a bend in the road, is the home of Dominic Jack, brother to the local chief. Nearby stands a little church, white and shining. For all things are white and shining around Dominic's abode— all colour is softened to quiet tones. A swiftly moving stream runs past the house. Between the apple trees, whose harvest reddens the

ground, are rope lines heavily laden with old clothes. These are the pride and joy of Old Louise. New clothes do not begin to fascinate her as do the old and no matter how many she gets, she always wants more. What she does with them remains a mystery.

At the side of the house a fire had been kindled to make a smudge. Thick, creamy smoke rises from it to drift across several large deer hides that are tightly stretched from tree to tree. This is part of the process of tanning. Very soon Louise will scrape them with rough stones until the skin becomes soft and smooth. Then her deft fingers will fashion them into fine gloves. "Four pair I get from one hide," she tells me.

Local nimrods bargain with her for one pair of finished gloves in exchange for one raw deer hide. Louise does plenty of business on this basis but she does it in her own good time and no amount of coaxing or persuasion will quicken her pace one jot.

A friend of mine, living in Penticton, who is a member of the gun club there, told me that many months ago he had proudly presented Louise with a hide, the result of his prowess in the hills, and she promised the gloves in six weeks. Punctually, he arrived at the appointed time to claim them but Louise, looking at him with infinite pity and compassion in her bland, brown eyes, said she had been "too busy." On several succeeding occasions he had hopefully driven around to see if the gloves were ready but she was "still too busy," a condition which had seemingly become chronic.

After all, what did six months, more or less, matter to her? There was always plenty of time and there were always more deer hides appearing over her horizon, so why all this vulgar impatience? And that is the logic she finally instilled into the impetuous soul of my young friend, for now he troubles her no more but, rather, waits in subdued resignation until the spirit moves Louise to activity.

When I got out of the car, Louise and Dominic came to meet me. They answered my greeting with blank stares and were frankly curious. Since I was accompanied by Mrs. White, wife of the retired Indian doctor, they decided to accept me as a friend.

It was difficult to make them understand that I wanted to paint their portraits. I showed them photographs of some of my paintings and they thought I wished to take snapshots of them but I explained that I wanted to paint them and that I was willing to pay them for their trouble. Louise said, "Too busy, I have a lot of work to do."

I assured her that I would not keep her long but she repeated, "I have big lot of work to do." I was a bit sceptical of this statement, however, as there was no evidence of excessive activity about the place, so I told her that I would give her a specific amount of money if she would sit still for half an hour and do nothing. Dominic Jack interrupted to tell me that a man once took a photograph of him and gave him twice as much.

I felt somewhat crestfallen at this staggering piece of news but held my ground, explaining that I was the one who did all the work and got nothing for my trouble. There was no point in enlarging on the sad fact that artists are seldom affluent.

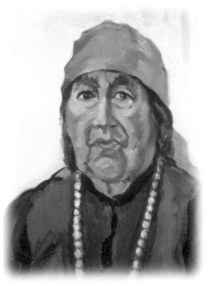

Louise

At last Louise decided that my offer looked good to her and slowly ambled off to the house to get ready for the sitting. I took one look inside the kitchen and concluded that the verandah was a good place to paint, so I got my equipment in readiness.

Very soon Louise reappeared, a charming figure, wearing a bright red satin bandeau and a long string of beads as a concession to the artist. She also sported a very pretty engraved silver bracelet. I made her comfortable and began to work, chatting to her all the while about her home and family.

She expressed childish pleasure when I showed her the portrait and said, "You send me one?" meaning that I should send her a photograph of it, which I did.

I painted only her head and shoulders. She looked at her treasured bracelet, then back at the picture and seemed mystified and disappointed that I had not included it. Then she sat down and told me her troubles. She was "sick inside," she told me and she felt "bad." "I see Dr. White some day," she assured, "and he fix him,"— referring to her stomach.

▸ *colour plate page 170* 237

Dominic was surprised that I wanted to paint him in his old clothes—just as he was. Louise had been restless, moving about a good deal and shifting her position, so I asked him to look straight at me and not move. He settled down comfortably, fixed his gaze upon me and for the next half hour was as sprightly as the great hills which looked down upon us in imperturbable grandeur. There was something almost uncanny about his resolute immobility. I wondered what was going on behind those inscrutable eyes. I surmised that he was counting my vertebrae, for I felt that he was looking right through me and beyond.

I spoke to him a few times but he made no sign that he had heard. I worked with great speed and finally I had finished. Not until I arose and laid my brushes aside did Dominic relax from his stony posture. Like Louise, he was pleased and intrigued with the portrait and said, "You make him for me?" I promised I would send photographs of both paintings.

I asked Dominic about his Indian name and he told me it was Wis-tash-iaken.

Not far from his house is a sweat bath, something seldom found nowadays except among the Okanagan Indians and in connection with the Sun Dance of the Plains Indians. A little path leads from the house to the same stream that flows past Dominic Jack's door and there, on the bank, is the forerunner of the palatial steam baths which may be found in any modern city.

Its construction is simply and beautifully fashioned. The ground has been excavated to a depth of about six inches and above it long, slim saplings have been bent to a beehive shape. These are closely intertwined with smaller branches, making a very strong and firm fabric. A circular opening has been left, just large enough for a man to crawl through. Over the top, earth has been tightly packed to a depth of several inches, making it airtight and it is overgrown with bright green grass. Nearby is a heap of stones and the remains of a recent fire plus freshly cut wood for the next occupant.

Usually the bath is used for cleansing and healing purposes but often it has a much deeper meaning, of a spiritual nature, and on these occasions secret ceremonies accompany its use. The stones are brought to a great heat in the roaring fire, then, with the ceremony of an ancient ritual, are rolled into the sweat bath and the opening tightly closed. Water is poured over the hot stones, causing

steam and inducing perspiration. Strange chants and incantations are part of the procedure, which is supposed to be a cleansing of the body, soul and spirit. Later a plunge into the stream closes the pores and completes the ceremony.

Manuel Louie

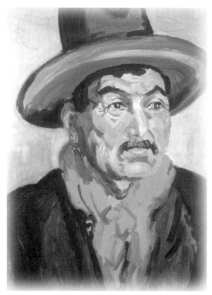

Manuel Louie

Here Life takes on new leisure,
And Time takes on new worth,
And wise are they that treasure
This Eden of the North.

So sang Bliss Carman, beloved vagabond of Canadian poetry many years ago, of the beautiful Okanagan Valley of British Columbia and so, too, think the Indians of this area who love every stick and stone of it today.

Manuel Louie loved it as much as any of them, for it had been his home always. He was a tall, handsome man with a ruddy face and merry black eyes—which gave him a fetching, blithe, Lothario sort of look not common among B.C. Indians. His features, too, were different, for his father had been an Iroquois who long ago had come west and married one of the Okanagan women. Manuel could not remember him but he bore an enduring record of the union in his face.

Perhaps, too, it was from his father that he had inherited the

independence of mind which culminated in his leaving the Indian community and running his own farm entirely apart from it.

His modest home stands on the bank of the river. Chickens, turkeys, dogs and cats rambled about the yard in happy fellowship and, in the fields nearby, fine, fat cattle were grazing. Manuel would rather raise stock than grain but he did a little of both.

This [particular] morning he was sitting by his warm kitchen stove but yesterday he had stood in water to his knees, from ten in the morning until three in the afternoon, fishing or trying to do so [far from the river bank], for children had frightened the fish out from the bank and he was obliged to go into deeper water. Then he began to chill and came home after catching only twenty-five salmon.

"Years ago," he remarked, "we could catch up to two thousand fish at a time but when the Americans built a big dam further down the river the salmon did not come any more in large numbers."

Manuel's wife had wanted him to go fishing again today but he was reluctant to stand in the water again. She was a purposeful woman and Manuel would probably have yielded to her wishes had I not mercifully appeared on the scene, desiring to paint his portrait. Ah! Here was salvation indeed—just the excuse he wanted to sit quietly by the fire—and never did a sitter pose so willingly!

He had ideas, had Manuel, and an eye for the picturesque. From a cupboard on the wall he extracted a high cowboy hat and a bright red scarf which he knotted rakishly around his throat. Then he sat as close to the stove as he could get. Everything he did was accompanied by laughter and every word he spoke rang with merriment. There was sound psychology in his attitude to life. "I tell my boys to laugh at everything," he said, "and to meet everyone with a smile. If you are happy you live a long time; if you have long face you die."

Manuel himself was living proof of his philosophy. I just could not believe he was over seventy, for he looked like a man in the full prime of life, but he assured me that his age was seventy-four. He attributed his long life to his good cheer and his knowledge of Native medicines. Every fall he goes up in the mountains to gather certain red berries that grow there and these he eats to purify his blood.

He tells his family not to waste their time reading silly patent medicine advertisements but to eat the good red berries that nature

has provided without price. "That's all they need to keep them well," said he.

Every day, winter and summer, Manuel swims in the nearby creek. He never suffers from colds and he never has rheumatism.

Indians of this region, however, gave time and thought to many things other than the welfare of their bodies. From generation to generation legends, customs and secret knowledge have been transmitted from father to son [to ensure] that the cherished traditions of the race might not pass away. Lacking a written language, their history is perpetuated by memory from age to age.

There were wise men among them—mystics, prophets and seers—who spent much time in meditation but seldom revealed their thoughts, save to those who were deemed worthy of the trust. Manuel told of the old chief of his tribe who was honoured and revered as one possessing this ancient wisdom and of how he had been instructed by him as a boy.

With one or two other youths, who had been specially chosen, he would go late in the evening to the old chief's home, probably

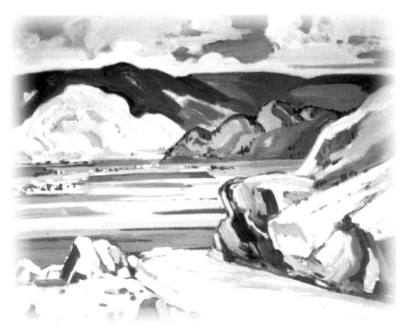

Osoyoos from Anarchist Mountain

242

about ten o'clock. There they would sit, mute and grave, waiting for the throbbing pulse of the outer world to grow still. At one o'clock in the morning, when all nature had gone to rest, the wise man would break the silence and, in deep solemnity, begin to impart the secret lore of his people.

Pointing to his head, he would say to his wide-eyed listeners, "This is your pen." Then, laying his hand on his heart, "This is your Bible, write what I say on your heart." Thus, like Hiawatha of old who "in his wisdom taught the people," did the old chief in the Okanagan relate to the chosen ones how the Indians were created over 6,000 years ago and how white men came to be. He told them many strange and wonderful things pertaining to the Great Spirit and revealed many mysteries which it is not lawful for white people to know.

After he had talked to the boys long and earnestly they were required to repeat that which he had said to see if they remembered it accurately. If there was any error they would have to say it over and over until all was indelibly imprinted on the "pages of their memory." When the first flush of morning crept rosily over the brooding mountains above them, the boys would walk, wordlessly, home, pondering in their hearts all that the old chief had told them.

Now Manuel does the same with his own boys and other young men who are likewise charged with these solemn obligations.

Many other memories arose before Manuel's mental vision that morning as he sat by the fire. One experience after another presented itself as his loquacity expanded. His black eyes flashed with relish as he recalled the time, back in 1921, when there was talk of putting an irrigation ditch through the reserve, which lies in the fruit belt where all the orchards must get their moisture through irrigation in this semiarid district.

Life had been serene and uneventful for the Indians up until this period and they were fearful that the ditch might mean relinquishment of some of their tribal rights—that it was just another trespass by the white man. They decided that they would not let the ditch go through. There was much discussion and apprehension and many an earnest council meeting among the leaders of the tribe.

One day Manuel was talking about the matter in the nearby town of Oliver. Some one said the only way to stop the ditch going

through was to get action from Ottawa. "Ottawa?" exclaimed Manuel in astonishment, "Who is he?"

"It's a city where the government is," he was told.

Manuel scratched his head in bewilderment. "Ottawa, where it is I don't know. How I get there I don't know."

One day the chief, Manuel and Paul Terrabasket went to town together and sauntered into a little store for supplies. Said Manuel to the shopkeeper: "Do you know where Ottawa is?"

"Sure," said the shopkeeper.

"Do you know how to get there?"

"Sure, but it takes time and money."

"Will you take us to Ottawa? We will get you the money."

The man agreed and a few days later the three returned. The chief planked down $2,500 on the counter. "You keep $500 for yourself and the rest is to take us to Ottawa. [If] That's not enough we get you some more."

So it was that the three Indians in the tow of a small town storekeeper went, as a delegation, to Ottawa. The long journey must have been a continual source of wonder to them but Manuel did not dwell on that. On arrival at the capital they went straight to the Department of Indian Affairs. Very much agitated and confused, they made no headway with the officials there and it began to look as though the long trip had been in vain.

Then Manuel had a bright idea. They would go and see the prime minister. After all, he was the big chief.

At that time Arthur Meighen, serious and dignified, was guiding the affairs of state. The Indians decided that the proper thing to do was to phone the prime minister's office. Several days in the city had taught them the mysteries of the pay phone.

Manuel dropped a shining nickel in the slot and dialled. "The prime minister's office," answered an obsequious clerk.

"This is Manuel Louie, Paul Terrabasket and the chief from the Indian reserve at Oliver, B.C., and we want to see the prime minister."

"Indians," sniffed the clerk, then into the telephone: "The prime minister is busy and cannot see anyone this morning." Up went the receiver. Manuel felt that he had been snubbed but, with incurable optimism, he plunged his hand into his pocket and fished out another nickel. "All right, we try him again."

"The prime minister's office," answered the clerk for the second time.

"This is Manuel Louie, Paul Terrabasket and the chief from..." but he did not get a chance to finish.

"No, you cannot see the prime minister this morning, he is busy," and the receiver clicked angrily.

Nothing daunted, Manuel dug out another nickel. "We try again," he chuckled.

"No!" yelled the clerk. "No, you cannot see the prime minister," and cut off with a bang.

"We got lots of nickels," said Manuel jubilantly.

It pays to persevere and luck was with the Indians that morning. Just as the clerk, red in the face and very angry, was refusing them admission for the umpteenth time, the prime minister came into the room and wanted to know what all the fuss was about.

"Oh, it's just some Indians from B.C.," snorted the clerk. "I told them you were too busy to see them."

"Let them come up," ordered Prime Minister Meighen.

It was the clerk's turn to be rebuked. "You can come up at once," he said icily into the phone—to the great delight of the men waiting patiently at the other end of the line.

Awkwardly and rather scared, the three Indians walked into the sumptuous office of the First Minister of Canada, who greeted them kindly as he shook hands with them. "Well," he asked, "what is your trouble?"

"Mr. Premier white mans want to put big ditch through Indian Reserve. Indians not like but white mans says yes, so we come see you."

"No," Mr. Meighen assured them, "white man cannot do that without your consent. The Great White Mother, she said, 'This is your land forever, no one can touch it.' She is dead now but her grandson does the same. They cannot put ditch in unless you all sign paper and say they can. No good one Indian sign, or five or ten, but all must sign if they want ditch to go through. That is what the law says."

"Arthur Meighen good man," said Manuel with great sincerity, "treat us good, tell us everything. He said, 'The ground is yours. The stakes have been put there by the Queen's command and everything within the circumference is yours forever, not only the ground but

right up to the sky,'" and Manuel made a large gesture to show exactly what the prime minister had meant.

Their minds at peace and with a new sense of security, Manuel and his companions returned to their homes in the valley knowing that the government of Canada stood behind them as a bulwark of integrity against aggression of any kind.

Arthur Meighen's term as prime minister was brief and stormy, and fate ordained that his brilliant capacities should never be exercised to the full for the Canada he desired to serve. But here in the quiet sanctuary of this fruitful valley, he is a vivid and well-loved memory—this man who had not been too busy to turn from affairs of state to listen to the troubles of three humble Indians, to treat them with respect and consideration and to send them home satisfied, confident and happy.

Saga of the Similkameen

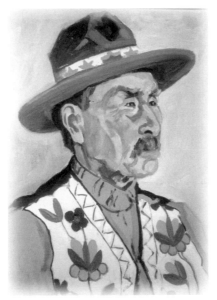

Chief Joseph Louie

British Columbia's Similkameen Valley lies close to the famed Okanagan Valley. Less accessible and less settled than the Okanagan, it seldom figures in the news but it has special interest for me because Indians live there. I wanted to paint Chief Joseph Louie and Paul Terrabasket in particular.

My good friends, the Millars at Oliver, had long desired that I make this trip but the road was known to be very difficult. No average car owner would dare to hazard the trail going over the mountain. Through the kindness of Mr. Millar it was arranged that I should go with Mr. Oster, a Polish apiarist, who kept bees in the valley and went in once a week to care for them in his truck—and knew the route.

With bulging lunch baskets we left at 7:30 in the morning and started toward Osoyoos, soon leaving the highway and turning into the mountains. Immediately we began to climb the narrow, precipitous trail which twisted and turned through clumps of grey-green

sagebrush, dark-toned greasewood, crimson sumac, golden cotton-wood trees and sombre, brooding pines. The soft glow of bunch-grass against a billowing sky added a subtle note of muted colour.

The road spiralled about the mountain as we chugged steadily upward, every curve presenting breath-taking views of wild beauty. This strange, lonely land is throbbing with mystery. One drives for miles, never meeting anyone or seeing sign of human habitation—just rocks, hills, trees and the enormous sky.

Then, suddenly, you come upon a home, dropped into the wilderness like a pebble in a pond, swallowed up in the immensity and solitude of the mountains.

Far back from the trail was a house where a married woman lived with a man who was not her husband. She was said to be six feet tall and very beautiful. Here, in the wilderness, she was living her own life in defiance of manmade laws and social tolerance.

Miles and more bumpy miles of lonely road, then, abruptly, we came upon a huge, prosperous-looking white frame house with many fine barns, neat fences and an unmistakable air of modern progress. Galloping down the lane were cowboys in chaps and wide-brimmed Stetsons. This was the famous Richter Ranch. At one time it had 10,000 cattle on the range. Down near the lakes in the valley were grain fields which fed the cattle through the winter months. Three or four men were always in attendance.

The big ranch was soon lost to view as we pursued our journey past little lakes, deep shrubbery and woods. Once we caught sight of a black bear ambling off out of our way. Several times rattlesnakes wriggled off the roadway where they had been basking in the sun. "The rattlesnake is a gentleman," explained Mr. Oster, "he always warns you when he is going to strike."

We turned up a sharp corner at the top of a rise and there, with overwhelming grandeur, loomed lordly Mount Chupacca, deeply seamed and crevassed and wearing a glittering diadem of snow. High above the surrounding peaks, it was an awe-inspiring sight.

As we gazed in silent wonder the clouds parted above the top-most peak and a scintillating rainbow, in gorgeous colours, arched over the glowing summit. The utter stillness of the place, the over-powering sense of majesty and awe of the scene before us, rendered us speechless. We could only gaze as though we had been permitted

a glimpse of higher realms, something that lifted the imagination far above all worldly thoughts.

Far away we could see the Similkameen River winding, like a turquoise ribbon, around the feet of mighty Chupacca and through the dazzling green of the little fields below. Wordlessly we drove down to lower levels, turning on to a dirt road that followed alongside the river. Here and there were houses and little fields and orchards.

We were bound for the dwelling of Mrs. Smitham, a woman who was half white and half Indian, biologically speaking, but all Indian by temperament and choice. She could speak the language of the Similkameen Indians and we needed her service.

We opened a small, ingeniously contrived gate made from poplar poles. A small, unpainted house, huddling among other buildings of similar hue, proved to be a warm and comfortable little home with geraniums blooming gaily in the windows. A huge iron stove overshadowed everything else in the kitchen. Beside it sat a white man on a chair, tilted back at a precarious angle.

He was holding the smallest, oddest looking infant I ever laid eyes on. It was easy to see he loved this child of his, as I supposed it to be.

Mrs. Smitham was busy preparing the baby's food and the man said that it completely ruled the household. They never put the lamp out at night and when the baby yelled they got up and walked the floor with "his lordship" until he decided to go to sleep. Here were two, apparently sane adult people, the willing slaves of an odd little piece of humanity. It was only a few months old, they said, but its face was old—very old and wise and cunning.

I was puzzled over the whole set up—it just did not seem to make sense. How did these three get together and what was the relationship between them? It turned out that the baby did not belong to either the man or the woman. It was an illegitimate child that had been prematurely born in the hospital at Oliver.

Mrs. Smitham and her companion heard about it and asked if they might adopt the baby. The hospital authorities, glad to dispose of their unwanted charge, had commissioned Mr. Oster to take it out to them in his truck on one of his trips. In a matter of weeks the child had reduced his benefactors to, what appeared to be, a condition of abject (though willing) slavery.

Mrs. Smitham's house was sparsely furnished, but it was very clean, with an air of comfort and hominess. Her greatest treasure, next to the baby, was an enlarged photograph of her son in Canadian Army uniform. I expect her devotion to the baby left her no time for personal attention, for her dress was ripped from under her arm to her waistline and, at every movement, you could see the plump undulations of a well-fed body, several shades lighter than her face and hands. She bathed the baby and fed him, wrapped him snugly in a blanket and we set off in the truck together.

Our first stop was at Paul Terrabasket's home, several miles down the valley. Paul was not home but his wife was. She had a tight little face and, despite Mrs. Smitham's animated conversation in her own language, she was not in any mood to be painted. She said that no one had wanted to do it when she was young and pretty and no one was going to do it now when she was old and ugly. I could see her point and dared not dispute it. The evidence was irrefutable.

Just as we were thinking of going on our way in disappointment, Paul Terrabasket's wagon and team drove into the yard. He was as hospitable and genial as his wife had been morose and uncommunicative and, at once, consented to let me paint him. I did not lose any time getting at it.

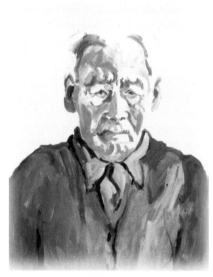

Paul Terrabasket

The old woman was furious. While I worked she kept grumbling, saying she didn't know why he let me do it. She shuffled about, banging the stove lids, pushing furniture about and generally showing her displeasure. When she saw that this had no effect on me she was so mad that she bounced out into the yard and sat on the woodpile, all by herself, until I had finished. What she said to her husband, after our departure, I could only imagine.

As we drove back up the valley I began to wonder

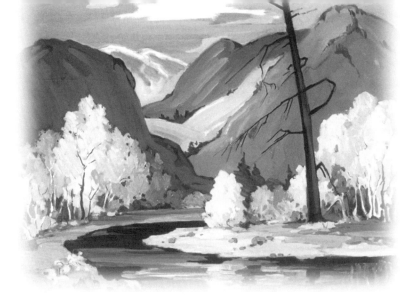

Autumn in Similkameen

about the chief and how I should get to him, but as we approached the home of the chief's nephew, Mr. Oster said, "That's the chief's horse tethered to the fence."

The chief, himself, was inside the house, all dressed up in his ceremonial regalia. His own home was across the river and I had been told the only ways to get to it was either in a dugout canoe or to swim over "on horseback." I could not make up my mind which means of transportation I preferred but was saved from making the decision after all. With the thoughtfulness and generosity that the Indians so often display, someone had gone across, while I was down in the valley, and told the chief what was in the wind and he had obligingly come to me to save me the trip across the river.

Chief Joseph Louie is a fine, serious-minded man, conscious of his responsibility as the sole leader of his band and never, for a moment, did he forsake his dignity of manner and speech. His costume was beautifully beaded. The workmanship was beyond reproach. The floral designs of the white men were meaningless and effete compared with the old Indian designs of long ago—now all but forgotten.

The chief claimed to be ninety-five years of age though he looked much younger. He had been chief for twenty-five years. He was born on the reserve and had always lived there and seldom leaves for any reason.

▸ *colour plate page 160*

Work aNd Be NimbLe

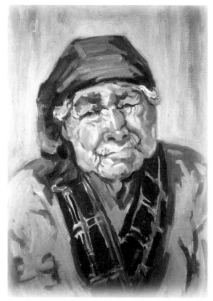

Mrs. Mary Dick

Old Mrs. Snowball and Mrs. Mary Dick were the only Thompson River Indians I wanted to paint. I heard about them years ago but, by the time I got around to their reserve at Lytton, Mrs. Snowball had gone on her last long journey.

During her lifetime she had been the subject of much curiosity. She and her husband were said to have been the wealthiest Indians for miles around, but how they got their wealth was a great mystery. They never indulged in arduous toil and they did not gamble—nor did they have any rich relations, yet they seemed always to have plenty of cash for anything they wanted to buy. No one knew the source from whence their affluence came. Many suspected, however, that the turbulent Fraser River could tell a tale if it had the power of speech.

The Fraser is literally a river of gold and old prospectors claimed the yellow metal could be found on almost any sandbar along its course by those who were diligent enough to pan for it.

Better still, there were occasional pockets of gold that yielded returns if you were lucky enough to find them.

People thought Mr. and Mrs. Snowball had made such a discovery and, with Native sagacity, had kept the knowledge to themselves. When the old man died many years ago his wife remained the sole possessor of the secret—and she was not telling.

They had only one son, who had an insatiable thirst for firewater. Mrs. Snowball wisely concluded that more money simply meant more liquor for him, so she died without revealing to him the source of her wealth. How many people would have shown as much restraint and wisdom, combined with all the power of a mother's love, in the same circumstances?

Mrs. Snowball was dead and the secret of her wealth had been buried with her. Mrs. Mary Dick remained, the sole survivor of her generation.

A group of little Indian girls was playing about the St. George's Residential School and I asked if any of them knew where Mary Dick lived. "I do," piped little Allana. "She is my grandmother."

"Will you take me to her?" I asked. "I want to paint her portrait."

"She is my grandmother too," chimed two more dark-eyed little maidens.

I thought it strange that she should have three granddaughters so near of an age, so I marched them all off to the matron to get permission for one of them to accompany me to Mary Dick's house.

It turned out that Allana was the real grandchild. The prospect of watching me paint had been so alluring that the other two had risked a fib in order to get in on it. They were chided by the matron while Allana and I went off together. "How far is it?" I enquired.

"Just a little, little way, through the field, just five minutes," my wee guide told me.

I gave Allana part of my equipment to carry. She swung the heavy bag over her shoulder as if it had been a feather. We crossed the lane, scrambled through a wire fence and began walking over a pasture. Cattle were grazing there and the more curious ambled after us, following at a respectful distance like obedient puppies.

Another field and another fence—barbed wire this time. Every effort I made to crawl through, a pointed barb would catch my clothing and bring me up with a jerk. Going over the top was more pre-

carious still—the barbs caught just the same, only in different places. Competent Allana grasped the lower strands in her strong little fists and raised them high while I crawled under on my stomach like a worm in the dust. I got through intact and then held open the strands for her.

It was midsummer with a blazing hot sun. Dust rose in little clouds with every step as we crossed the next field and I began to think it was a long five minutes to Mary Dick's. Allana strode ahead of me and I puffed and gasped wearily after her, vainly trying to match her steps. Presently we came to a high gate with a mysterious lock. Allana fumbled with it and eventually found the combination, so we walked through without effort and in full possession of our dignity this time.

A little cabin seemed to stare at me through curtainless windows. Ha! This must be the place—but no, Allana had started blithely down the old Cariboo Road without so much as a glance in my direction. "Aren't we nearly there?" I asked hopefully.

"Just a little bit more way," was the cheerful response and she suddenly left the road, turning into a narrow path through some woods. Up to now we had been proceeding more or less on the level, but that path led up hill as far as I could see. I slackened my pace and Allana politely did the same. Through an opening in the woods I saw across the river where a cluster of buildings caught the sunshine.

That must be it, I thought, but Allana said it was Joseph's place and that they were drying salmon. Then I noticed the racks covered with hundreds of red salmon being cured in the sunshine.

Up and ever upward we trudged, talking little, conserving our breath. Far away I could hear the barking of a dog. "That dog belongs to Jimmy Peters," said Allana. "It's awful cross. They put salt on its nose to make it bite people."

"Do we have to pass that way?" I asked with trepidation.

"Yes," was the uncompromising reply. "We'll keep quiet and see if we can sneak by without letting him know."

We crept along in real Indian fashion with silent, careful tread. Another ten minutes and we had safely passed the danger zone. "Aren't we nearly there now, Allana?"

"Just a little bit more way," was the reassuring answer as we

came bang up to another fence where the path suddenly ended—for no reason at all that I could see.

"We just crawl through here and go up the hill and cross another field and go down by a little stream and there is grandmother's."

I had my doubts by this time as to whether I should live to finish the journey, but to go forward was shorter than to turn back and I hate to be beaten. I tramped along, dully wondering just what "a little bit more way" meant to an Indian child. They were accustomed to the woods and the trails, thinking nothing of hiking all day. No non-Indian child could ever keep up with them.

Finally we reached Mary Dick's cabin in a little valley with majestic mountains rearing their mighty flanks around it. We went in at the open door. The remains of a meal were on the table and unwashed dishes but no Mary Dick was in sight.

"She is in the garden," assured Allana.

"Well," I gasped, as I sank, exhausted onto the back steps, "you go and look for her while I catch my breath." My face was burning, my legs ached, my feet were sore and I felt too hot and weary to paint the old woman, even if Allana could find her.

A couple of lean, yellow dogs appeared from nowhere and began circling and sniffing around me, uttering an occasional curse in dog language. I kept still and said nothing, knowing that is the best policy with Indian dogs. Pretty soon they went away, to my great relief. In the distance I could see Allana and an old woman approaching and could hear the low, soft cadence of their voices. Perhaps Allana was telling her what a softie I was.

When they came nearer I went to meet them. Mary had been working in her garden and the good brown earth covered her hands and arms to her elbows. She hesitated to shake hands with me, but what is a bit of dirt between friends? I gave her a hearty handclasp and she grinned as I did so.

Mary had several acres of garden in beautiful condition and she had done all the work herself. This was something of an achievement for she was said to be over a hundred years old.

"You are a wonderful old woman," I said admiringly, "to be doing all that work at your age."

"Oh, me not lazy," she explained. "Do lots of work, not get stiff."

255

"Well," I pondered, "that is something to remember to ward off decrepitude."

Then she added: "Eat lots of salmon, salmon good food, meat no good."

"That's right," I agreed, "Salmon is good food."

The old woman leaned over and peered quizzically into my eyes. "You know Jesus?" she queried, pointing with a knobby, brown finger to the sky. I nodded my head solemnly. "He eats salmon," she said with conviction and suddenly I knew she was thinking of the loaves and fishes, bless her heart.

Mary Dick is a devout person who seems to have accepted the Anglican faith without reservations. "Too old to go to church now," she told me, "so sometimes I have church here in my house. Two, three, five people come and we have church here."

She made a willing subject for me in her little cabin and my portrait of her intrigued her interest greatly. As I turned to go I slipped a bank note into her hand. She examined it closely and spoke in short, hasty sentences to Allana in her own language. I asked what the trouble was and Allana said her grandmother wanted to know what the money was for.

"Why that is because she was kind and let me paint her," I explained.

Then she understood. She had stopped her work and sat there patiently, without thought of reward.

"You good, good woman," she announced with a broad grin. "You good woman, you come again."

Fort Babine

Hudson's Bay House, Fort Babine

You may "go in" or "go out" from Fort Babine either by way of Hazelton or Smithers. Both towns are pretty well "out" from Vancouver, Victoria or the rest of Canada.

Not many go in from Hazelton nowadays [circa 1946], for it is tough travelling on the old prospector's trail on foot or by pack horse. Forty soul-testing miles of the old trail took me right to the very top of a mountain and there, below, lay Fort Babine on the shores of the loveliest lake one could dream of.

Pack horses learn a trail better than men and are twice as wise. Tony West's old horse, Scandal, knew it better than most. He had been over it countless times and was acquainted with all its hazards. Scandal took his time on the journey, figuring, with good horse sense, that it was better to arrive late with his legs and pack intact, than never to arrive at all.

Today the trail is little used and is not kept open as it used to be when it was the only route into the never-never land of Lake Babine. Sometimes, when great storms roared over the mountains, big timbers were snapped off and laid across the trail like twigs. Travellers had to find a way over or around them.

When old Scandal saw such an obstruction ahead of him he stopped and leisurely looked the situation over. If he thought he could get past, with his loaded packsacks on each of his flanks, he would approach, very carefully, edging his way along, inch by inch.

If his pack stuck, ever so little, he would back out just as carefully as he went in and try another route. When he had exhausted all the possibilities of surmounting the obstacle, the wise old horse dismissed the matter entirely and decided he must go around. Eventually he would find his way through the wilderness, back on to the trail ahead and, always he came up to the mountain top triumphant—with his pack secure.

The rest of the trip was easy for Scandal. Even though difficulties might be encountered, he knew the trail's end was in sight with the reward of rest and food and, at last, good grazing in deep pastures until the time came for the return journey.

Large pack trains used to traverse over the Hazelton trail in the old days, sixty mules to a train. On arrival at Fort Babine their freight was transferred to a couple of sailing vessels, each carrying seventy tons, and transported down the lake to Topley. There it was loaded on to another pack train and taken, overland, to Stuart Lake where, once more, it went by boat to Fort St. James.

Fort Babine was an isolated place when I visited. In the winter, when horses and sleighs traversed the lake, the residents got mail once a month. During the summer, when the waterways were their only highways, they got it just whenever a boat happened along—which was very seldom.

The freeze-up comes before Christmas and everything is tightly sealed with ice and frost until well on into May. The fur season begins in the fall, when every Indian who is able, is out on the trap lines. By February piles of skins were accumulated at the Hudson's Bay Company post. These were baled and packed out by sleds and horses down the lake to Topley and the Canadian National Railway line. It took four days of hard going to get there and four days to return again with time out for eating and sleeping (as camps had to be made en route). From Topley the skins were shipped to Montreal where they were graded and sent on to England. There they were auctioned at Beaver House in London.

For the Indians of Fort Babine life had not changed greatly from the old days and the old ways. They are still the children of nature, little influenced by their occasional contacts with white people. They have borrowed a few customs from the neighbouring Tsimshian Indians but they are Carrier Indians with different traditions and different background.

The Carrier's migrations took them north and south but rarely were they inclined to travel east or west. They derived the name Carrier from the fact that, in the early days according to custom, a widow was obliged to carry the charred remains of her husband [after cremation] in a skin pouch, constantly with her until the pre-scribed mourning period of two or three years was over, when she was then free to marry again—if she survived the ordeal.

Men going over the Hazelton trail had to be prepared to hack and chop their way through innumerable windfalls. They always tried to get over the summit before nighttime because it was a favourite rendezvous for grizzly bears. No one would willingly pitch his camp there but would push on, even in the dark, toward Fort Babine and safety.

When I was painting Indian portraits in villages along the Skeena River I never dreamed I would have a chance to "go in" by either of the routes but when Jim, the RCMP constable and Jeff, the Indian agent, offered to take me in tow on one of their rare trips to Fort Babine, I jumped at the opportunity in case they should change their minds.

"All you need is a sleeping bag," said Jeff.

"You can have mine," volunteered the genial manager of the hotel at Hazelton who was all for adventure and new experiences.

So off we went early one bright September morning with mists rising from the river and autumn lying like a halo on the quiet land. It is hard to believe that this country is in the very heart of British Columbia. It always had seemed north to me—north of everything I knew but actually it is in the dead centre of this vast province.

If you would like to see it at its best, go in September when the world all around you is a rich tapestry of green and purple and gold. When the nights are crisp and frosty, the stars brittle and bright and softly drifting fog banks cover the river in the early morning. Soon a wandering breeze lifts it and carries it up, twining it like some ethereal scarf from another world, around the throat of the moun-tain. A round, red benevolent sun creeps up and disperses it entire-ly. Then you find yourself discarding that extra wrap, so welcome an hour earlier.

All through the long afternoon you breathe the clean, sweet smell of pines. Breathe deeply of the keen, tonic air and store your memory with the vast, rugged and majestic scenes that will forever

remain an incalculable repository of grandeur for you to draw upon. The lush, green valley runs along beside you and the imperturbable mountains tower above you, ever more grandly, as you proceed toward Smithers.

Externally Smithers is just another town with no particular character except for a feeling of potentiality. It is a railway centre and, during the war, was a very "hush hush" place because of the huge aerodrome built there. Few British Columbians knew the aerodrome even existed.

Leaving Smithers, the Bulkley Valley unrolls before you in an ever-changing panorama of form and colour. Every turn of the road reveals new horizons and everywhere the poplars clothe the hills with a garment of gold pierced with the dark shapes of the evergreens.

Babine Lake

Occasionally you are startled by little isolated farming communities when you suddenly come upon them. They seem to have been dropped there by some omnipotent giant from another world. Dutch farmers have cultivated dark green rows of spinach instead of their native tulips. They grow it for seed, not for food, and do so with conspicuous success.

This is a land of abundance. The streams are alive with salmon at this time of year. Deer and goat are numerous in the mountains; pheasant and grouse are plentiful.

The road winds and curves by the river, around the mountains, following the line of least resistance. Years ago it was a rough path which the moose had made. Then came the Indians, following the moose. Later came the prospectors and settlers, walking in the footsteps of the Indians. It still remains for man to find a better route than the moose had instinctively chosen through this lonely, misty and intriguing land.

▸ *colour plate page 172*

There are few lovelier villages than Telkwa, "the place where the rivers meet." Rivers, in this case, being the Bulkley and Telkwa. Strange forms some of the mountains take. "That's Jack Barret's hat over there," Jim announced, pointing to a far peak which plainly was shaped to fit some super being's head. Jack Barret had been an old-timer hereabouts. Long since gathered to his ancestors, he had been immortalized by the mountain (or at least his hat had).

We were approaching an enormous stone standing by the side of the road, as though some giant had carefully placed it there. "That is the marriage stone," Jim informed me. "In the old days Indian maidens chased their sweethearts around the stone. If a girl caught her man, she had him for keeps. If she was slow of foot and he got away, it was just too bad for her."

The road ended at Topley. From there on it became just a good trail—the same trail that the moose, the Indians and the prospectors had followed, not so long ago. Wagons could manage it with ease but cars did not take kindly to its undulations.

The back of our car was piled high with things for the Indians and I was wedged firmly between Jim and Jeff, both six-footers and wide in proportion, so there was not much danger of me getting bounced out. Jim had been over the road before, many times—so had the RCMP car. They both knew the best way around the bumps and through the puddles. We could not have made the trip with more comfort and safety.

Presently we were passing through a vast cemetery of dead trees. Fire, the despoiler, had been at work and here was dreadful evidence of its consuming power. Stark, tall, blackened and ghostly the naked skeletons of thousands of trees stabbed the bright, blue sky. Mile after mile they crowded to the roadside, gaunt, accusing and depressing. It was a forest of the dead. Leaving it was like going out of a morgue, so heavy on the heart was the feeling of desolation. Here and there, as if to offer a ray of hope, fireweed was bravely trying to hide the wounds and scars with its bright pink brilliance.

Then came the meadows, the Moose Meadows, a lovely lush, green valley as verdant as the dead forest had been barren. Where you can see the lordly moose quietly grazing at almost any time of day, feeding off the low, succulent willows which grow in great abundance.

No other travellers disturbed the sanctity and solitude of this

261

Indian village near Fort Babine

wide land. Up and down over the trail we went, ever winding toward the lake and, there at last, in the gathering dusk, we caught a glimpse of the waters of Lake Babine at Topley Landing.

Several comfortable cabins had been built on the lake shore to accommodate wayfarers, mostly hunters who found their way to this remote spot. Fortunately for us, two of them were vacant. Manlike, Jim and Jeff unloaded the commissariat into their cabin and carried my belongings into the other one.

I had asked no questions when we left Hazelton as to the where, when, what, how or why of anything and had expected that my sleeping bag was meant to be thrown under a tree with me in it, or maybe to hang from two convenient boughs with, perhaps, a grizzly bear sniffing at my toes. Being deposited in a snug cabin for the night was a pleasant surprise.

I felt like a fifth wheel as I watched the two men skilfully getting dinner ready. "Did you ever eat billygoat?" enquired Jim.

"No, honestly, I never did but I am willing to try anything once."

"Well, you are going to get it tonight."

Jolly good it was, too, equal to the best beef. Jim was a good shot and his wife was equally good at canning mountain goat. We dined royally and went to bed early in order to get a good start up the lake in the morning. There were good beds in the cabins and pil-

lows but no bedding. My sleeping bag was warm and inviting on the mattress. All I had to do was zip myself into it and doze off.

I awoke next morning to the compelling odour of frying bacon being wafted to me from the cabin of my two gallant companions. Funny what the woods does to your appetite. Usually I eat very little breakfast but here I was as hungry as a lumberjack.

It was a morning of unbelievable beauty, so I hurried off to paint a sketch while the men brought the boat around and transferred our luggage into it from the car and cabins. It took some time to adjust the motor, fill up with petrol and get everything ready for the journey upon the lake. I was just putting the last strokes on my sketch when the men shouted "board" and I was with them in a jiffy.

After a few asthmatic coughs from the engine, we headed for the middle of the lake, leaving a long, curving wake of foam trailing behind us on the calm surface of the water. What a lake! And what a day! What good companions, what beauty all around us! We were alone, absolutely alone in a wide and wonderful world. No breeze ruffled the tranquil water, no bird called, no leaf stirred. Vast, billowing, imponderable was the utter silence and the immensity of it all. The lake was a gigantic mirror reflecting its blue to the heavens above. Only the occasional leap of a salmon disturbed the glassy surface. Along the shores the dense poplars, yellow-green and the dark conifers cast their images into the deep water and, marching over the mountains everywhere, were the regiments of autumn foliage in riotous colours.

Here, in this ravishing universe of abundance and diversity, we seemed strangely apart from the world at war and of greed and competition. We were creatures in another and better form of existence—one with the primeval splendour of nature, able to interpret, in some small degree, the inimitable script of the Master craftsman who had imprinted His hand on everything about us.

Our boat was a cabin cruiser, very old and not too safe in my estimation. Water was leaking into her steadily and the two men took turns bailing. They analysed the situation and declared that they were bailing at the rate of 120 gallons per hour. Thinking I was superfluous in a labour confined to two, I established myself, with my paints, in the bow of the boat. I could see wonderful scenes approaching for quite some time before they passed and worked furiously to capture something of their fleeting glory.

This I did throughout the whole livelong day. What matter that I grew weary. Days like this were rare. Opportunities like this might never occur again. One scene after another I sketched in water colours, as they sped by.

At the back of the boat the faces of Jim and Jeff were occasionally visible, looking forward over the cabin as they took turns at the wheel. When I finished a sketch I held it up for their approval. Immediately there were loud cheers of acclaim and delight. Never did an artist have so encouraging and so uncritical an audience! Thrilled and enthused, I would start another sketch. I was going at it fire and tongs when suddenly the motor was cut off and we moved toward a quiet little bay with an inviting, sandy beach.

"Mug up," announced Jim and I realised that the sun was high and stomachs calling. I had been working with such zest that I had utterly forgotten there were such mundane things as pork and beans and fried eggs. Not so with Jim and Jeff who quickly set up a little gas stove and produced a meal fit for gods.

Piping hot tea—and lots of it. You do not know what a heavenly elixir that is until you sip it from a mug in the bow of a boat secured to a sandy beach with your legs dangling over the water. We loitered for a short while, then pulled out into the centre of the lake again, refreshed in body and soul, and settled down to the routine of the morning—painting, cheering, bailing and steering as the hours and dazzling scenery slipped by.

Presently we could see a little settlement tucked in among the hills. There was a tall, white spire and red roofs. "Old Fort," yelled Jim above the roar of the engine. "We'll be stopping there coming back."

There were no signs of life about the place and we were later to know the reason.

As the afternoon was waning, we approached our destination, Fort Babine. The arrival of a boat was an occasion that warranted a welcome from the entire population. All the white people in the settlement awaited us. They were not a very large group at that—just the Hudson's Bay Company manager and his wife, his assistant, the priest, the school teacher and the nurse. Behind them were a few Indians and back of them were hundreds of more Indians.

The Hudson's Bay Company manager took me to a gleaming white house on the hill top. It was attractive, comfortable and very

well furnished. Everything in it was supplied by the company from silver and china to linen and film for a camera. "All you need to do," I was told, "is walk in with your suitcase and take possession."

As soon as I put my luggage down I sat on the back step and began making a sketch of the Indian village with the lake beyond and the mountains towering above. It was all so new to me and so vital I could hardly wait to record it. I could see an old woman scraping a large moose hide and a great deal of salmon hanging up to dry.

That same evening a provincial policeman and another man arrived by way of the Hazelton trail. They increased the white population substantially. There must have been nearly a dozen of us by this time.

Down on the beach were a cabin and a tent which provided temporary shelter for the transient visitors. I was to be a guest at Hudson's Bay House, Jim was going to sleep in the boat and Jeff was allotted the tent. The other two men took possession of the cabin. Visitors were such a rarity here that they were always very welcome.

That evening my hostess and I walked down to the cabin to join the crowd. It was mug-up time and the men were in shirt sleeves. There were a few extra cups—not Royal Doulton to be sure—but they held tea and some of them had handles. What more could you ask?

Presently Jim and Jeff joined us. "This is going to be a field day for you," said Jeff to me. "There are Indians here from all parts of the country. Every house is full."

Good news, indeed. If there is one thing I like better than Indians it is more Indians. It looked as though I might be really satisfied this time as to both numbers and diversity.

I was surprised to find myself sleeping in a nice bed again with all the comfort of a city home. It was so amazingly quiet I could not sleep, except by snatches. The silence in these remote places is different from anything you have ever known before. You can feel it in every fibre of your being—you can almost reach out and touch it with your hand, so tangible it is.

I was awakened [from one of my short naps] to strange sounds. Surely there could not be burglars in this far off spot and, if there were, why didn't they follow their pursuits more quietly? It sound-

ed more like a drunk man but where could he get whisky hereabouts? Jim and Jeff certainly did not bring any and the provincial policeman did not. Surely it could not be the Indians. Why were not the big dogs at Hudson's Bay House making a fuss?

Clump, clump, bang, bang, rattle, rattle it went on intermittently. After a while I dared to crawl out of my warm bed to peek through the window. A large phantom-grey shape passed below me. It was Scandal, the policeman's old pack horse, having a good time knocking over all the tin cans in which geraniums had been carefully planted. When he could not kick a tin, he settled for the whitewashed stones around the flower beds. There was not much around the place that old Scandal had not pushed over by morning. So much for primeval silence!

The next day I found the Indian village to be picturesque in the extreme. The sun shone brightly on the unpainted houses, turning the drab boards to a rich gold. Women and children were gaily clad and on the fences were thrown quilts and blankets of every imaginable hue.

Early in the evening I could hear sounds of revelry from across the way. I hurried to have a look. There was a heterogeneous group of all ages, straggling down the hill, rattling cowbells, tin cans, pails, anything that would make a noise. They stopped at each house as they went along and added to their numbers. At the bottom of the hill was Sarah Bouquet's home and it transpired that the demonstration was in her honour—hers and Joe Manson's.

They had been married that very afternoon and this was a chivari, Indian style. They had all gathered at Dominic West's hall first, then came, singing and shouting, down the hill to where the bride and groom lived to serenade them and to give them candies. Next morning the ground was littered with the tin cans on which they had been banging.

Sarah was a lot older than Joe but she had a good house and they were both alone in the world. She was also clever at tanning hides— a virtue not to be despised in an Indian wife. Indians love celebrations of any kind and this marriage merely provided an outlet for their natural carnival propensities.

Later in the day another group came down the hill and one of the men carried a "calling stick," going from house to house, tap-

266

ping on each door and inviting the occupants to a potlatch to be held that night.

Percy Foster, who had come in over the Hazelton trail and was well known to the Indians, and Don, assistant at the Hudson's Bay Company store, had been invited to attend. I was green with envy. "Oh, I wish I could go. I would love it."

"Come along with us," invited Percy. "It will be all right."

At eight-thirty it was pitch dark but we stumbled over a crooked little path with flashlights and went up the hill to Dominic's hall. Dominic is not

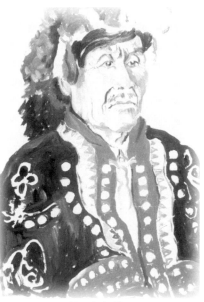

Dominic West

a chief but he is a born leader and a very likeable chap. The chief was getting old and preferred to sit by his own fireside so it was left to ambitious folk like Dominic to uphold the traditions of the tribe.

Dominic was a good trapper and used his money wisely. He had built this large hall himself and got revenue every time it was used—which meant practically every night at this time of year. He had carved a rude totem pole which stood just outside the hall and this, he thought, gave added distinction to the place and bolstered his own reputation.

A few Indians were there when we arrived, Dominic among them. My companions introduced me, telling him about my work and explaining that I belonged to two different tribes in other parts of the country.

Soon Indians of all ages came pouring in—old folks hobbling along with sticks, infants in arms, young men and maidens—whole families. There was nothing noisy about the gathering. Indians are not boisterous people as a rule. They chatted with animation in soft, musical voices. Several different bands were there with their chiefs. I was told that one clan or crest gave a potlatch one night and another the next. Two clans never held them together.

267

Soon the hall was filled. Chairs were found for Percy, Don and myself. I sat among them with complete impartiality. People were sitting in double rows, on benches, all around the hall, facing each other. Some of the younger men came in with rolls of building paper, about two feet wide, which they spread on the floor between the two rows of people. This served as a table and on it were piled heaps of food before each person—dried salmon, huge packages of hard tack and innumerable boxes of corn flakes.

Everyone had a deep soup plate and a generous helping of soup was served from big enamel vats. Young men moved about with thick white cups. Others carried between them enormous enamel containers filled with very strong, half-cold, tea to which had been added copious quantities of sugar and canned milk. We had one cup for the three of us and we all cheerfully used it in turn.

The dried salmon looked like nothing in the world so much as old shoe leather but it tasted all right if your teeth were well anchored. From our three chairs, at the end of the room, we could see all that was going on. From time to time a new chief was brought forward to make my acquaintance. They were very eager to explain everything and did all they could to make me feel welcome.

Quantities of food were left over after the feast. Huge sacks of it had been distributed and each person could take home all they failed to consume. An old, crippled woman near me was given a 100-pound flour sack and she filled it to the brim, shaking it and pushing its contents down [in order for it] to hold more.

When the feasting was over, everything was quickly cleared away. Once more the calling stick came into action. Someone went around and tapped each important guest to the place where they were to sit. When all was in order, the fun began.

It was a lively and colourful scene. Those who had no benches or chairs sat on the floor in little clusters. Here and there a woman tumbled out her breast with total unconcern, and calmly nursed her baby. Little boys played pranks on the oldsters and little girls peeped shyly from behind their mother's skirts. One wee tot of about four was a picture for an artist's brush with her little pink dress and a large resplendent lady's hat which had been tied firmly under her plump little chin.

Once, during the evening, a baby began to cry lustily and its mother tried vainly to hush it up. Soon, the father crossed from the

other side of the hall, took the child in his arms and cared for it the rest of the evening. I saw him carrying it home very much later, sound asleep. On the whole, the children were quiet and well behaved.

Dominic was master of ceremonies. He announced every event. Helpers shouted from the corners of the room that which was being given away and the name of the donor. I was astonished at the amount of money in evidence. I had thought of these people as being poor in this world's goods but, men and women alike, pulled out rolls of bank notes and waved them as their contribution. Lots of laughter, banter and gleeful jokes accompanied the giving.

Dominic explained to me that it was a charity feast, given to all present. People just loaned the money he said. Those who received it paid it back at the next potlatch. He did not tell me the rate of interest, for usually the recipient is expected to return at least double the value received. It was so in the old days.

Much good clothing was given away, women's dresses, hand-knit sweaters, pullovers, coats, Hudson's Bay blankets and flan-nelette sheets. Whole bolts of cloth were torn into lengths and given away. To me, one of the most interesting things of all was a huge moose hide going the way of all the other goods. It was big enough to cover a double bed.

I was glad to see a little crippled lady getting lots of money and much good warm clothing. This would be for her to keep, I was told, and she was not expected to give at the next potlatch as were others. [Inasmuch as potlatches were illegal, Jim and the provincial police-man must have turned blind eyes.]

From time to time Dominic went around with a little skin pouch containing eagle down. This was another of the good and beautiful customs common to most British Columbian tribes. Usually the down was sprinkled over the heads of those whom they especially wished to honour, but tonight Dominic dropped it gently on the heads of those who recently had been bereaved, as a gesture of sym-pathy and respect.

It was early in the morning before the celebration broke up and we stumbled over the rough ground and through the barbed wire fence back into our own territory for a few hours rest.

I had not reckoned on the dogs. Around every Indian village are innumerable dogs and this was no exception. There were hordes of

them. They knew, as well as we did, that a potlatch had been going on. Where the Indians left off, the dogs took over and their throaty revels lasted until sunrise.

Sometimes they would quiet down and all would be still for a whole half hour. I would just begin to feel the first evidence of divine slumber when some canine fiend would let out a long, loud, dismal wail. Instantly there would be another equally long, loud and dismal wail from another part of the village. Then there would come an answer from some other quarter and soon every last dog in the village would be in on the cacophony.

At last, one or two, tired in the jaws, quit. A few more dropped out from sheer exhaustion and gradually the unholy din subsided. By the time the last ones stopped the first ones were ready to begin all over again. I expect one might get used to it in time, but I would like to have wrung the neck of every canine in the north country!

In my comfortable quarters at Hudson's Bay House I was somewhat concerned about Jim and Jeff. The boat had a cabin with seats along the sides which were covered with old automobile cushions. These were Jim's mattress but the seats were narrow and Jim was wide so I wondered how he fared and what he did about the "overhang" part of him. I noticed that he was up early every morning with the excuse that he was looking for ducks but he did not fool me. I had visions of the whole 230 pounds of him, zipped up in his sleeping bag like a huge cigar, draped precariously over the narrow bench. One false move and he would be on the deck with a thud. I was looking for signs of bruises but, if he had any, they were where they did not show.

Meanwhile Jeff, I think, was more comfortable in the tent. The nights were cold with a touch of frost but he had a sleeping bag and plenty of room. Jeff was longer than Jim but not nearly so wide, so his problem of distribution was very different. He did not hang over the side as did Jim but there was a generous surplus at both ends. I expect such people become expert at doubling. Jeff must have mastered the art, for he always looked well rested.

He had a surprise, one night, though. The teacher and the nurse, who happened to be man and wife, lived in a wee house beside the tent and when they put their cat out in the cold it ventured in quest of comfortable lodging, curiously poking around the tent. What could be more inviting than a nice feather-padded sleeping bag?

Carefully she crept into the very bottom of the bag and settled down for a good night's rest.

When Jeff stuck his long legs into it later in the evening, he got a shock when his bare feet met pussy's warm, soft body. Why he hauled her out is a mystery to me—on a cold night—and he with no hot water bottle.

Jim made periodic visits into this lonely land, carrying the might and majesty of the law upon his broad and capable shoulders. He knew most of the Indians by name and was equal to any emergency. On one occasion an Indian woman, who was quite well to do, came to him and said she wanted to get rid of her common-law husband who refused to leave. She had many possessions, of a kind, including a good red wagon but she did not want the man.

The policeman told the man to surrender the wagon to the lady, who was the rightful owner. The man said the wheels of the wagon belonged to him. He had put new ones on it and had paid for them himself. This complicated matters so the policeman compromised by saying the man could have the use of the wagon for five days. After that he must turn it over to the lady for keeps.

Strange are the ways of mortals. It was just as hard to separate that couple as it was to divide the wagon. Eventually they decided to bury the hatchet, made up the quarrel and lived together again.

Portraits at Fort Babine

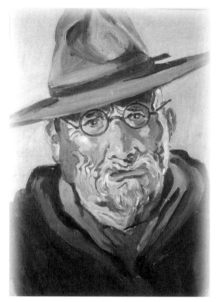

Old Chief, Fort Babine (RCMP hat)

It was fun painting at Fort Babine. Due to the generosity of Miriam at Hudson's Bay House I was permitted to do the work in her comfortable kitchen.

I painted Dominic first, all "dolled up" in his button blanket and his fancy head gear. He was visibly flattered about sitting and doubly pleased when I paid him for doing so. The blanket was really but a poor imitation of those worn by the Kwakiutl tribe but it was decorative and looked official, which was important to Dominic. In order to get it he had to give a potlatch and all his people gave money to help him with it. The blanket was given by another crest or clan. According to their traditions, his own wife could not make it—someone else had to do it. The other clan gave it to him but he had to pay for it by giving the potlatch.

Dominic has a comfortable house and his wife is a good house-keeper with one of the cleanest homes in the village. He looked more French than Indian and was quite loquacious.

▸ *colour plate page 170* 272

Roman Catholicism has been established on this reserve for a long time with nearly always a French priest in charge. Many of the Indians have French names. I was told that all of them attend church as regularly as they eat and sleep and they could recite reams of Latin though they could not understand a word of it.

I wanted to paint the old chief who went around with a twisted stick for a cane and always wore a mounted policeman's hat. No one ever saw him without it. He spoke very little English and seemed thoroughly puzzled about what I wanted to do. He sat gazing at me for nearly an hour with bewilderment written all over his face. Afterward, when he was going down the hill, he met Jeff who asked him about the portrait. His reply was brief and positive: "No good."

That made Jeff really curious to see the picture, so he came up to inspect it. Everybody else thought it was one of my best efforts, so perhaps the chief had an exalted idea of his own features. It is just possible, too, that he had never looked in a mirror.

Then there was Rosie. She was the wife of Daniel Leon, a smart, arrogant fellow who kept all the others guessing. He was usually a few jumps ahead of them in his thinking and Rosie thought him a very smart man.

Daniel and Rosie lived down the lake at Topley Landing and only came to Fort Babine for special occasions. There had been a time when they were a permanent part of the population at the fort but that was before "the trouble."

Daniel had spent the early part of his life in that area. Sometimes he used to go to Hazelton over the old prospector's trail when he always made it a point to look in to see Dr. H. C. Wrinch, for whom he had a profound regard. Dr. Wrinch was the pioneer doctor in the district and founder of the Hazelton hospital.

How it happened, no one knows, but it transpired that

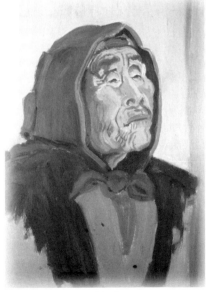

Rosie

▸ *colour plate page 174* 273

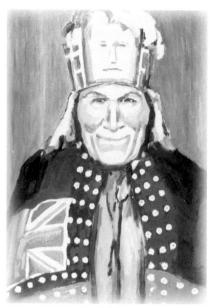

Daniel Leon

Daniel was once on the scene when the doctor performed an emergency operation for appendicitis. He just made a little slit, lifted out the offending organ and deftly sewed the patient up in short order. The patient got well and stayed well, too. It all looked very simple and easy to Daniel and he never forgot it. Years afterward, when Daniel and his brother Jim were far away on a lonely trap line, his brother suddenly took ill with severe pains in his side. Daniel managed to get him into a cabin where he diagnosed the case to be appendicitis.

Memories of Dr. Wrinch and the operation at Hazelton came flooding into his troubled mind. Of course, why had he not thought of it before? All his brother needed was to have his appendix removed. Dr. Wrinch had done the trick, why couldn't he?

How he convinced his brother of the feasibility of such a scheme is a mystery—perhaps he was beyond caring. Daniel pondered deeply as to just where the little piece of mischief might be lying. He pushed up his sleeves, as Dr. Wrinch had done, and valiantly used the only instrument he had, his old hunting knife. In two ticks he had explored poor Jimmy's tummy, chopped off the appendix and sewed him up with a length of fishing line. Looked like a mighty neat job to Daniel as he surveyed his handiwork. Pretty soon Jimmy would be out on the trap line again. "A lot of hooey, all this fuss about doctors and operations," quoth Daniel. "Anyone can do it."

Alas, poor Jimmy was a great disappointment to Daniel. He never rallied from the shock and the next day his weary soul departed for a better world. Daniel was now faced with the awful culpability of his brother's death. Somewhere in that isolated land he buried him and returned to Fort Babine, a sober and saddened man.

▸ *colour plate page 174*

Weeks went by, and when Jimmy failed to put in an appearance, questions were asked. There were doubts, fears, suspicions and dark thoughts directed at Daniel. Finally the matter was reported to the police who arrested Daniel and accused him of his brother's death. When he was brought up for trial he stood up and spoke in his own defence, saying, with incomparable and irrefutable logic: "Sometimes Dr. Wrinch lose 'em. Maybe I lose 'em too."

Nothing much you can do about an argument like that. The judge gave him a good talking to and let him go with a warning never to use a knife on anyone again.

Since that time Daniel and Rosie have lived at Topley Landing. He had always been powerful in councils of the tribe, so the tribe continues to show him a certain deference but will not allow him to live at the fort any more.

As may be expected, Daniel is the sort of man to have strong convictions on many matters. He is death on home brew—so ruinous to many of his race. Once, when he was at the old fort, he found several barrels of the stuff. Without the least compunction he calmly smashed each one and, with great satisfaction, watched the last drop trickle into the ground. The Indians who owned the brew were furious but dared not say or do anything, knowing that Daniel is clever and influential. To incur his anger and antagonism might have results far more disastrous than the loss of several barrels of bad whisky.

It is a pity that there are not more Indians who feel as Daniel does about drink. At Fort Babine they are deprived of many things that would benefit their health and which they could freely obtain but for this weakness.

"Do Indians bake bread?" I asked, as my hostess turned her plump homemade loaves out on the kitchen table. Of course no bread is shipped into that remote place.

"They can and they ought to but we cannot sell them yeast because they will use it for home brew. The same is true of canned fruit. We have it in the store and they need it for their diet but they use it for fermentation, so we cannot sell it to them.

"They eat lots of pork and beans, spaghetti, rice and potatoes but their chief food is salmon. They make bannocks and also a sort of sour dough which they bake in the oven. When the season is on,

they get huckleberries and some of them go to the trouble of canning them."

White men's food, without a balanced diet, is not as good as the Indian's natural food. Few of the older Indians have good teeth nowadays. I have never heard that there was gold in this country but there is plenty of it in the mouths of the Indians. The nearest dentist is at Burns Lake, 140 miles from Fort Babine, so getting to him is a major undertaking

Before they started eating white men's food, the Indians had good teeth. Nature, it seems, is a better guide than science in these matters but Indians imitate the whites and lose their teeth as a consequence.

Family allowance makes a big difference to school attendance. Whole families used to go out on the trap lines and children would be out of school until the season was over. Now most of them are kept in school so that parents can collect the money.

Indians are fond of sports. At Christmas and New Years the Indians of Fort Babine hold a big hockey match with the Indians of Old Fort who travel up the lake on sleds for the event.

When not indulging in white men's fare, they live bounteously off Mother Nature, never lacking for fish or fresh meat. During the war, when many foods were in short supply, nothing was rationed at the Hudson's Bay Company's trading posts. Quantities of the best canned foods were always available and the countless barrels of sugar at the fort would have caused a riot in the southern cities.

Old Rosie got a thrill out of being painted. She was a friendly, jovial soul with much character written on her face. Mrs. Barwick, the nurse, came in to watch and, with Miriam in whose kitchen we were assembled, we made a jolly foursome. Rosie laughed

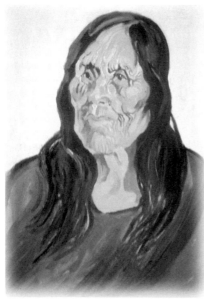

Melanisse

276

fair to split her sides when she saw the painting. Perhaps, like the chief, she had never looked in a mirror.

I painted Melanisse too—poor, old Melanisse, whose face, Miriam said, always reminded her of a skull and crossbones. Melanisse's eyes did not match but that was because, when she was a child, a dog had bitten part of her face away. At seventy-six her hair was black as a raven's wing and hung loosely around her gaunt shoulders. Her face was crisscrossed with myriads of tiny seams. Her figure was thin and spare, yet every winter found her far out on the trap line, alongside those who were half her age.

Babine River

All the Indians were much interested in what I was doing but they could not figure out my relationship with Jim and Jeff. Being concerned for my respectability, they spoke of me as Mrs. Indian Agent, much to the amusement of the white minority. The Indians did not call Jeff the Indian agent but dubbed him "the long fellow," which was a very apt description.

Babine Lake is the largest lake in British Columbia, being 110 miles from end to end. Babine River flows into it from the north. Nilkitwa is the Indian name for it, which denotes an abundance of fish.

Thousands of salmon make their way through the river annually into the lake. For statistical purposes the government built a fence across the river, at a cost of $9,000, in order to count the fish going through. Suspicious of anything that interfered with nature's methods, the Indians complained that the fence threatened their fish supply, thinking the fish were being held back by the fence. To satisfy them, Jim and Jeff determined to investigate and see for themselves if this was true. The day they had chosen for the project we awoke to a cold, windy morning with drizzling rain but Jim said I had to go along whether I wanted to or not. One doesn't argue with the Mounted Police so I submitted to being bullied into a project I was eager [in any case] to undertake.

The men had secured a riverboat for the trip. The Indians make these special boats themselves and they exactly suit the purpose. They are about thirty feet long and four feet in the beam and deep enough to carry fifteen men or a good load of freight. They are propelled by a "kicker" at the stern.

Big Matthew came with us. He was an unusually tall, well-proportioned man and quite good looking. He walked with a sort of feline caution and was always appearing where you did not expect him. Creeping Casper Mrs. Barwick called him—which leaves room for a wide variety of interpretations. Big Matthew was a good river man and there were many things I learned from him on the trip.

It was open season for ducks so Jim and Jeff had brought their guns along in the hope of winging tomorrow's dinner. They had

their fishing gear also. Failing duck, they were confident of landing trout or salmon.

The scenery on Lake Babine had stirred my artist's heart deeply. Upon reaching the river the scenery continued to stir me, but it was altogether different. Something that was intimate and idyllic, passive and gentle, pervaded the landscape. The river idled in and out of many a curve. Now the water was very deep, now it was so shallow that you could count the pebbles on the shining river bed beneath the boat. Peering into the crystal depths you could see myriads of salmon, mostly plump or "humpies" as Big Matthew called them. Occasionally you would catch sight of an enormous fish, the grandfather of them all, which moved majestically among its fellows. This was the mighty spring. As you watched, the whole river seemed in living motion. From shore to shore was one great, writhing, wriggling mass of salmon, richly red, all in a terrific hurry to get to their final destinations.

They were travelling at thirty miles an hour, which is good going, even for salmon. So dense was the movement that there were times when we seemed to be moving through fish rather than water. Big Matthew said that spring salmon were four or five feet long and fully a foot in thickness. "When I'm a young man," said he, "big skookum young man, I hook him—salmon, spring salmon. He pull hard—too big for me—pull me right into the river, him so strong."

Life along the shore was fascinating. We never saw people but there were signs of them. At intervals there would be a small haystack; here and there a cache for food. The latter were well built, like tiny houses on stilts that were bound with metal to keep mice from climbing them. Once I saw a black bear ambling off through the bushes. The gulls, white and beautiful, formed lovely patterns against the stormy blue of the mountains as they swung gracefully above us.

A keen-eyed fish hawk soared alertly about looking for his dinner. From a great height he could clearly see the little rainbow trout in the water. This was his favourite diet. He soared blithely around, then suddenly there was a straight plunge, a splash and, in an instant, he would be aloft again with his prize held firmly in his talons. "See him," called Big Matthew, "fish hawk with little fish high in air." He was too far away for me to distinguish details, but

many Indians have marvellous sight and see many things that escape our vision.

Once we heard the far [off] tinkle of a bell and knew that an Indian cayuse was grazing within call of its owner. Otherwise there was no sound but the steady cadence of the engine. The bigness and silence of our surroundings enveloped us completely. When we spoke our voices instinctively dropped to a low register as though we felt it would be irreverent to speak in normal tones. The tranquillity, the utter peace and majesty of this lonely land pressed into our consciousness with an insistent power. In this wide, primeval world we were of equal consequence with the minnows in the water or the late bee making for his late clover.

The hills, the trees and the streams seemed to hold impenetrable mysteries in their keeping—we were interlopers. Our presence was suffered for a moment and when we had slipped by there would be no trace of our passing. The walls of silence would close in behind us and it would be again as it had ever been—deep, calm and holy— the very sanctuary of God.

Sometimes we were so lost in contemplation that the boat would drift into shallow water before we noticed. Then Big Matthew would stand up and gently pole us out into the main channel again. From time to time small flocks of wild ducks flew over our heads, their wings beating the still autumn air. The low tone of Big Matthew's voice, the dip of the pole, the sudden splash of a salmon leaping high in the air—these are all indelible impressions etched upon my mind.

Big Matthew pointed out places of interest as we went along, hour after hour. Sometimes we saw Indian cabins, half hidden in the shrubbery. The poplars, tall, ethereal and slender, their white trunks standing out in dazzling contrast to the dark pencil-slim spruce trees standing shoulder to shoulder in the background. Clumps of golden foliage showed up against the blue and purple of the mountains, great glaciers coldly glistened on the incredible heights, cumulus clouds drifting lazily over the vast skies and always the river, winding like a shining satin ribbon through the land.

Here was a little white cross to mark the spot where an Indian woman had drowned not long ago. Now and then the weird, rattling cackle of the loon smote rudely on our ears. We passed a small smoke house in which we could see salmon drying. Dozens of great

black crows were loitering around, hoping to get a feed if there was a chance.

Further up the river many nets were draped over poles along the shore. The gulls were increasing in number. White and grey, old and young, they were larger and fatter than those seen on the coast. They fluttered like great white petals against the evergreen trees or stood in long white rows on the sandbars like beads on a string. A king-fisher darted past on swift wings, low over the water. The huge spring salmon and humpbacks struggled together to keep in the main channel.

"This is a born place for spring salmon," explained Big Matthew, meaning that they spawned here. Sockeye were here, too.

We were nearing our destination, the fish fence. Jim shut off the motor and we drifted silently toward the shore. It is estimated that the Indians take 60,000 fish a year in the vicinity of the fish fence. They thought that the fence was injurious to their fishing but they used to build dams, of sorts, themselves and used nets, which the government provided, to catch fish. Now they say, "You put in fence and it stops fish."

Actually it did nothing of the sort, only tending to funnel the fish down into traps where they can be counted as they transit the fence. The fence had been built entirely for tabulations purposes and had no effect on the fish migration.

As many as 18,000 salmon went through in a single day. There were four traps in the fence and every half hour an attendant let them out, one by one, and clocked them on an instrument hanging by a cord around his neck.

Swimming against the current, which rushes through the fence with great force, the fish plunge and leap again and again before they get into the traps. Hundreds of them become casualties, lining the shore with their carcasses. Getting over the fence, however, is not nearly so difficult as are the rapids and jagged rocks that must be negotiated in their journey to the sea. Records of their movements are carefully kept. Some of the fish are tagged to determine where they go and how long it takes to get there, etc.

Nature is careless and extravagant of life. Thousands of fish lie about, bruised, battered and dead. Many others are in the last stages of decomposition. All of them are ruby red in the water. The river

looks calm but the water boils through the fish fence. Already, during the season, they had counted 400,000 salmon.

A Mr. Eaton was in charge of the fence. During the summer he had the assistance of several university students but they had gone back to their books and he was now the only white man within many miles. It was an event to have visitors, and Mr. Eaton entertained us royally in his comfortable little cabin with his own homemade bread and cake, canned apricots and quarts of good, strong tea, which we drank from capacious enamel cups. He also had dried salmon that he had cured himself. Ever since I had sampled it at a potlatch, I had wanted more. I now received advice on the proper etiquette for eating it.

"You kind of pick it up in your fingers like corn on the cob or pick it off in small pieces to eat," explained Mr. Eaton.

It was delicious and very nourishing, too. After lunch I did a sketch from the window of the cabin looking down the river while my guides washed the dishes.

Returning was a memorable experience. It was even quieter than in the morning. We felt cut off from the world, cut off from strife, from work and worry—suspended in time in this northern paradise. Colour was rampant and intensified as the golden poplars and tall evergreens cast their perfect images in the clear water. High overhead a flock of geese, in a graceful V formation, flew toward the horizon. Their strident honking fell upon the heavy silence like sounds from another planet. Soon they disappeared—swallowed up in the measureless blue.

One knew that far up in the mountains grizzly bears went silently about their business and, doubtlessly, many a cautious and curious eye watched us from the thick growth along the riverbank but never a sound or a movement betrayed the creatures of the wild. Soon we would have vanished and the wilderness would be their own again.

Jeff was grieving to see thousands of lovely fish going by and not one that was willing to be his supper. We were in very shallow water now so Big Matthew poled over to a quiet backwater. Jim shut off the motor and there we sat, in absolute silence, as Jeff prepared his fishing gear. Over and over again his line was cast only to return empty. Now and then we caught sight of a pretty rainbow trout, light and sparkling among the struggling salmon. There was much exal-

tation when Jeff finally caught two of them. Then we thought that we had better be going but the motor had other ideas. It refused to start. Jim humoured and coaxed it and cajoled it and eventually got it to turn over. Like ourselves, it was loath to leave such a beautiful spot.

In and out we went again, over shallows and through deep water, around little islands. Sometimes we lost the channel and had to pole carefully until we found it again. I sat amidship and painted like mad, trying to catch some fragment of this fleeting glory. On and on we glided, under the bridge, at last, and into Fort Babine which lay quiet and serene in the fading light.

HoMEWard BouNd

Next morning we started on our homeward journey. Jim was up at daybreak with hopes of providing wild duck for our menu but the wary birds kept far away though some of them flew, insolently, over the Indian village as though they knew that an officer of the law dared not take a chance of shooting them over the houses.

We left Fort Babine early in the morning with most of the inhabitants at the wharf to see us off and wish us well. The weather showed signs of breaking and the skies were glorious.

The old routine of bailing and steering began again. The engine purred contentedly and, towards noon, we came within sight of Old Fort which is about halfway down the lake. The bright red roofs of the Hudson's Bay Company buildings stood out in strong contrast against the background of sky and cloud. This had been the first Hudson's Bay Company trading post in the area but now most of the trading was done at Fort Babine. Once a month the manager came down to Old Fort to distribute supplies. Otherwise, the buildings were no longer used.

Jim had a special reason for calling at Old Fort. Some of the Indians had asked him to look in and see how Old Adele was faring. There was no wharf, so we just ran ashore and jumped for the land. Absolute silence enveloped the village. There was not a sign of life. Flowers bloomed in the windows, wash tubs were overturned at the back doors, children's toys lay discarded on the beach but no door opened, no voice called.

Jim and Jeff started out in search of Old Adele. Being blind and ill, she was not able to go to Fort Babine with the others so the Indians had chopped a pile of wood for her, stocked her cupboards with food and gone off for a week without her.

From house to house the men went searching for the old woman with no results. I could see that Jim was becoming anxious. He said he was looking either for movement (an indication of life) or smell (an indication of death).

A little footpath ran through the shrubbery along the lake front. The men followed it and I tagged along, not knowing what to expect. We came to a little clearing where the merest excuse for a house was standing. I saw Jim's big form filling the doorway and heard him talk-

ing, so knew he had found the old woman—alive, thank goodness. That old house was not much better than a wood shed.

A tiny, shrivelled figure, wrinkled and unbelievably old, hobbled out, turning her sightless eyes to the sunlight. Two enormous dogs followed her. They had been her sole companions while the rest of the population was away. Had she died in their absence the dogs would have been the only beings at her side.

Old Adele could speak no English but did not require any language to tell what she needed. Jim and Jeff hauled off their coats and began sawing up logs and splitting wood. Before we left a neat pile of fuel was within easy reach for the old woman and sufficient food to last until the return of her kinsmen.

This is just an example of the varied duties and responsibilities which confront mounted policemen and Indian agents in the north. They must be men of many parts, willing, efficient and adaptable.

We ate our lunch then hurried away as a storm appeared to be gathering and we had no desire to be caught on the lake in our decrepit old boat should a storm strike. Dark clouds were scudding across the sky as we sped along on a fast current. Sharp showers came and went. When I could not paint outside, I did the best I could from within the cabin. One landmark after another was sighted. There was Bear Inlet at last and the Red Bluffs and finally we pulled into Topley Landing, thankful that we had made it before really bad weather had overtaken us.

Once again we slept in the cabins and next morning made our way into Topley. Here was the nearest post office to Fort Babine so we posted letters and purchased money orders. The entire population, six in number, was vastly curious about my portraits. They knew all the Indians within a wide area so, to please them, I unpacked my wet canvases and ranged them around the car in the open sunshine, putting on an impromptu exhibition while the car was being filled with gasoline.

There were shrieks of delight over the portrait of Old Rosie and the chief. "That's old Rosie, all right, the spitting image of her and the chief too. And that's just like Dominic, all in his button blanket and fancy hat."

"Poor old Melanisse—and she let you paint her—with that face!"

Such were the comments of my uncritical audience at the gasoline pump.

These then, are my memories of the trip to Fort Babine.

Cariboo Annie

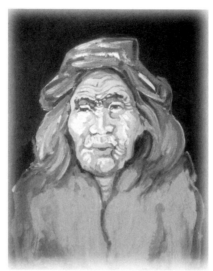

Old Annie

Whatever it is that makes an Indian like Old Annie live to the advanced age of 105, Annie had plenty of it. Long before I was on her trail I had heard of the tough little Native woman who had figured so vitally in the lives of many people now living in the Cariboo.

Goodness knows how many of them owe their lives to her, for she had been a famous midwife over a period of sixty years or more. She had ushered hundreds of children into the world, so old-timers say, and it was her proud boast that she never lost a baby. With none of the newfangled notions such as sterilization, twilight sleep and anaesthetics to aid her, she had beaten the doctors at their own game. She knew exactly what to do and she did it with promptitude and skill.

It has been said that some people are born with green thumbs because all growing things respond to their touch. Likewise, artists, musicians, scientists and doctors are supposed to be blessed with certain talents. They come into the world with hands predestined to a special task. This was also true of Old Annie. A quirk of fate had

286

placed her on an Indian reserve but nature had equipped her with the sure, deft, intuitive hands of a surgeon. She had never heard of the word obstetrics, but her instinct unerringly chose the right method. Doctors and nurses were amazed at her ability to handle some of the most difficult and dangerous cases with the ease and confidence of a specialist.

Old Annie's hands were nothing much to look at. They were thin and brown like withered leaves after an autumn rain. If she had an ego, you would never suspect it. She had not asked for the job of midwife or the fame that went with it. Had she been born in another environment, Old Annie might well have been a noted healer. Yet, who knows whether, in the long run, she would have rendered any greater service to mankind than she had so freely given in the lonely isolation of the Cariboo in her earlier days?

Some people believe that we each have a guardian angel hovering above to protect us from harm. Some of them must have been particularly vigilant in the good old days before modern hygiene and sanitation were introduced—but then no self-respecting germ would dare to show its nose around Old Annie, and I say so advisedly.

Not that I would cast the shadow of a doubt on Annie's wisdom or ability, but, judging from her appearance, I would be willing to bet my best paint-box that she had never been washed since the day she was born. This, however, had left no noticeable effect on Old Annie's health and happiness—or her skill as a midwife. The old woman had never been ill. Her mind was bright and alert, her memory keen and clear and her eyes gleaming black. Obviously she had been a sturdy woman once, but her flesh had shrunken away until there was little left of her now except her indomitable spirit.

The first time I went to see Annie she was away. She had risen early and had gone off down the valley on some business of her own, saying she would not be back until dusk. She was always doing something, the neighbours told me. She was always on the move.

Whatever may be said of Indian men, I have yet to see one lazy Indian woman. Their patient fingers are never idle. I am convinced that Old Annie was not indolent—she simply had a sublime disregard for housework. I knew exactly how she felt when the high hills and the open trails were calling—calling to the inmost soul of her.

With those persistent voices luring one away, who would be mindful of such sordid things as dishes, dirt and drudgery? Annie responded to the beckoning of nature and chose to ignore manmade shackles.

It paid her dividends, too, for how else did she acquire her slender, agile frame, her bright, fearless eyes and her uncompromising tenure on life? Submission to the conventions of others would have probably robbed her of all this and might have precluded her long life. As it was, she guilelessly and happily pursued her own way, piling up experience, wisdom and years.

A little later I made another attempt to waylay the old woman in an effort to paint her portrait. A young priest from the nearby residential school had driven me over to the Sugar Cane Reserve where she lived. The houses on the reserve were made of stout logs and they were arranged in a great circle in neighbourly fashion. They looked well-built and warm. The peeled logs seemed appropriate in that lovely setting between mountain and lake but the windows were too small, I thought, for people who must battle eternally with tuberculosis.

I found Old Annie's house and went in without knocking. This you are expected to do if you are a friend of the Indians. The one large room contained two old box stoves and nothing else but rags and wood—and Old Annie. No table, no chair, no bed, no nothing. She was sitting on the floor with wood chips, dust and pieces of old clothing all around her.

Life had ceased to hold surprises for her any more, so she merely looked us over and continued to sit. She understood every word when I asked if I could paint her but she was in no hurry about coming to a decision.

Long ago I learned to curb my impatient spirit in the presence of Indians, so I did not press the matter. Presently Annie wriggled to her feet, offering me a long, limp hand several shades darker than either of the old iron stoves. A coloured rag was twisted about her head and her straight grey hair hung like bits of frayed string about her thin shoulders. She said something about washing her face but there was no water basin for this novel operation so nothing was done about it.

A plump black iron pot was sitting on one of the stoves and God only knows what it contained. Curiosity overcame the priest, a gen-

tle, impeccably dressed young man. He went over and took one look at its contents and then made a bolt for the door, holding his nostrils as he ran. He remained, discreetly, in the car, buried in his prayer book during the remainder of my visit.

I told Annie I would like to paint her in the house next door, so she followed me to more congenial surroundings. This house was just like Annie's only it was clean and it had some furniture. Its occupants made us very welcome.

I used the only chair in the room for an improvised easel and hauled out a long bench that stood along the wall, placing Annie firmly at one end of it while I sat at the other end—as far away as circumstances would permit, and began to work. Every few minutes the old woman would peer around the canvas to see how the portrait was progressing and this did not make my task any easier.

Other Indians came in and stood around, watching me paint. They were intensely interested, and though it complicated my problems, I was glad to talk to them as I worked and answer their questions. Not every day is there a break in the ordinary routine of our lives.

I had a silver dollar in my purse, which I had been saving for some special occasion. I figured that I would never see anyone more special than Annie, so I gave it to her when I was through with my work. She could not have been more delighted if I had given her a fortune and said that was the easiest money she had ever earned. I am betting that she punched a hole in it to wear around her neck as a bangle. Indians dearly love jewellery and she would never waste good silver on mere merchandise.

Many a tale is told of Annie's prowess when she was young. Year after year she and her husband, long since dead, would hitch up their team of horses to an old wagon and make the long trek to Chimney Creek where they would remain for six or eight weeks hunting and fishing.

No man could outshoot or outtrap Annie. She had an old muzzle-loader, always at the ready, and with that she could pick off a grizzly with the best of the men.

A great many years ago Annie saw, for the first time, a door with a glass panel and this impressed her profoundly. She decided she would also have a glass door for her own little house. She cherished this ambition for a long time before she had the opportunity of

fulfilling it. Years afterward, in a hardware store at Lytton, she saw the glass door of her dreams.

It is a long, hard trail from Lytton to the Sugar Cane Reserve, a tedious enough trip by bus. What must it have been like in those days with a big glass door on your back? Annie knows, for she packed her purchase home, every inch of the way, under her own steam.

Picture, if you can, this little shred of a woman, tramping over the mountains and through valleys on lonely trails and by rushing waters, going through rough and narrow gullies, stepping over logs and edging her way around boulders, mile after dreary mile, day after toilsome day, bent under her precious burden. One can see her at night, stopping by the side of the trail to sleep with the quiet stars and dark evergreens above her and a lean, brown hand resting on her treasure. Then, toting it all again each and every day until the long backbreaking journey was over.

I like to imagine Annie's expression when she finally got that door swinging on her little cabin. I like to think of her pride and satisfaction and her almost holy joy as she revelled in the admiration and envy of her less fortunate neighbours. How she must have loved the bright, shining newness of it, the thrill of the sun flooding through it in daylight into her dingy room and the pale luminescence of the moon at night.

Annie was a famous horse woman and the Indians still tell how she would gallop off on a pony, rope a wild bronco and break it with all the skill of a trained stampede rider.

The wind and the weather, the toil and the hardship and the long, relentless years had withered her face and her body but her health was unimpaired and the soul of her looked out with undaunted serenity and peace through her glowing black eyes. Her interest in life and in the great natural world about her was as keen and strong as in the days when her name was a byword for skill, courage and dexterity.

A Few Legends

The Man Who Would Not Die

Among the Coast Salish people in the early days there were forty medicine men who belonged to a secret order. One of them was called "the man who would not die." His name was Ka-na-polis and he lived near [where] the Second Narrows Bridge now stands over Burrard Inlet. He had the power to kill people by secret means and could make people sick. All evil and bad fortune was blamed on him. He was greatly feared and hated by the people.

One day the young Indians said, "This has got to stop. We shall have to do away with him." So they made a raft of cedar logs and took him up the inlet. They had also made a big box which they had on the raft. When they got far out on the water they put Ka-na-polis into the box.

The medicine man knew they meant to do him harm so he made one request. He asked to be given some matches. The young Indians gave him the matches, put him in the box and bound it up tightly with cedar ropes. Then they paddled to the centre of the inlet, dumped the box overboard and watched it sink to the bottom. [The significance of the request for matches is not explained.]

"Now we shall be rid of him," they said. But the medicine man had the power of the thunderbird. When the box sank to the bottom of the inlet the thunderbird became very angry. He caused a great storm to roll up. The lightning flashed and the thunder roared in a most frightening manner. The Indians were very much afraid and ran away.

Then the thunderbird dived to the bottom of the inlet and cut the cedar ropes from the box. The man rose to the surface of the water and made for the shore. He went back to the village at night when everyone was asleep and knocked at every door to let them know he was alive—that they could not kill him. The people said, "No, we cannot kill him."

One day, when the medicine man was riding his horse, an Indian hid in the bushes and waited until he came along the trail. When he passed by the Indian shot him through the temple. The medicine man fell to the ground and the young Indian ran away.

291

Again the thunderbird was enraged at this act. He caused the rain to pour down in torrents, the lightning to flash and the thunder to roll more than it had ever done before. The rain poured down on Ka-na-polis and revived him. Nearby some fireweed was growing. He took its pollen and stuffed it into the hole in his head where the bullet had hit him and got to his feet.

He then returned to the village and knocked again at every door to show that they could not kill him. And, again, the people said, "No, we cannot kill him."

Sometimes the old medicine man used to go to New Westminster and get very drunk. The police would throw him into the jail and all the Indians would know what had happened immediately because a big storm would come up with terrible thunder and lightning. Then the Indians would beg the police to let him go. As soon as he was released, the storm would die away.

Many times he would visit another medicine man called Toe-ho-qua-kin. He was very powerful also and belonged to the "great order." He was a big man, 6 feet 4 inches. He was killed when he fell off the old Burrard Bridge in 1891.

These medicine men used to perform miracles, bring dead animals back to life. They had secret medicine charms that they used to bring skeletons and even old skins back to life—so the Indians believed.

Ka-na-polis lived to be a very old man. After many, many years he called all the people into his house and told them: "The time has come when I must take a long, long walk and leave you. You must do as I tell you." So he held a big potlatch, gave all his belongings away and instructed the people to make a big wooden box and put his body into it, tie it up with cedar ropes and put it in the middle of the house. Then they must set the house afire.

This they did exactly as he had commanded, with great fear in their hearts because he was so powerful. The house burned furiously. Thunder rocked the skies and the lightning was terrible. The house burned to the ground. Nothing was left except in the middle of it the death box remained, still tied with the cedar ropes.

They opened it to find it empty. Ka-na-polis had gone to his fathers, to the great and powerful company of medicine men of all time who had preceded him—the man who would not die—the man they could not kill.

The Story of Yowt-yos

[As told by Isaac Jacobs]

One day a young man and his father were sitting outside on a nice day and the young man said, 'Look there, father, look down there.' The father looked and could see nothing but the young man saw something because he had 'the great power' and his eyes were 'different.'

"A lot of the people came to see what he was looking at and what he was talking about but none of them could see anything unusual.

"The young man asked his father to help him to put his new canoe in the water. Then he went out with his spear and caught a great number of fish. The people could not see any fish in the water at all but pretty soon he had his canoe full. They watched and were amazed when he came to shore and said to his father, 'Take the fish and divide them amongst the people.' He gave them all away to the people who needed food.

"This was a great thing to do and, because he was such a good man, one of the older chiefs gave him his daughter to show his respect. Soon another chief did likewise and another and another. They like to give their daughters to a good man. Indian womans not know anything about jealous in those days—all happy, all work together and help him in his good work.

"He grew to be a very old man and everybody loved him. When he died, he did not leave his people entirely because his spirit went into the blackfish, into the killer whale called Yowt-yos, so now he will never die. If anything happens to the whale that has his spirit it would go into another one and he lives forever. When a good man dies he changes into an animal or something. We all know this is true.

"That is how I came to believe that Yowt-yos is really a person," continued Isaac. "If you want to talk to Yowt-yos and you are a good man, you can do so, but bad man can't.

"My father was a great and good man and he used to talk to Yowt-yos. When he was hungry, he would ask Yowt-yos to give him some meat. Then he would travel along the beach and he would see a seal put there for him by Yowt-yos.

"The killer whale can travel with great speed and it never trav-

els alone but always with others. If you say to them, 'I want a deer,' they will get it and put it in front of where you are going. My father did this many times.

"Only good man can see and talk to Yowt-yos, so he's glad he's got the great power. Few people get the great power. Common people cannot get it but a few high people can.

"The blackfish is the most powerful of all creatures. They can kill anything. My father had the power of the blackfish, the power of Yowt-yos and that is why the blackfish is the most treasured crest of my people."

The Faithful Wife

A long time ago there were three brothers who had just been married. They went out together looking for mountain goat in the high mountains. They had travelled far without seeing any and were becoming very weary when, at last, they spied a little white goat that was dancing in the sunlight.

This was a strange sight. It appeared to be quite tame but, whenever they came near, it danced a little farther away. They could not catch up to it so they kept following it. Each time, as it danced away from them, it looked back to see if they were still following. In this manner it led them into an enormous cave, high, very high in the mountains, and in it were hundreds of goats.

The brothers rushed forward to kill some for themselves when suddenly there was a terrific roar and a huge snowslide came down from above, completely filling the entrance to the cave, making them prisoners with the goats. They were trapped there and, as time went by, they worried. They said, "Maybe, when the snow melts, we can get away. Meanwhile, there are lots of goats here. We can eat them."

All winter they lived in the cave, ate the goats' meat, drank the goats' milk and packed the skins in bundles to take home with them when the snow melted.

The two older brothers took their imprisonment philosophically but the youngest brother was very sad. They wondered if their people were searching for them and if they missed them. The two older

brothers said they guessed their wives would have taken new husbands but the young man said, "No, I love my wife. She loves me. She will not take another husband. She will be faithful to me." The older brothers laughed at him and said, "You do not know women, she will not be faithful to you."

The months went by, spring came and the snow began to melt. Gradually it fell away from the cave opening until, one day, the men saw blue sky and the sunlight streamed through. At last they were free. They loaded their goat skins on their backs and started down the mountain. They also carried plenty of goats' meat.

When they arrived back at their village, the people stared in amazement. They could not believe their eyes. They had given them up for dead long ago.

It turned out that the older brothers were right. Their wives, thinking that they were dead, had indeed, got themselves other husbands but the wife of the youngest brother ran to meet him with great joy. She had been faithful to him and had never given up hope that he would return.

To reward her faithfulness a great potlatch was held and the people put up two huge posts with a cross beam upon them. Then they made a swing of mountain goat blankets. The older wives were scorned but the faithful wife was placed in the swing as an example to the other woman. As the people went by they gently pushed the swing to keep it moving and, in this manner, she was greatly honoured.

Today all that is left on the scene is one of the posts and a part of the other to tell the story of the faithful wife.

The Blackfish and the Grizzly

[In the words of Old Billy]

One time some womans went up the coast [in their canoe] looking for a place to pick berries. In the distance they saw a blackfish. The woman who was the captain of the canoe, said some bad things about the blackfish and the others warned her: 'Why you say that? Look out, he will hear you, not like it.'

"They went on and the blackfish came nearer, its big dorsal fin

sticking out of the water as it rolled along beside the canoe. Then the captain said some more mean things about it.

"The others said, 'Don't do that. He won't like it. Blackfish understand Indian language.'

"They were getting near the shore now and the captain said some more bad things, so the blackfish swam right under the canoe and upset them all into the water because the woman had said bad things about him.

"Another time some womans made a fire to cook some things near the beach. After a while they hear something coming and the bushes opened up. There was a great big grizzly bear coming straight toward them. He stood up on his hind legs and walked toward one of the womans who was standing by the fire, his huge mouth wide open. She was scared but she stood still and waited until he got close to her, then, quick as a flash, she rammed her arm right down his throat before he could bite her and choked him.

"She pushed her arm way down deep. The poor old grizzly let his paws drop and fell down like dead, so they all got away safe."

The Sasquatch

Are there great, hairy giants living among the unscaled peaks of British Columbia's mountains, similar to the Abominable Snowman of the Himalayas? Many of the older generation of Indians thought so.

We have often heard of Sasquatch being seen in the Harrison Lake area and a group of white men made an attempt to find one, dead or alive, but their search proved fruitless.

Squamish Indians claimed they have been seen in coastal regions and why not? After all, it is only a few healthy steps for a giant from Harrison Lake to Anvil Island and, also, why should there not be many of them?

Johnny Baker said he was going up Grouse Mountain one day when he came across a large tree, partly fallen. It was leaning at an angle of about forty-five degrees. This intrigued him so he climbed up on it to get a good view of the country about him. To his surprise he saw a huge Sasquatch walking along near the top of the mountain, taking giant strides and swinging his great arms vigorously

with every step. Each time he swung his arms he turned his head sharply to one side or the other as he walked.

Willie Baker of North Vancouver, whose widow is still living, told me of his experience. He, his brother and another Indian boy went in a dugout canoe to Anvil Island to sell fish to a Scotsman and his sons who were camping there. Willie had a bow and arrow. One of the other boys had an old-fashioned gun but just one cap with which to load it.

In the evening they were sitting outside their tent when they heard the sound of leaves rustling. It was summer time. There had been no rain for a long time, the grass and twigs were dry, so they wondered who was coming. Then they heard the sound of steps crunching on the gravel by the sea. By this time they were much afraid so they went into their tent and closed the flap. They got the gun and the bow and arrow ready and waited.

Presently they heard a Sasquatch outside. He walked around the tent and pulled out some of the pegs. Then he pulled the flap aside and peeked in. Terrified, the boys grabbed a rush mat and fastened it over the opening. They sat there, afraid to go out and afraid to go to bed.

Then the older boys thought of a scheme to get rid of the Sasquatch using the smallest of them, Willie Baker, as bait. They figured that if one of them went outside to shoot the Sasquatch [with the bow and arrow] he would be seized before he could take aim but the other two boys would have time to shoot with the gun, so it was decided that the two older boys would get their weapon ready, then throw the smallest boy outside. The Sasquatch would immediately try to catch the lad and this would be their chance to shoot it.

This was a good idea for everybody but the little boy who objected to being offered as bait to the big giant. Though he yelled and kicked furiously, the older boys pushed him outside but he sprang back like a boomerang. Every time they pushed him out he came back. Hearing all this commotion, the Sasquatch decided he wanted no part of it and went on his way without molesting any of them.

"Once there were several [of us] boys in a tent up in the mountains," Willie Baker told me, "and they heard someone calling a long way off. It kept on calling, calling and they think 'what is it?' The voice kept getting closer and they were very much frightened."

Creatures

▸ *colour plate page 156* 299

Willie had a gun, which he was loading, when the creature drew the flap of the tent aside and looked in. It was an enormous man, all covered with black hair. When he saw the gun he turned and went away. Willie tried to follow it, but the Sasquatch took long strides and went too fast for him. Later he tried to walk in its foot prints but they were twice as large as his feet and the strides twice as long as he could take.

"Another time," he said, "some womans went into the mountains looking for wild cherry bark for their blankets and they heard someone singing. It kept on singing for a long, long time—a long way off, just kept on singing. One of the womans got a long piece of pitchwood, about four feet long and three inches wide, and poked it in the fire. After a long time the singing came closer and they see a huge man, all covered with black hair, coming to the fire. The woman with the pitchwood stick told him to face the fire to get warm. When he did this she pushed him into the fire and his hair began to burn. He ran away, all on fire, and they never saw him again."

Willie Baker is also credited with the following story: A middle-aged woman and several beautiful Indian girls went to Anvil Island to camp. They had a nice time all day and in the evening made a fire to cook their meal. Then they sat by the fire and began to chant, as Indians do at their dances. This went on for some time when suddenly they heard a loud voice saying "Kloochmen," the Indian word for women. The voice kept repeating this word and they knew that it was the Sasquatch coming.

The girls ran to their Chinook canoe but the woman stayed to defy him. Once before she had put a Sasquatch to rout with a spear dipped in pitch and lighted. She had come to Anvil Island prepared and had such a spear with her, so she just sat by the fire and waited.

Presently he appeared, a huge manlike creature, all covered with black hair from his head to his feet. Just as he was about to grab her, she pushed the pitchwood into the fire and got it ablaze. In a flash she thrust it between his hairy legs and immediately he was afire. He gave a great yell of pain and a jump, running away, enveloped in flames and with a "hotter behind" than he ever had before.

In telling about this episode Willie said, with boundless admiration, "It took guts to do that!"

It appears that the female of the species is more deadly than the male—and also more courageous. There is a story of a woman and her husband who went from Squamish to Anvil Island in their canoe to camp there. Night came so they built a fire beside the trunk of an enormous cedar tree that had fallen. It was like a shelter from the wind.

After a while they looked up and saw a great, hairy man coming toward them and they knew it was Sasquatch. Greatly frightened, they ran to the canoe to get away. The man ran faster [than the woman] so he got there first and paddled away, leaving the woman to face the giant alone.

She ran back to the fire and the Sasquatch chased her from one side of it to the other, over and over again. When he almost had her within his grasp, she grabbed his breech cloth and threw it into the fire. This made him so angry that it diverted his attention from the woman as he tried to retrieve his breechcloth from the flames. Taking her chance to escape, she made a dash for the shore and swam out to the canoe. When the Sasquatch saw her swimming to

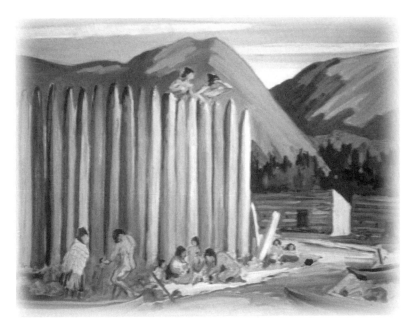

Palisade in Burrard Inlet (c. 1800)

301

the canoe he waded out after her but he could not swim. When the water came up to his neck he turned back and the man and his wife got safely away.

Some Indians believe that the Sasquatch are just looking for food. Others say they are merely curious, do not wish to harm anyone. They say that both big men and big women came to Jervis Inlet, Sechelt and Squamish (many years ago). At Sechelt they found enormous thigh bones. Basil Joe of Sechelt knew they had been in the vicinity.

Kaht-ka-kaliuck was the name of a Sasquatch woman seen at a logging camp near Pemberton where she used to steal food. A young Indian saw her making bread from flour she had stolen from the logging camp. Finally, they caught her and brought her down to Vancouver on a scow. According to Tommy Moses she talked the Cowichan language and had long, black hair cut in bangs across her forehead. Alex Peters said she had also been seen in Point Grey in the early days.

Indians say Sala-qui-nas was the name of a Sasquatch woman who would kill you and just take your heart. Chief August Jack says they used to see the Sasquatch nearly every night.

Said he: "Once a young girl put a spool of thread and a needle on a fence post and said 'It's for the Sasquatch.' That night the Sasquatch came and took it away with him. Next night he came again and brought a big deer to pay for the spool of thread and needle.

"The neighbours told the young girl the Sasquatch was around. She said, 'I must give him a mirror and a comb.' So she put these [items] on the fence post and, sure enough, he came and took them away. Next night he came and dragged up a big tree, two feet in diameter at the butt, roots and all and laid it at the girl's gate to pay for the mirror and comb. He knows it's for him and he pays for what he's got. He is not bad. He is something like a mind-reader. He can hear people talking. If they get rough with him, he gets rough with them.

"They see him up and around Hope in the mountains there. Two Indians saw him. They put a net in the river and the Sasquatch came, pulled up the net and took the salmon that were in it, every time. The Indians got mad one day and said 'If we see him we shoot him.' So when he came [again] he got a big rock and tried to break the

Indian's canoe. They shouted at him, had to get out of their canoe and run away. The Sasquatch are very powerful. They can throw rocks right across the Fraser River, even at its widest part.

"In the summer time he is around here. Sometimes he visits the United States. He is all covered with black hair, wears no clothes, doesn't have to go to Hudson's Bay to get a blanket, grows his own food," according to August.

"Once an Indian had a parcel of dried salmon. It was too big to go through the door of his house but the Sasquatch came, picked it up and threw it a long ways off, then took it away with him." This was told by a Musqueam Indian.

I was told, "The Sasquatch doesn't stay in one place. In winter he goes south but always stays in the mountains, eats deer and fish. Uses only a club to kill things. At Snohomish there is an Indian village where he comes at night. People won't allow their girls to go out because he is looking for a wife. The Sasquatch have a language of their own but can understand any language. It just comes into their mind[s].

"They leave huge foot tracks, like a human but much larger. Nature grows fur to protect people. A woman in North Vancouver went crazy. She took to the woods for a few months and started to grow fur. Her clothes were all torn off and nature started to grow fur on her to keep her warm."

Thinking on the subject further, August Jack says, "There were three different kinds of Sasquatch at Squamish. They were called Simlick, Klelaquin, and Naanchosin. They lived in different parts of the mountains.

"Kolkolish, a big Sasquatch woman, lived near Point Grey. Any time people would be going to get smelts she would watch and when the older people had left for a minute, she would take their smelts. If hunters left their ducks for minute, she would steal them.

"She had all kinds of kids she had stolen from the village. She would steal them and take them away with her, then put pitch on their eyes so they could not see. She put it on their seats also, so they would stick to things and couldn't get away. She fattened them and ate them.

"She kept one bigger boy as a guide for the little kids she had stolen. One day he made a big fire. They told him to make it bigger as they were cold and hungry. So he made it bigger and bigger. The

kids asked him to show them how to dance around the fire. Then they asked the old woman to dance and when she was dancing around the fire they pushed her in. She called to them, 'Take me out,' but they got a big stick and pushed her further into it and burned her so she could not harm them anymore. Her head was square, like a box, and that was the end of her.

"Then the big boy, whose name was Deaitkitson, put grease in the eyes of the kids which took the pitch off and they could see again. He took them down to the village, to their families where they belonged. All this happened at Musqueam or Point Grey, as they call it now," said August.

He went on to say, "There were two of these women there. The other one wanted to go to Vancouver. She asked the people at Musqueam to take her over and they said, 'all right, we will.'

"So they got a big canoe and told her to pull up a lot of rose bushes to pile up on the seat of the canoe as it leaked a little bit. She did this but they told her to get more to make it really high so she wouldn't get wet. Then they told her to sit high on it, even with the edge of the canoe.

"When they got far out on the water one of the Indians stood on the edge of the canoe and made it capsize. She couldn't swim, so she was drowned and that was the end of her!"

Funeral Party

▶ *colour plate page 143* 304

Epilogue

With only a few exceptions, the sketches included in this account of the Indians I have painted and the stories told me were written at the time from extensive notes that I could not allow to grow old. When the accounts were written, the subjects were still alive. Because these interesting people still live so strongly in my memory and to preserve the sense of their contemporary place in these accounts as freshly set down, I have chosen, quite deliberately, not to edit the pieces into the past tense. Old when I met them, so many have gone, taking with them the lore which, for lack of a written language, these original inhabitants of our land memorized with infinite care and passed down through the generations.

However, it is advisable that at time of publishing there should be a statement, inclusive of postscripts, since the sketches were written down to the present year of 1966. It is ironical that in this age, when political aim appears to take from the rich and give to the poor in the name of social justice and practical politics, the Indians should have been called criminals if they continued their age-old potlatch ceremonies. The potlatch not only accomplished that purpose of wealth distribution, but had the merit of being one of the happiest of celebrations, quite in contrast with the reluctance with which we see the tax collector accomplish the same general purpose. The potlatch was dishonoured when the white man's strong drink was added and this is less of a reflection on the Indians than on the people who later made them wards of the state.

To Chiefs Charley Nowell and Herbert Johnson, both of whom were painted in 1946, the potlatch was of supreme importance. Sometimes called the "gift feast," it was an occasion when goods, in huge quantities, were distributed to show the wealth and prestige of the one giving the feast. The potlatch was usually given by a chief though anyone with sufficient wealth might hold one. They were attended by hundreds, sometimes thousands, of people who would be invited long before the event took place.

The ceremonies lasted for days or weeks, the host providing all the food and accommodation for the people. Often his relatives would help him if need be. A man might labour for years to accumulate enough goods to hold a potlatch, thus adding to his stature among his fellows.

Blankets, furs, clothing, guns, canoes, utensils and many other articles of value—and, in later years, money sometimes running into thousands of dollars—were given away.

Some chiefs continued to hold potlatches even after it was banned by the government on the grounds that it impoverished the Indians. Charley Nowell was sent to jail for doing so, but sympathetic white people managed to secure his release. On the other hand, Herbert Johnson told me of a potlatch he had held, after it was forbidden, at remote Simoon Sound. If anyone knew about it nothing was said. He "called" people from many villages along the coast. They came in eighty-five gas boats. He paid for the gasoline and treated them all as guests for many days. He displayed his masks, sang his songs and did his dances, all of which were personal properties, and gave away many things of great value, but the crowning event was "the breaking of a chief's copper."

There was nothing greater that a chief could do. He broke the copper and gave all but one piece away. This he kept for himself because he had paid $24,000 for the copper and it was not quite all paid for. Herbert was an industrious fisherman, which explains this feat of prodigality.

Moody Humchitt, painted in 1947, had been born into the old tradition and had given many a potlatch in the ancient village about a mile or so from the present location [Bella Bella]. Walking through the woods to this old site, I saw many coffins, some piled high on each other with personal belongings of the deceased heaped beside them. This was where the rank and file of the people rested; across the channel was Gulf Island, a hallowed spot, where only the chiefs took their last long sleep in little wooden houses that had been built for the purpose.

A Few Final Notes About My Indian Friends

❖ Chief Hemos Johnson, deceased, was painted in 1946. He was a wonderful father who left a heritage of tolerance and goodwill behind him.

❖ Chief Philip Brown's most important crest was the blackfish, which he displayed on his headdress and his speaker's stick. He told me that his daughter could speak his language and would inherit his crest.

❖ Andrew Wallace was painted in 1947. Both he and Philip Brown have long since passed away.

❖ Mrs. Mary Moon, matriarch of the Comox people, was the only person living who knew the old songs of her tribe. These I recorded on tape and [also] painted her portrait at her home in 1952. She passed away in 1960. Her son, Chief Andy Frank, and Mrs. Frank, were also painted in 1952. Both are still living at Comox. They enter fully into the life of the community, yet properly retain pride in their Native heritage, both having beautiful ceremonial costumes.

❖ Chief Napoleon Maquinna carries a name in the line of indirect succession to the famous Nootka chief who captured the sloop Boston in 1803, slaughtered the crew, plundered and burnt the ship, but spared the lives of the ship's armourer and sailmaker whom he kept as slaves for more than two years until they managed to escape.

❖ Mrs. Agnes Russ, grand old lady of the Queen Charlotte Islands, passed away in 1964 at 105 years of age. Some of her people claimed she was 110. Her grandfather was the famous Chief Weha of Masset. She met and married Amos Russ in 1879. They were instrumental in building three churches in the Queen Charlottes.

❖ Mark Spence, a true gentleman, since deceased, was painted in 1941.

- Chief Heber Clifton and Mrs. Clifton were painted in their home in 1948. He died in 1964. His wife predeceased him in 1962. The village of Hartley Bay is a shining example of what dedicated Christian leadership can do. The descendants of this noteworthy couple made history recently when they established a continuing Indian scholarship for Indian children, the first Natives ever to do so.

- I am indebted to the late Rev. Victor Sansum who was closely associated with the Tsimshian many years ago for information concerning Mrs. Duodoward and also to her son, Chief Ernest Duodoward, deceased.

- The story of Gunnanoot is one of the most tragic chapters in the life of B.C. Indians. It is said that all the time he was in hiding he continued to hunt and trap, taking his catch to a white man who befriended him. He, in turn, sold the furs and gave Mrs. Gunnanoot the money which enabled her to care for their family and keep them in school. I thought the sadness of her life was plainly inscribed on her face when I painted her in 1948. She has since passed away.

- Chief John Bolton, a very important man at Kitamaat, was painted in 1947. He died some years ago.

- Mary Capilano was the first Indian I painted in British Columbia, in 1935. She died in 1949 at the great age of 108. I painted many others in the immediately following years—people whose stories have yet to be told.

- Chief Mathias Joe, hale and hearty, is still living on the Capilano Reserve, in his late seventies. I painted him in 1947.

- Tommy Moses, noted carver and a very dear friend, was painted in 1942. He has since passed away.

- Siamelaht was an aunt of Chief Augustus Jack Khatsalano and a very important person, indeed. She was known as Aunt Polly and her views were not lightly regarded. She was 106 when she died many years ago.

- Chief August Jack Khatsalano, probably the last of a gallant generation, is still living at Squamish near the century mark. He

recalled the last big potlatch given in Victoria when he was a small boy: "No wharf then, no parliament buildings, no Empress Hotel, just one big Indian village." Chief Scum-you-cus called the people from all along the coast. He fed and housed them for a whole month. Everyone received gifts. August said there were 2,000 or more in attendance.

❖ When the government, for health reasons, ordered the Indians to bury their dead underground, the box containing the remains of the Prophet of Squamish was interred in a secret and sacred place far from Squamish. Only two people living know of its whereabouts. I painted August Jack and Mary Ann in 1938.

❖ Chuchoweleth told me she was ninety-seven when I painted her in 1940. She has long since departed.

❖ Denny Jim, painted in 1941, was the oldest Indian I have ever painted. He passed away a good many years ago at 116 years of age.

❖ Mrs. Chief George was a descendant of the warrior Wautsauk, who was famous because he kept a wolf for his constant companion. She told me that long ago there used to be a palisade of cedar trunks on Burrard Inlet just below their village, similar to the one at Homulcheson. Behind the protection of this primitive fort her people could defend themselves against warring tribes from the north who might come, at any time, to raid them. Of course, no trace of the fort remains. I painted Mrs. George in 1943. She died in 1963 at ninety-five years of age.

❖ Isaac Jacobs was painted in 1943. After he passed away in 1956, someone broke into his church and stole the Jesus picture. I can only hope that it is still giving out the message of love and peace that Isaac cherished for his little sanctuary.

❖ Jim Pollard, a mighty man in his day and great authority on the history of his people, was painted in 1946 and has long since gone to his reward. It was my privilege to record, on tape, all the old songs that those remaining in Bella Coola in 1946 could remember.

❖ Chief Sam Pootlas, a remarkable man, was painted in 1946. He died some years ago.

❖ Tommy Pielle, deceased, was painted in 1944.

❖ Big William, painted in 1944, may be living still.

❖ Manuel Louie, Dominic Jack and Louise and Paul Terrabasket were all painted in 1944. Paul Terrabasket passed away several years ago.

❖ Mrs. Mary Dick, deceased, was 103 when I painted her in 1943.

❖ The paintings at Fort Babine were done in 1946. Rosie Leon and the chief have since died.

❖ Chief George of Sechelt was painted in 1938, and Cariboo Annie, who died in 1948, was painted in 1946 at 105 years of age.

Surely it is remarkable that so many of these people lived to such advanced ages. It is my belief that the simple life, nature's food, their own faith and a characteristic inward peacefulness of spirit had much to do with their longevity.

—M. V. THORNTON, 1966

Index to Colour Plates

Trees, Stanley Park

- *Page 132*
 Chief Billy Assu, Kwakiutl
 Cape Mudge, B.C., 1945
 Oil on board, 30 x 20 inches
 Collection: private

- *Page 133*
 Chief Moody Humchitt, Kwakiutl
 Bella Bella, B.C., 1947
 Oil on board, 24 x 20 inches
 Collection: private

- *Page 134 (top)*
 Fantasy of Masks, Kwakiutl
 c. 1943
 Oil on board, 30 x 40 inches
 Collection: private

- *Page 134 (bottom)*
 "Rain Call"—Thunderbird Dancers
 (as described to artist)
 Bella Coola, B.C., c. 1945
 Oil on board, 30 x 40 inches
 Collection: private

- *Page 135*
 Susan Gray, Haida
 Skidegate, B.C., 1946
 Oil on board, 22.5 x 16 inches
 Collection: private

- *Page 136*
 Chief Hemos Johnson, Kwakiutl
 Kingcome Inlet, B.C., 1946
 Oil on board, 24 x 20 inches
 Collection: private

- *Page 137*
 Mary Moon, Kwakiutl
 Comox, B.C., c. 1950
 Oil on board, 22.5 x 16 inches
 Collection: private

- *Page 138*
 "Where have all the people gone?"
 Haida fantasy, c. 1964
 Oil on board, 36 x 30 inches
 Collection: W. M. Thornton

- *Page 139*
 Leaning Totems, Tsimshian
 Watercolour, 17.5 x 11.5 inches
 Collection: David Hancock

- *Page 140*
 Mrs. Andy Frank, Kwakiutl
 Comox, B.C., 1952
 Oil on board, 22.5 x 16 inches
 Collection: private

- *Page 141 (top left)*
 Chief Napoleon Maquinna, Nootka
 Kakawis, B.C., 1943
 Oil on board, 33 x 19 inches
 Collection: Westbridge Fine Art Ltd.

- *Page 141 (top right)*
 Chief Heber Clifton, Tsimshian
 Hartley Bay, B.C., c. 1945
 Oil on board, 22 x 16 inches
 Collection: private

- *Page 141 (bottom left)*
 Mark Spence, Haida
 Masset, B.C., c. 1941
 Oil on board, 24 x 18 inches
 Collection: private

- *Page 141 (bottom right)*
 Chief Amos Williams, Tsimshian
 Kitwanga, B.C., c. 1945
 Oil on board, 22.5 x 16 inches
 Collection: private

- *Page 163 (bottom)*
 Squamish Nation Makes Peace
 With Comox Tribe
 (as described to artist), c. 1940
 Oil on board, 30 x 40 inches
 Collection: Glenbow Museum

- *Page 164 (top left)*
 Tommy Pielle, Cowichan
 Kuper Island, B.C., 1943
 Oil on board, 24 x 18 inches
 Collection: private

- *Page 164 (top right)*
 Isaac Jacobs
 Ordained Minister, Squamish
 North Vancouver, B.C., 1943
 Oil on board, 20 x 16 inches
 Collection: private

- *Page 164 (bottom left)*
 Madeline, Squamish
 North Vancouver, B.C., 1944
 Oil on board, 24 x 20 inches
 Collection: private

- *Page 164 (bottom right)*
 Manuel Louie, Okanagan
 Oliver, B.C., 1944
 Oil on board, 24 x 18 inches
 Collection: private

- *Page 165 (top)*
 British Columbia Coast
 Alert Bay, B.C., c. 1950
 Oil on board, 24 x 30 inches
 Collection: private

- *Page 165 (bottom)*
 Oolichan Fishing
 Bella Coola, B.C., c. 1943
 Oil on board, 30 x 40 inches
 Collection: private

- *Page 166*
 Big William, Chief of Salmon Arm
 Reserve, Shuswap
 Salmon Arm, B.C., 1944
 Oil on panel, 18 x 17.75 inches
 Collection: private

- Page 167 (top)
 Hudson's Bay House
 Fort Babine, B.C., c. 1942
 Oil on board, 22 x 30 inches
 Collection: private

- *Page 167 (bottom)*
 The Gamblers
 Bella Coola, B.C., c. 1941
 Oil on masonite, 30 x 40 inches
 Collection: private

- *Page 168–169*
 The Hao Hao Dance of the
 Bella Coolas
 1947
 Oil on canvas, 30 x 40 inches
 Collection: Reg Ashwell

- *Page 170 (top left)*
 Chief Joseph Louie, Okanagan
 Similkameen Reserve, B.C., 1944
 Oil on board, 24 x 20 inches
 Collection: private

- *Page 170 (top right)*
 Chief William, Carrier
 Fort Babine, B.C., c. 1944
 Oil on board, 22.5 x 16 inches
 Collection: private

- *Page 170 (bottom left)*
 Dominic Jack, Okanagan
 Penticton, B.C., 1942
 Oil on board, 20 x 16 inches
 Collection: private

- *Page 170 (bottom right)*
Louise, Wife of Dominic Jack
Okanagan
Penticton, B.C., 1942
Oil on board, 20 x 16 inches
Collection: J. M. Thornton

- *Page 171*
Mrs. Mary Dick, Thompson
Lytton, B.C., c. 1943
Oil on board, 24 x 18 inches
Collection: private

- *Page 172 (top)*
Indian Village Near Fort Babine
Fort Babine, B.C., c. 1943
Oil on board, 30 x 40 inches
Collection: Westbridge Fine Art Ltd.

- *Page 172 (bottom)*
Babine Lake
c. 1943
Oil on board, 20 x 30 inches
Collection: private

- *Page 173 (top left)*
Chief Charley Nowell, Kwakiutl
Fort Rupert, B.C., 1946
Oil on board, 30 x 22 inches
Collection: private

- *Page 173 (top right)*
Chief Tom, Cowichan
Sechelt, B.C. 1942
Oil on board, 24 x 18 inches
Collection: private

- *Page 173 (bottom)*
Haida Totem Carver
Skidegate, B.C., c. 1945
Oil on board, 30 x 40 inches
Collection: private

- *Page 174 (top left)*
Sarah Gunanoot, Tsimshian
Cassiar, B.C., 1948
Oil on board, 24 x 20 inches
Collection: private

- *Page 174 (top right)*
Chief George, Cowichan
Sechelt, B.C., 1940
Oil on board, 20 x 16 inches
Collection: private

- *Page 174 (bottom left)*
Rosie (Mrs. Daniel Leon), Carrier
Fort Babine, B.C., 1946
Oil on board, 22.5 x 16 inches
Collection: private

- *Page 174 (bottom right)*
Daniel Leon, Carrier
Fort Babine, B.C., 1946
Oil on board, 22 x 16 inches
Collection: private

- *Page 175*
Chief Tommy Paul, Cowichan
Saanich, B.C., 1948
Oil on board, 24 x 20 inches
Collection: private

- *Page 176*
Tsimshian Totem Poles
Kispiox, B.C., c. 1944
Watercolour, 14.5 x 11 inches
Collection: David Hancock

The Estate Collection of paintings
and watercolours by Mildred Valley
Thornton, FRSA, CPA (1890–1967)
is represented by Westbridge Fine Art
Ltd., 1737 Fir Street, Vancouver,
British Columbia V6J 5J9.

Additional paintings by Mildred
Valley Thornton are available from
Westbridge Fine Art Ltd. These
include portraits of both the Plains
and West Coast First Nations
peoples, painted in the 1940s and
1950s, together with a selection of
paintings dealing with native culture,
mythology and lifestyle, as well as
many fine Canadian landscapes in
both oil and watercolour. Many of
these pieces can be viewed online at

Buffalo People
Portraits of a Vanishing Nation
Mildred Valley Thornton
ISBN 0-88839-479-9
5½ x 8½ • sc • 208 pages